The Indian Style

The Indian Style

Raymond Head

THE UNIVERSITY OF CHICAGO PRESS

The University of Chicago Press, Chicago 60637

George Allen & Unwin (Publishers) Ltd., London WC1A 1LU

95 94 93 92 91 90 89 88 87 86 54321

Library of Congress Cataloging-in-Publication Data

Head, Raymond.
 The Indian style.

 Bibliography: p.
 Includes index.
 1. Architecture – Europe – Indic influences.
2. Architecture, Modern – Europe. 3. Art, European –
Indic influences. I. Title.
NA954.H4 1986 724 85–30228
ISBN 0–226–32224–6

Set in 11 on 13 point Garamond by Nene Phototypesetters Ltd, Northampton
and printed in Great Britain by Richard Clay (The Chaucer Press Ltd),
Bungay, Suffolk

For Anthea and Susannah

CONTENTS

Introduction *page* xi

Acknowledgements xiii

A Passage to India – and Back 1

A Pleasing and Tasty Style 21

Other Sheep I have 64

Imperial Sentiment and Anglo-Indian Architecture 73

Indian Crafts and Western Arts 95

Marble Walls and White Reflections 119

Fantasy and Illusion 134

Ex Oriente Lux 157

Abbreviations 170

Glossary of Indian Terms 171

Photographic Acknowledgements 173

Notes 174

Bibliography 200

Index 206

Introduction

My theme is that of Indian influence on the architecture and taste of the West from the seventeenth century to the present. Hitherto the subject has been little investigated perhaps because the scope is so very wide and diverse. Because of this diversity I have concentrated upon selected themes which provide a coherent view and no attempt has been made to be comprehensive. I hope that other researchers will take up some of the subjects that could not be included.

The examples have been chosen for their specific reference to Indian architecture and taste. This has been done because it was my purpose to discuss not a generalised East replete with European orientalisms but a sub-continent called India, whose boundaries before Independence in 1947 also included Pakistan. The object of this was to establish the particular importance of Indian influence in the realms of style and taste.

One of the results of this approach has been to rescue India from the cul-de-sac of the picturesque and to demonstrate that her influence has been continuous. It cannot be doubted that the existence of the British Indian Empire was of paramount importance for the dissemination of Indian visual ideas, and forms such as the bungalow. The imperial bridge between East and West encouraged a flow of information and ideas in both directions. Had it not been for this connection Indian crafts would not have made the impact on art school policy which they did during the mid to late nineteenth century. This and the recognition that India had a valid craft tradition was to lead to Anglo-Indian architecture and its use in other tropical colonies. India's influence on other tropical countries has only been sketchily indicated because of the difficulty of inspecting original material.

My interest is in the influence India had on the European or Western mentality and sensibility. For this reason the design of contemporary Indian restaurants are not discussed in this book since they clearly show Indians promoting their own culture. In contrast, I do mention Indians who lived in nineteenth century Britain because they were so inter-related with Victorian taste and imperial progress.

This account begins in the seventeenth century when the various East Indian Companies were established. But it was not until the end of the eighteenth century that India directly influenced buildings. One of the reasons for the delay is that its acceptance depended on changes in the political and artistic climate.

These only occurred at the end of the eighteenth century. Two subjects which were important but which have so frequently been discussed that they are only briefly mentioned here, are the acceptance of picturesque theory and developments in landscape gardening. Both subjects are of course intricately connected. At a time when 'plain Grecian' had fallen into disrepute picturesque theory together with the cult of the sublime and the beautiful encouraged a new delight in irregularity, intricacy and the use of the imagination. As a result some artists and architects were prepared to look elsewhere for sources of inspiration, and to challenge the accepted classical orthodoxy and European traditions. They did this because of the limitations orthodox ideas imposed on the imagination and thought. Within this aesthetic ideal Indian forms, like her philosophies, were seen as liberating influences. However, for Britain the use of Indian forms could not easily be freed from their political implications. Over several centuries Westerners have come to respect and admire Indian aesthetic and philosophical traditions and at various times have publicly admitted that they had much to learn from them.

Acknowledgements

I owe a great debt of gratitude to many people who have helped me in this project. I would especially like to thank Mildred Archer for her constant help and encouragement and John Harris. For the comments and suggestions of Sir John Summerson and Mark Girouard I am most grateful. Thanks must also be given to the British Academy who gave me an award so that I could pursue my investigations in the United States, and to Duncan Robinson of the Yale Center for British Art for granting me a short-stay fellowship at the Center in New Haven, Connecticut.

Others I would like to thank are: Paul-Louis and Nina Albertini, Robert Barnes, Mosette Broderick, Anne Buddle, Anne Burrows, Kenneth Cardwell, Yu-Chee Chong and Yu-Chit Chong, staff of the Colorado Historical Society, Patrick Conner, Mrs B. Crichton, Stephen Croad, Philip Davies, Simon Digby, Giles Eyre, Toby and Gael Falk, Janet Foreman, Julia Foskett, Christopher Frayling, Sven Gahlen, David Gebhard, Thomas Hancock, Neil Hobhouse, Tom Houghton, Hilary Jacobs, Deborah Jaffé, Charles Jencks, Jean-Marie Lafont, Robert McKinstry, Ian Molyneux, Michael Moodabe, Akhros Moravansky, Sten Nilsson, Lt Col. Nye, Paul Overy, Mrs S. Peake, Cynthia Polsky, Stephen Rapley, W. O. C. Roberts, Elizabeth Ryecroft, Balwant Saini, Martin Seggar, Dennis Sharp, Robert Skelton, Mahrukh Tarapor, Lynne Thornton, Peter Thornton, Andrew Topsfield, Brian Turner, Betty Tyers and Anthea, my wife who made many helpful comments and typed this manuscript, and Merlin Unwin for his help and enthusiasm for the book.

A Passage to India – and Back

H ad it not been for the dramatic rise in the price of pepper in the late sixteenth century, the British Empire would never have been founded. For many years the lucrative spice trade had been in the hands of the Portuguese, but by the end of the sixteenth century their influence had declined and the trade was largely in the hands of the Dutch. Their monopoly of the trade was resented by many countries, including England, and when they sharply increased the price of pepper in 1599, this provocative act was bound to produce a positive response.

In England the reaction to this move was immediate; at last the time had come to contest the supremacy of the Dutch. Eighty of London's leading merchants met together in the Guildhall and formed the East India Company which was granted a charter by Queen Elizabeth in 1600. Their action broke the Dutch monopoly and forged for England an important position. At first Indonesia rather than India was the main focus of attention since it was here that all the spices which Europe wanted were to be found. But it was not long before the fabulous jewels and luxurious textiles of India were as eagerly sought after.

The first voyage of the fledgling company took place in 1601. It was moderately successful and encouraged further expeditions in succeeding years. While the Dutch and Portuguese continued to dominate trade, King James I was invited by the Company in 1614 to send an 'official' embassy to the Mughal Emperor Jahangir in the hope that this prestigious contact would lead to special concessions for the English. Sir Thomas Roe, who was not a merchant of the Company, was appointed ambassador by the King. His selection marks the beginning of an ambivalent relationship between the government and the private company which continued for over two centuries. In March 1615 Roe's expedition, laden with presents for the Emperor including a virginal and a musician to play it, left for Surat, the chief port on the west coast of India. It arrived in September 1615 and the party took the strenuous route across country to Ajmer where the Emperor resided. For four years Roe patiently and repeatedly requested that Jahangir should grant special trade concessions in favour of the English but a highly evasive Emperor would have none of it. Roe returned to England in 1619 having to make do only with assurances that from henceforth English traders could live unmolested by the local Mughal governors within the Indian ports.[1]

Trading links gradually increased. In 1639 the Raja of the Carnatic granted the

Company some land in Madras to build a fort which became known as Fort St George. 1650 saw the foundation of a small base on the Hooghly which eventually led to the establishment of Calcutta. Bombay came into the hands of the British after 1661 when it was granted by the Portuguese to Charles II as a part of the marriage dowry of Catherine of Braganza. Gradually it grew and finally superseded Surat as the chief port of the west coast. By the end of the seventeenth century the embryonic Presidencies of British India: Bombay, Madras and Bengal had been formed. The Danish held on to their trading posts at Tranquebar and later added Serampore, and the Dutch held theirs at Pulicat and Masulipatam. They were joined by the French in 1664 at Pondicherry in the south. Though it was not realised at the time, the stage had been set for the action of the late eighteenth and nineteenth centuries.

Many of the original traders and merchants published accounts of what they saw which were avidly read by interested people in Europe. Their responses clearly indicate the prejudices of the European attitude to Indian customs, arts and religions. While they tended to find Hinduism perplexing, many were not wholly dismissive. One traveller, the Reverend Edward Terry who was sent out to take over on the death of Roe's first chaplain, wrote an account in 1622.[2] As a Christian he was uncompromising about the religious beliefs of the Hindus and found it difficult to understand why the Jains of Surat should want to set up animal hospitals and reverence the life of 'inferior' beings.[3] The Italian merchant, Pietro della Valle enthused about much in India, especially the curries – 'the best and wholesomest meats that can be eaten in the world, without so many Artificial Inventions as our gutlings of Europe'.[4]

Responses to the architecture were mixed. Before the seventeenth century Hindu sculptures and temples were invariably seen in terms of the medieval European demonic tradition. Johann Hughen van Linschoten, the Dutch traveller who lived for five years in India, published an account of his stay in 1596 which over the years became widely translated and much quoted.[5] In it he described a visit to the temples of Salsette, Bombay in the most emotive language, finding the sculpture 'fearfull', 'horrible and develish'. Nearby Elephanta he thought so 'evil favoured' that to enter it made 'a man's hayre stand upright'.[6] Later authors were less subjective when confronted by the spectre of India's past. With a few exceptions, such as Roe who thought that the ruined Rajput city of Chitor with its rich carvings and Hindu temples could hardly be equalled anywhere, most early travellers found Hindu temples and sculpture monstrous. There early developed a preference for Islamic architecture, which, like the prejudice against Hindu sculpture, was to continue for centuries.

Before the Taj Mahal was erected one of the most admired buildings was Akbar's tomb at Sikandrabad, built in 1613. The Reverend Terry saw it soon after its completion and found it a 'most stately sepulchre . . . of all these buildings the

most admired by strangers. All have spoken very great things of it.' Another traveller, Peter Mundy, who saw it in 1632, thought it excelled all others in India and he made a drawing of it which more closely resembled the buildings he had seen in Constantinople.[7] However, this monument was later surpassed in grandeur by the Taj. Today it is difficult to imagine India without the Taj Mahal and its status as a 'wonder' was firmly established even at the time of its construction. Jean-Baptiste Tavernier, the French jewel trader who saw it in 1670 thought it 'most magnificent', following this with a corrective statement lest he should mislead his readers by his enthusiasm suggesting the dome was a 'little less magnificent than that of the Val de Grâce, in Paris'.[8] His opinion of Hindu architecture was sharply critical.

A compatriot and friend of Tavernier, the physician François Bernier, published an account of his twelve-year residence in the East in 1670. However hard they tried, many of the writers of early accounts of India could not help but slip into fanciful descriptions of miraculous events and wondrous architecture. As early as 1622 Terry had endeavoured to introduce a new note of objectivity by assuring his readers that his narrative was taken from 'eye-witness' accounts only. Bernier, who studied with the philosopher and scientist Pierre Gassendi, informed his readers that his observations were taken from 'facts and actual occurrences'. But so completely did he fall under the spell of the Taj Mahal that all objectivity was cast aside. His enthusiasm for it led him to conclude that his taste must have been corrupted by his long residence in India. Nevertheless he thought it deserved a special place in European books on architecture.[9]

In describing the Indian scene he was acutely conscious of his own nationality and was led to make comparisons between India's rich and vast Mughal empire and the state of high perfection to be found in Louis XIV's France. Mughal India emerged as a remarkable country to be sure, some of her cities, especially Delhi and Agra, were considered very fine indeed, but inevitably they were infinitely inferior to Paris 'the capital of a great empire, the seat of a mighty monarch'.[10] There was no doubt in Bernier's mind that Paris was the finest, the richest and altogether the first city in the world. To enhance the grandeur of Paris as the first city of the world and Louis XIV as the supreme monarch, the Finance Minister, Jean Colbert, the founder of the French East India Company and a correspondent and friend of Bernier, encouraged the king to decorate some new apartments in the Louvre in the styles of various countries. They were to be 'à l'italienne, à l'allemand, à la turque, à la persane, a la manière du Mogol, du Roi de Siam, de la Chine'.[11] The suggestion of a Siamese room would indicate that it was proposed after 1673 when an embassy was sent to Siam, but before 1678, the year when work on the Louvre was abandoned.

According to Charles Perrault in a description published in 1697, the rooms

were also to be embellished with exact copies of the ornaments to be found in each nation's palaces and fitted with all the appropriate furniture and decorations, so that visitors from these countries would find their own country so to speak, and all the splendours of the world in a single palace. The symbolism of the scheme was overt: the seven countries like the then seven known planets were to be considered an integral part of the universe at the centre of which was the 'Sun' king himself.

Drawing on the detailed information which the French travellers brought back it would not have been impossible to have designed a room 'à la manière du Mogol' (i.e. Mughal)[12] but the scheme does not seem to have materialised. Charles Perrault and his brother Claude, a physician by profession whose authority in architectural matters was entirely due to his translation of *Vitruvius*, have both been credited with the design of the scheme. It is more likely to have been the work of Claude who had been brought in by Colbert to design a new elevation for the Louvre. This exotic scheme would have provided a perfect opportunity for Claude to display his skill in the use of styles other than the classical, which he and his brother attacked because it had acquired the significance of eternal wisdom. For both Perraults it was inconceivable that classical architecture could be the only architecture of worth or that a powerful state like modern France could not surpass Ancient Greece or even produce new forms of beauty. The Louvre scheme would have provided a good opportunity for them to flex their artistic muscles, but it was not carried out.

In London the publication of Bernier's travels in 1670 attracted the attention of the dramatist John Dryden. *Aureng-Zebe*, a melodramatic tragedy, was derived from Bernier's observations of the Emperor Aurengzeb and indeed paraphrased much of the Frenchman's narrative. The play was produced with great success in 1675 and became a favourite at the court of Charles II. *Aureng-Zebe* was itself the product of a taste for *chinoiserie* and it was doubtless staged with all the fantasy that late seventeenth century London could command. London, like the rest of Europe, had been flooded with Chinese porcelain, lacquered screens from Japan and China, spices, chintzes, calicoes, jewels and exotic woods. Queen Mary who had a predilection for oriental things had her apartments in Kensington Palace decorated with an extensive porcelain collection, lacquered cabinets, screens, chairs and textiles, including seven tapestries 'after the Indian manner'. Four tapestries had been ordered from John Vanderbank of Great Queen Street, London in 1690, two further examples in 1691, and another in 1696. All the motifs were taken from Indian and Chinese sources, the term 'Indian' was a very general one: it was applied to India proper and what was called Further India, that was China, Japan and South East Asia.

People of the time rarely differentiated between these countries and articles such as lacquered screens and cabinets and porcelain were often referred to as

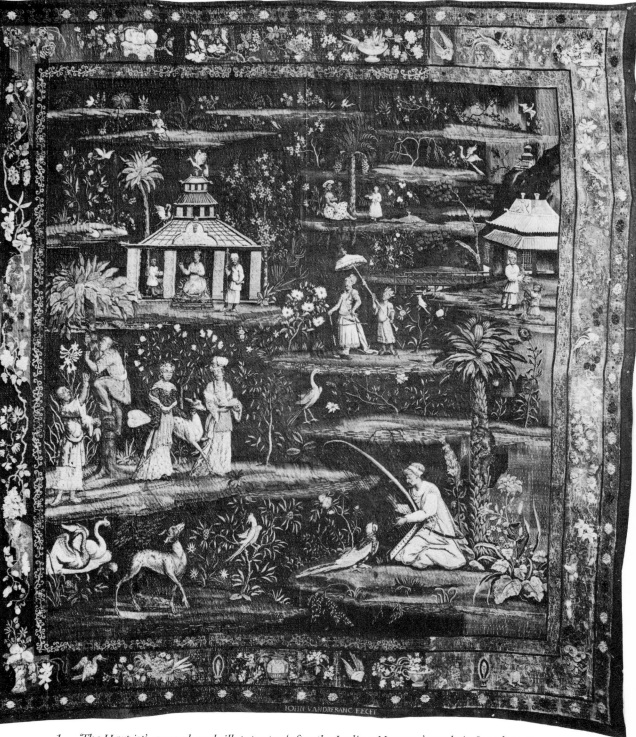

1. 'The Harpist', a wool and silk tapestry 'after the Indian Manner' made in London at
the end of the 17th century by John Vanderbank. The individual motifs were taken from
Indian miniatures, book illustrations and japanned lacquer cabinets.

'Indian' even when the items were obviously from China or other countries of the Far East. It was tó be expected that the many *chinoiserie* rooms which existed all over Europe would often be called 'Indian'. The motifs on the tapestries were taken from a variety of sources, including books on China and Chinese export screens, Indian miniatures and carpets **(1)**. Several sets were produced in various combinations of motifs.[13] It has been suggested that Vanderbank was inspired to produce these unusual tapestries as a result of seeing the Indian miniatures thought to have been brought back from India by the rich nabob Elihu Yale. Since he did not return until 1699 and it is by no means certain that he had a collection, there must have been another source.[14] Archbishop William Laud's famous collection of *ragamala* miniatures given to the Bodleian Library, Oxford in 1640, had been in England since 1619. After ninety years of contact and some interest in foreign lands and customs it would have been very surprising indeed if this were the only collection in England. Robert Robinson, a painter of *chinoiserie* panels has been suggested as the designer, although his dreamy exoticisms are far removed from the naive formality of the Vanderbank tapestries.[15] Because most of the motifs of the tapestries were clearly derived from Indian miniatures the Queen's drawing room in which the tapestries were hung can be considered the most 'Indian' of the many 'Indian' rooms that existed in Europe. Even so, the Indian elements, were not only seen to be synonymous with decorative motifs from China, they were inextricably part of the taste for *chinoiserie* that had become so popular in the later seventeenth century. Authentic Mughal miniatures once owned by Rembrandt in the mid-seventeenth century were used in a similar context and for similar purposes in Schloss Schönbrunn, Vienna in the mid-eighteenth century.[16]

Elihu Yale was an early member of a new caste, the nabob, whose wealth, created through private trade in India, had become legendary. Officially such interloping was frowned upon but in practice there was nothing the East India Company could do to prevent it. This position continued until 1784 when private trading and the receiving of presents from Indian princes and merchants was prohibited, a law which was enforced with some rigour. In the seventeenth and for most of the eighteenth century nothing could stop the nabob from amassing huge fortunes. Critics of the seventeenth century made him a figure of fun, his love of personal display, his vulgar ostentation and gaudy *nouveau riche* taste were satirised rather than despised in this period. In Crowne's play *Sir Courtly Nice* (1685) Sir Thomas Callico, President of the East India Company, is portrayed as a person who loves to flaunt his almost 'Mughal' ostentation and despotism. John Ovington had witnessed similar behaviour in Surat and wrote a scornful description of such people observing that they behaved more like the local Indian princes, going about with numerous Indian attendants and musicians, rather than English gentlemen.

During the early years of the eighteenth century 'Indian' money paid for the building of some of the most important houses in England of the day. Wanstead, near London, built for Sir Robert Child, the son of a wealthy banker and former Governor of Bombay, Sir Josiah Child, became the most celebrated mansion of its time and was of seminal importance. It was designed by the Palladian architect Colen Campbell between 1713 and 1720 and was much copied in later years, becoming one of the models for British engineer-architects in India.

England's foothold in India was to get even stronger during the 1750s. General Dupleix was recalled to France from his outpost at Pondicherry in 1754, opening the way for British ascendancy in naval power and signalling the waning of French influence over the sub-continent. France had had important settlements at Masulipatam on the Coromandel Coast, a port in Malabar, and Chandernagar in Bengal. Chandernagar was destroyed by the English under the command of Robert Clive in 1756. Clive's expeditionary force had been sent from Madras following the famous Black Hole saga in Calcutta to take retaliatory action, and his subsequent victory at the Battle of Plassey in Bengal in 1757 marks a watershed in relations between the East India Company and India.

The financial rewards of military victory were high. As a result of the treaty which was agreed with Mir Jafar after Plassey, Clive received £234,000 in addition to an annual payment of £30,000. The flood-gates had opened. In 1765 Clive managed to secure from the Mughal Emperor Shah Alam, a grant of the *Diwani* of Bengal. This effectively gave the Company the land revenues of Bengal in exchange for its protection. Few if any Company employees, civil or military, could restrain themselves from amassing huge sums through private trade in the next two decades. It is clear that this was felt to be a just reward for facing the hardships of life in India and the real prospect of an untimely death. Another inevitable effect was that many of the nabobs of the time, particularly in up-country Bengal, took to Indian habits dressing in Indian costume, smoking hookahs, taking Indian wives and eating local food. Somewhat surprisingly some even became converts to Islam and Hinduism. Those who eventually returned to Britain brought their wealth with them and occasionally their Indian wives and servants. They also brought their Indian habits which they transferred to cities like Bath, Cheltenham and Edinburgh, 'the manners of the Cutcherry and the morals of the Zenana'.[17] So many old 'Indians' returned to Cheltenham and Edinburgh that these two cities became renowned for the delicious curries to be had there.

The luxury in which they lived became legendary. The means by which they were supposed to have won their fortunes, that is by extortion from the natives, were mercilessly lampooned and condemned in both the press and in popular plays such as *The Nabob: or Asiatic Plunderers* published in 1773. In the preface to this play the anonymous author stated that despite a national enquiry into the recent famine disasters in Bengal nothing had been done to apprehend and

charge the culprits. The reputation of Clive had proved like 'Ajax's shield in Homer, a Refuge, for those who have done great Disservice and have stained the very name and annals of our Country with Crimes scarce inferior to the Conquerors of Mexico and Peru'.[18] Walpole remarked in a letter to Sir Horace Mann that the East India Company's adventurers had starved 'millions by monopolies and plunder', nor was England free of this blight since the nabobs also created a 'famine at home by the luxury occasioned by their opulence, raising the price of everything, till the poor could not purchase bread'.[19] This may well be an exaggeration on Walpole's part but it does show the depth of feeling against these people and the effect they were thought to have had on the economy. It also shows how far merchants had come to be despised by the hereditary lords of the land and their actions viewed with suspicion.

Few houses built by these nabobs contained any Indian references at all. The first nabobs such as General Smith, Sir Francis Sykes and Sir Thomas Rumbold were more interested in Palladian grandeur and 'Asiatic' luxury. Commentators like Horace Walpole would not have expected less, for here were people whose avarice and corruption had brought them into comparison with oriental despots. Robert Clive, the most famous nabob of them all, returned from India in 1760 with wealth estimated at over £250,000.[20] He bought an estate on the borders of Worcestershire and Shropshire, and intended to build a house there called Plassey. A house in a fashionable part of London also seemed desirable so he bought 45 Berkeley Square, This was followed by the purchase of Claremont, Surrey in 1769. The house had been designed by Vanbrugh and the park by Kent, but Clive wanted something grander and it was demolished to make way for a new design by Lancelot 'Capability' Brown. In commemoration of his Indian activities the Eating Room at Claremont was to have an Indian character: the walls were to be hung with paintings by Benjamin West, depicting events from Clive's Indian career, and his Indian ivory furniture was to be placed there.[21] Others followed Clive's ostentation and built some of the finest and most famous country houses, mostly in south-east England near London. Sir Thomas Rumbold who returned with a fortune of about £200,000, built Woodhall Park, Hertfordshire to the designs of Thomas Leverton, a sensitive neo-classicist. For Nathaniel Middleton whose wealth was said to have been second only to Rumbold's, Leverton designed a classical house at Town Hill Park, South Stoneham, Hampshire. Joseph Bonomi, a noted classicist who worked for Leverton at Woodhall Park, is thought to have had some influence in the design of the interiors. He later worked at Stanstead Park, Sussex, for Richard Barwell who reputedly returned to England from India with £400,000.[22] Sir Francis Sykes built Basildon Park in 1776 to designs by the Yorkshire architect John Carr. Sykes and Rumbold were both friends and rivals. Their houses follow the same Palladian model although Leverton introduced some exquisite neo-classical interiors and a correspondingly greater degree of

decorative effect in the exterior of Woodhall Park. Rumbold did not live to enjoy his new house for long and three years after his death another nabob, Paul Benfield, bought the property.

At a time when large Palladian houses of the Wanstead type were going out of fashion because of their lack of convenience, another nabob, Alexander Callander (died 1792) selected a grandiose classical design by Robert Mitchall for his new home in Scotland. Preston Hall, begun in the year 1791, possesses one of the few 'Indian' style monuments in Scotland.[23] After Alexander Callander's death in 1792 a temple was erected to his memory by his brother, Sir John Callander, the heir to his estate **(2)**. It was never finished. The octagonal base surmounted by a cupola with its essentially Indian calix and over-hanging eaves would seem to be an interpretation in classical idiom of some of the cupolas to be found in northern India, particularly at Agra and Fatehpur Sikri, and which are shown in Hodges' *Select Views* (1786–88) and Thomas and William Daniells' *Oriental Scenery* published from 1795 onwards.

Despite the great number of returned 'Indians' who went to live in Scotland

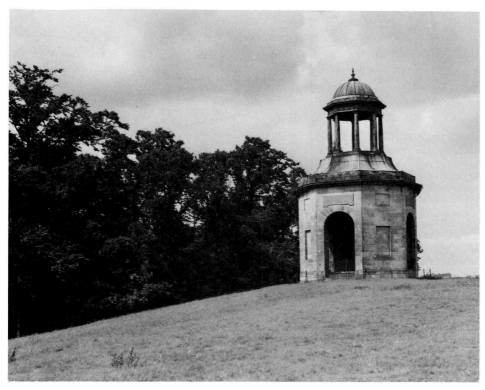

2. *An 'Indian' temple at Preston Hall, Scotland, erected to the memory of Alexander Callander a nabob who died in 1792. The octagonal base, cupola, calix and over-hanging eaves are a Western interpretation of an Indian form.*

so far very few houses have been discovered which appear to have been influenced in any way by their owners' Indian associations; Preston Hall is one of the few but there must have been more. The 'temple' at Preston Hall may have provided the inspiration for the 'mosque' or summerhouse which appears in the anonymous novel *The Nabob at Home* (1840). In this story a surgeon retired to Fernebraes, his family estate in Scotland, after thirty years residence in Lucknow. He was not rich but by carefully avoiding the excesses which life in India encouraged and saving the money obtained in fees, he had amassed ample means to retire in some comfort. His old Indian servant accompanied him. The narrative describes the strangeness he felt on returning to a country radically different from the one he had left. There are descriptions of the family in Scotland anxiously awaiting the return of the nabob son to an estate they had neglected. He had always been interested in Indian culture, but while in Lucknow he became homesick and sent a drawing of a mosque in Lucknow to his family in Scotland with instructions for the local builder to erect an 'Indian' summerhouse on the spot where he himself had first dreamed of going to India. When many years later he saw the summerhouse he was surprised to find how little it looked like the drawing he had sent.[24]

William Frankland whose family had long been associated with India, lived on a more modest scale. In 1765 he bought Muntham in Sussex, which had been used by the previous owner, Lord Montague, as a hunting lodge. Frankland greatly enlarged it into a two-storeyed building with a portico and veranda suggesting the Indian life which he would have led. In the garden he built an octagonal pavilion and on top of the hill behind the house a minaret. This is one of the earliest known Indian style buildings.[25] The minaret may have been used as a lookout tower, as the sea is not far away. Frankland was something of an adventurer. On his return journey to England in 1760 he had crossed the Persian Gulf dressed as a Tartar messenger, and had also journeyed overland to visit Baghdad and Jerusalem and the ruins of Palmyra. Sir Hector Munro of Novar, a much-detested improver of the land, is the only other person known to have had an 'Indian' pavilion. This appears on a plan of his estate in 1777 as a strange edifice with an 'umbrella' barely decipherable, but which may have been meant to represent something 'Hindoo'.[26] In the 1790s he built the *Gate of Negapatam* to celebrate his famous military victory in South India in 1781. Built on the summit of a neighbouring hill 1,500 feet above sea level, it provided work for all the poor peasants whose lands he had taken **(3)**.

Much more evocative was the Reverend Jolland's house at Louth, Lincolnshire which the landscape gardener and architect Humphry Repton visited in 1790. The living rooms were profusely decorated with prints and drawings and various curiosities sent by the owner's brother from India. A hermit's retreat dedicated to the memory of that brother had been constructed in the garden. In it was a secret room decorated with Indian bamboo furniture, matting and

trinkets, and the walls were lined with bound Asiatic manuscripts. Although this was a particularly bizarre example there must have been many more Indian rooms of this kind than are now known.[27] There were probably more garden monuments too, of the kind James Forbes erected in the garden of his house at Stanmore, Middlesex. It has been thought to be a temple, built some time before 1793 to house his Indian sculptures. A later visitor however makes no mention of a temple at Stanmore and only refers to there being 'some curious specimens of Hindoo Sculpture' in the gardens. Unfortunately there is no evidence to show what it looked like, only that it was octagonal. It was probably more gothic than Indian; the sculptures alone supplying the Indian element.[28]

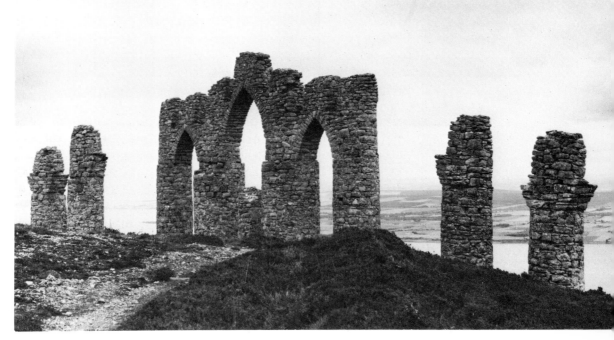

3. Gate of Negapatam, Novar, Scotland built by a nabob Sir Hector Munro in the 1790s to commemorate a famous battle which he had won in South India in 1781.

Undoubtedly the most famous nabob of the late eighteenth century after Robert Clive was the Governor-General of India, Warren Hastings. He came to symbolise all that was good and bad in the later nabob and his behaviour in India during his period of office from 1772 to 1785 encouraged strong feelings. When Hastings, who had been in India since the age of sixteen, came to the Governor-Generalship he was appointed to implement reforms which the Act of Parliament for 1773 insisted the East India Company carry out. In exchange the Company was to be given a life-saving loan by the Government.

Unfortunately, this dual control of the affairs of India was inefficient and in practice it meant that Hastings's recommendations could be overturned by his adversaries in London who had little or no knowledge of India. Understandably this irritated him beyond measure. More than anything else Hastings suffered from a conflict of interests. On the one hand he had to serve the Company's best interests, and on the other to represent the welfare of the Indians under his authority. This was especially difficult for a man as dedicated to the conservation of Indian culture as himself. He spoke both Persian and Bengali well and had a smattering of Urdu and Arabic. During his time in India he encouraged Charles Wilkins to translate the *Bhagavad Gita*, and Nathaniel Halhed's work on Hindu law, and actively supported the formation of the Asiatic Society of Bengal in 1784. Under pressure, however, his behaviour could become ruthless as in the case of his unfair treatment of Chait Singh of Benares and the Begums of Oudh. As a result of the agitation of Edmund Burke and his enemies in London, Hastings was recalled to London to face the humiliation of impeachment. So worried did many people feel in Bengal about possible prosecution and the limitations which would be applied to private trading as a result of Pitt's India Bill of 1784, that they returned to England in droves. The artist Ozias Humphry who went to India in search of rich patronage had the unhappy experience of seeing shiploads of potential patrons fleeing Calcutta, just as he arrived.[29]

Hastings's trial began in 1788 and continued intermittently until 1795, but so confident was he of eventual vindication that he commissioned a new house for his estate at Daylesford, Gloucestershire with an Indian dome **(4)**. It was designed by the architect Samuel Pepys Cockerell, brother of two nabobs, and it was perhaps at his suggestion that an Indian dome was introduced into an otherwise classical building. This was the first time that an Indian feature had ever been employed on the exterior of a nabob's house.

Hastings was finally acquitted of all the charges against him by which time he was financially crippled, exhausted and debarred from future employment and any honours. In a sense Hastings was the victim of a new attitude towards British relations with India. It was an attitude based upon a concern for and responsibility towards the good government of British India. It is still an erroneously held opinion that Imperial India did not develop until after the Indian mutiny of 1857. In fact Clive had realised the full implications of his victory at Plassey: that the sovereignty of Bengal and more was within the grasp of the Company and that the assumption of this sovereignty would be beyond the means of a mercantile company alone. He urged Government intervention. After the loss of the American colonies British politicians in 1782 both Tory and Whig spoke of British India as 'the brightest jewel that now remained in His Majesty's Crown'.[30] So changed had the East India Company become by 1800 that the Governor-General Arthur Wellesley told cadets at Calcutta that they were no longer merely 'agents of a commercial concern' but 'ministers and

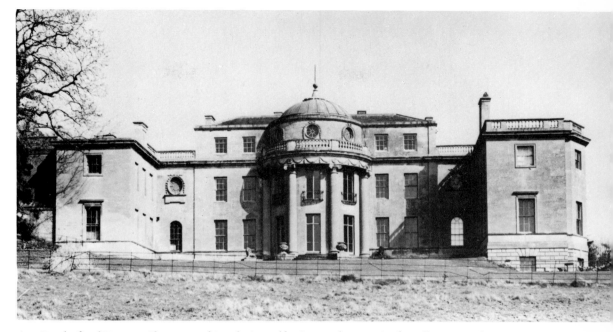

4. Daylesford House, Gloucestershire designed by Samuel Pepys Cockerell in 1788 for Warren Hastings, one time Governor-General of India. It is a curious mixture of a Mughal dome and a classicism derived from France and was built in a lovely honey-coloured limestone.

officers of a powerful Sovereign' with 'sacred trusts' for the good government of British India and the welfare of its peoples.[31]

Hastings's acquittal was greeted rapturously by his friends. Since no official monument was ever likely to be erected to Hastings, one of his friends, Major John Osborne, took it upon himself to rectify the situation. In 1800 the artist Thomas Daniell, recently returned from India, produced a design ('we understand gratuitously') for a Hindu temple at Osborne's estate, Melchet Park, Wiltshire (now Hampshire) **(5)**. Hastings really liked the building, particularly praising its 'chaste simplicity'.[32] The interior contained a bust executed in artificial stone by John Rossi which portrayed Hastings 'rising out of the sacred flower of the lotus'. An elegant pedestal bore the inscription:

> Dedicated to the genii of India who from time to time assume material forms to protect its nations and its laws, particularly to the immortal HASTINGS, who in these our days has appeared the saviour of these regions of the British Empire.

Osborne also arranged for a portrait of Hastings to be given to the Prince of Wales and he kept a portfolio of the letters he received on the subject of the

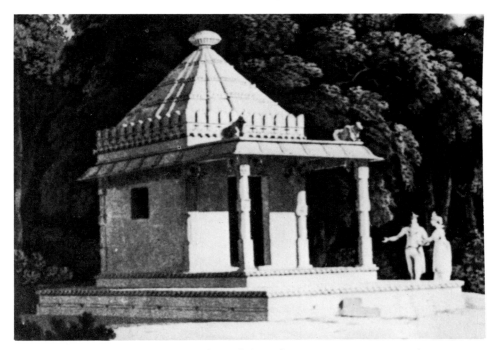

5. *Hindu temple at Melchet Park, Wiltshire from an engraving in the* European Magazine *which Major John Osborne commissioned from the artist Thomas Daniell in 1800 to celebrate the achievements of his friend Warren Hastings. The interior contained a bust by John Rossi which showed Hastings rising out of the flower of the lotus. The temple has long since disappeared.*

temple, which he hoped would survive to tell future generations of the glories of Hastings. But it has not survived, nor has the temple. Such is fate!

It is clear that the Hindu temple was more than a garden monument or merely a memento of India. It clearly articulated a political opinion which many held at the time concerning the affairs of British India and which many of Hastings's friends felt was the product of his management for which he had failed to achieve adequate recognition or just reward.

Daylesford and the temple at Melchet Park were soon joined by another tribute to the new relationship between Britain and India. This was Sezincote built on the limestone wolds of Gloucestershire, four miles from Daylesford, by another nabob Sir Charles Cockerell (6). It was designed by his brother, Samuel Pepys Cockerell in about 1805 with the expert advice of Thomas Daniell to make sure the Indian details were correct and appropriate. Over the next twenty years this English country estate became increasingly Indianised. Not only the house but the farmhouse, stables, gardener's cottage, garden and lodges all began to resemble a scene from one of Thomas Daniell's picturesque Indian views. To this house and its *raison d'être* I will return later.

Britain was not alone in having nabobs: Holland, Sweden, Denmark and France all had East India Companies while other nations like Switzerland and Italy had individuals who went in search of fortunes. France especially produced some colourful characters. General Claud Martin is probably the most well-known since he endowed a school in his home town of Lyon and established another at Calcutta, the Martinière. At one time a military adventurer, in 1763 he entered the East India Company's army and later served the nawabs of Oudh at Lucknow. He had Indian wives and adopted the unusual practice of looking after the children of Indian liaisons who were so often left behind in India when Europeans returned to the West. Martin died in Lucknow in 1800 having never returned to France. His extraordinary 'Eurasian' house, *Constantia*, still survives in Lucknow.[33]

One of Martin's friends in Lucknow was Colonel Antoine Polier an engineer-architect who worked in the service of Shuja-ud-Daula from 1771 **(7)**. He was born in Switzerland of French extraction and returned to Avignon in 1789. Like Martin his sympathies were wide-ranging and during his time in India he immersed himself in her culture, taking an Indian wife (their children were left behind in the care of Martin when he returned to Europe). His collection of Persian and Sanskrit manuscripts was consulted by many, including Sir William Jones who thought highly of Polier's abilities. The collection of Indian miniatures which he had was bought after his death by the wealthy aesthete William Beckford. At Avignon he doubtless continued the habits of hookah-smoking and eating curries. His lifestyle was known to be one of 'Asiatic' luxury. This would not have gone down very well in revolutionary France and no doubt precipitated his death. He was murdered by thieves during a robbery in his house in 1795.[34]

Of the same generation was General Benoît de Boigne, a decisive man of action who became a much admired commander in Mahadaje Scindia's Mahratta army.[35] He made a fortune in private partnership with his friend General Claud Martin and returned to Europe, with his Indian wife and children to whom he was at first deeply attached. De Boigne's wife was the sister of Bibi Faiz Bakhsh, Begum of Oudh. He gave her the name of Hélène and the anglicised form of his Christian name, Bennet. With some misgivings the de Boigne family left India in 1797 and returned to London. It was not long before he deserted Hélène for an aristocratic lady and went to live in his home town of Chambéry, Savoie. In 1804 de Boigne eventually bought the Great Ground House at Lower Beeding, Sussex for Hélène and her children, where she lived for nearly fifty years. She may have been the Indian lady whom the poet Shelley used to see wandering in nearby St Leonard's Forest. At Chambéry de Boigne became a public benefactor, giving his money to various charities and to the planning of the city. After his death in 1830 a curious obelisk was erected to his memory. Now called the 'Fountain of the Elephants' and affectionately known in

the town as 'the four bottomless elephants' **(8)**, it was designed by Victor Sappey of Grenoble in 1838. He was obviously none too sure of Indian details – the column is Egyptian. There are plaques showing scenes from the life of de Boigne on the pedestal and above are emblems of his life; Indian costume and armour, Hindu gods, courtly utensils and shields and swords. The life-size cast-iron elephants make an impressive display in the square although their rusting trunks need some attention.[36]

During the 1820s and 1830s there were many Europeans in the service of Maharajah Ranjit Singh, the powerful Sikh leader of the Punjab, including General Jean François Allard, General Jean Baptiste Ventura, Paolo di Bartolomeo Avitabile and General Claude Court, all of whom returned to Europe.[37] Allard brought his Indian wife and children back to St Tropez, France where they continued to live after his death. When the younger daughter Banu Pan Dei died at the age of 11 she was at first buried in the family grave at St Tropez. The custom in India is to build tombs in the gardens of the residence and Allard was

6. *Sezincote, Gloucestershire, a wonderful evocation of a Mughal building. It was designed in about 1805 by Samuel Pepys Cockerell for his brother Sir Charles Cockerell, a member of the East India Company who had resided for many years in Bengal. All the details had to be approved by the artist Thomas Daniell to ensure accuracy.*

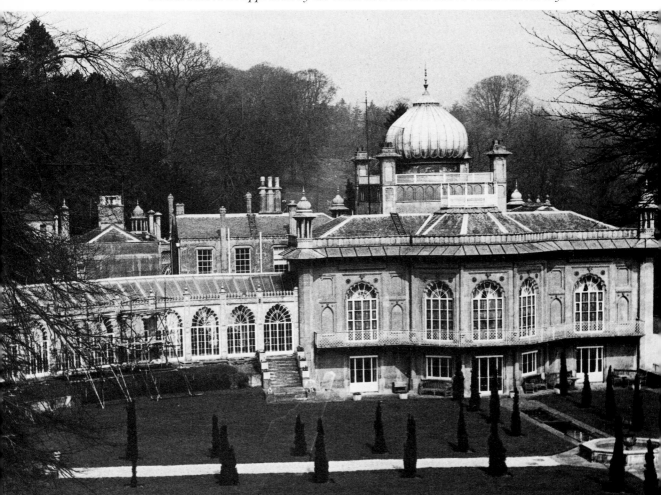

buried in his own garden in Anarkali, Lahore. The girl's mother could not reconcile herself to European custom and eventually had her re-interred in a tomb in the garden of their house. Ventura, known as Count Mandi after a military victory in the Punjab, also retired in great comfort to France. Court lived with his Kashmiri wife at Grasse where he died in 1861. Avitabile was the only

7. Colonel Antoine Polier watching a nautch painted by an Indian artist of Lucknow c. 1780, after a painting by Tilly Kettle. It shows Polier in his house at Faizabad in 1772 living in the Indian style, a style which he may have continued at Avignon upon his return to Europe.

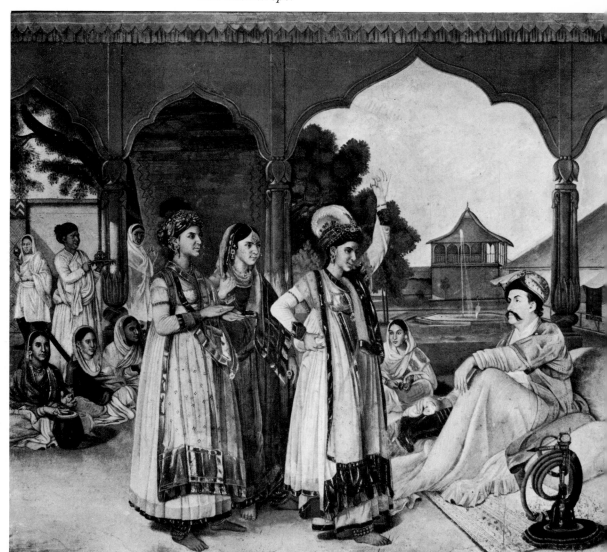

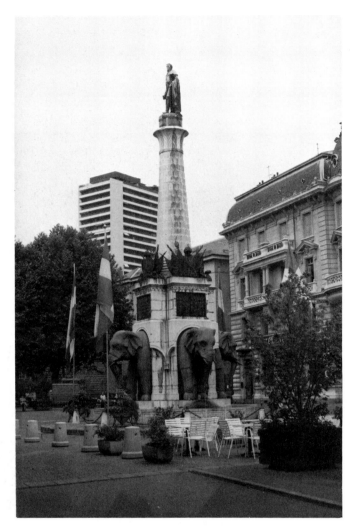

8. *Fountain of the Elephants, Chambéry, France, known locally as 'the four bottomless elephants'. It is dedicated to a French nabob General Benoît de Boigne who lived in Chambéry until his death in 1830. His statue surmounts an Egyptian pillar the base of which is decorated with scenes and emblems from his life in India. The monument was designed by Victor Sappey of Grenoble in 1838.*

latter-day nabob to build a house with Indian decoration. This was at Agerola near Naples, his family town, to which he retired in 1843. Nothing now remains of the house and from the brief description available it appears that he lived in the Indian style as he had done in the Punjab. There in 1850 he was poisoned, according to rumour, and died at the age of 59.[38]

A great deal had changed in the first half of the nineteenth century. The English East India Company staggered from one financial crisis to another, there were more Government controls. It became frowned upon to live with Indians or take Indian wives. Separateness was encouraged. Such changes did not really affect life in more remote areas of the country like Delhi until the 1830s. Missionaries were allowed into India after 1813 after much agitation

from William Wilberforce and the Clapham Sect. This tended to create discord and served to re-enforce a new political idealism and sense of righteous duty. The Macaulay Education Minute of 1835 introduced English as the main language of communication to a storm of indignation from pro-Indian scholars.

It was from a fast-changing India that Colonel Robert Smith returned to Europe in 1831. For the previous twenty-five years he had worked as an engineer-architect in Calcutta and Delhi. He was a skilful artist and the first restorer of the monuments of old Delhi.[39] Obsessed with India he continued to paint Indian subjects for the rest of his life. His retirement pension was £1 per day and unlike the military adventurers or earlier nabobs no fortune awaited him. The Company had rigorously cracked down upon private trade, the receiving of presents from Indians was prohibited. To make matters worse there had been so many recruits into the army that promotion only came very

9. Redcliffe, Paignton, Devon c. 1900. designed by the architect and artist Colonel Robert Smith in 1853 for his own use. Smith's career in the Bengal Engineers and his restoration work on the monuments of old Delhi in the 1820s is reflected in his house. It is thought to be oriented toward Mecca.

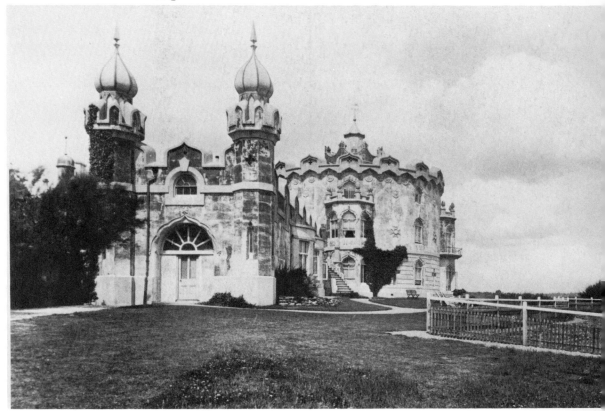

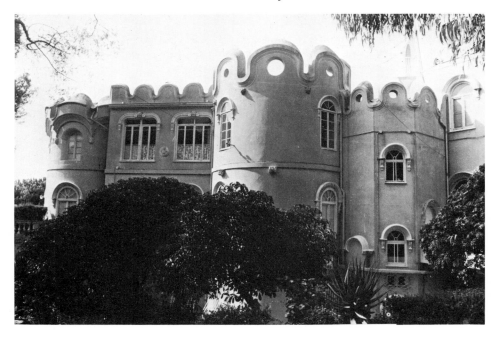

10. Château Smith, Mont Boron, Nice, France designed by Colonel Robert Smith in 1858. This is a partial view showing the incredible pierced, petal-shape merlons, a feature of the Red Fort, Delhi.

slowly indeed, and pay remained very low. At Delhi in the 1820s he could still live in an Indian style, being sufficiently remote from the reforms in Calcutta. It was Smith's marriage to a Florentine heiress and her death in 1850 which gave him the money to build highly eccentric houses, firstly Redcliffe in 1853 on the coast of Devon at Paignton **(9)** and then Château Smith **(10)** from 1858 at Mont Boron, Nice, France. Stylistically they belong to early nineteenth century architecture, though imbued with distinctive Indian details, especially noteworthy are the cusped doors and windows at Redcliffe, which reputedly is oriented toward Mecca, and the pierced merlons of the Château which are derived from the Red Fort at Delhi. Smith lived in solitary magnificence supervising the construction of his buildings, painting views of India, looking after the lions and tigers which roamed the gardens of his house at Nice and keeping up with old 'Indian' acquaintances. In his declining years he could contemplate an India vastly different from the one with which he was acquainted. An India which when he joined the East India Company in 1803 was still largely unexplored with a culture almost unknown. By 1873 the year of Smith's death, the East India Company had been abolished. India had become bureaucratised, her countryside criss-crossed with railway lines and canals – the nabob had disappeared from the Indian scene and so had 'the deplorable infatuation' with Indian life that led young men to become 'Indianised'.[40]

A Pleasing and Tasty Style

S trange as it may appear to us today it was an artist, not an architect, who first realised how important the study of Indian architecture could be. He was Sir Joshua Reynolds, the first president of the Royal Academy, a position he held until his retirement in 1790. His annual *Discourses* (later given every other year) on every aspect of painting were influential in England and Europe. Reynolds was concerned in his 1786 *Discourse* that the classical architecture of his day did not inspire its observers, nor did it evoke delight or appeal to the imagination. For some time it had been widely accepted that painting, music and poetry should appeal directly to the imagination, why not architecture?[1]

By the 1770s and 1780s many people had found 'plain Grecian' wanting in variety and imaginative appeal. On occasion such plain architecture could lead to problems as in 1772 when an Indian visitor to London, Munshi Isma'il, found the street in which he stayed so monotonously plain, and the house so without distinguishing features, that for three days after his arrival he did not go out fearing that he would never find his way home again![2]

In order to change this state of affairs Reynolds began to look at other architectural models. He suggested that the 'Castles of the Barons of ancient Chivalry'[3] be studied. This was because they stimulated the imagination through the association of ideas. They evoked delight and for this reason were used by the painter and poet, (as in the works of Claude Lorraine and Milton). Vanbrugh and his buildings were to be the heroes of Reynolds's new concept of architecture. In part this was because Reynolds admired Vanbrugh's painterly application of composition, originality and light and shadow, but also because he was a poet his buildings showed evidence of 'a greater display of imagination, than we shall find perhaps in any other'. To accomplish this Vanbrugh had recourse to 'some principles of Gothick Architecture: which though not so ancient as the Grecian, is more so to our imagination, with which the Artist is more concerned than with absolute truth'. This was a radical departure from the accepted canon of taste. Not only had Reynolds insisted upon the primacy of the imagination over the absolute truth of classicism but in a courageous move he sought the rehabilitation of Vanbrugh's works to justify it.

Gothic architecture was not to be the only model. 'The Barbarick splendour of those Asiatick Buildings, which are now publishing by a member of this Academy, may possibly, in the same manner, furnish an Architect, not with

11. *'A view of a Mosque at Chunar Gur', an aquatint made in 1786 by William
Hodges as part of his series* Select Views of India. *Hodges's unscientific, Claudian views
of India attracted the attention of Sir Joshua Reynolds.*

models to copy, but with hints of composition and general effect, which would
not otherwise have occurred.' To this he appended a salutary warning that the
'sound rules of Grecian Architecture are not to be lightly sacrificed' and then
'only by a great master, who is thoroughly conversant in the nature of man, as
well as all combinations in his own Art'.

 The artist William Hodges was the 'member of this Academy' to whom here
Reynolds referred.[4] He was in many ways a remarkable artist and without doubt
an intrepid one. Before he went to India in 1780 he had travelled around the
world as an official artist on Captain Cook's second voyage. Hodges's paintings
of India are moody, sometimes dramatic, and, unlike later orientalist painters,
quite without brilliant colour **(11)**. His was a Claudian view of romantic scenes
and exotic places which may partly explain Reynolds's interest, whereas Francis
Swain Ward's more accurate, but naive oil paintings of Indian architecture
which the artist had presented to the East India Company in 1773 made no
impression whatsoever.[5] After Hodges's return to England in 1783 he exhibited

his Indian views at the Royal Academy. The publication of his journal and speculations concerning India entitled *Travels in India* was published in 1793 and at once made the public aware of an articulate and original thinker whose writing was as sensitive as his paintings. In order to make his work more available to the public he published a series of aquatints from 1786 to 1788 entitled *Select Views of India*.

Thomas Sandby, the Professor of Architecture at the Academy since its foundation in 1768 was no narrow-minded classicist. His third lecture on architecture, first given in 1770, contained an extended section on Indian architecture.[6] It was illustrated with drawings of temples and other buildings including Tirumal Nayak's palace at Madura, a choultry at Srirangham, and the cave temples of Elephanta and Salsette. He was also familiar with the paintings by Francis Swain Ward. For Sandby the 'wild and extravagant' forms of Indian architecture had nothing more than curiosity value. Though he could admire the craftsmanship involved in their construction they had no relevance for English architects. It was this opinion that Reynolds endeavoured to alter.

George Dance the Younger, a rebellious and unconventional architect, was the first to fall under the spell of Reynolds's recommendations. He did so in an unusual way.[7] In 1787 the City of London authorities approached Dance and asked him to submit plans for the improvement of the Guildhall and other buildings in its immediate vicinity. The south front of the Guildhall was in a very poor state of repair and needed urgent restoration. In its existing form it consisted of a chaotic arrangement of ogee and cusped arches, panels, and a porch. Dance's first design was strictly gothic, but by May 1788 he had radically transformed his design while still retaining the original porch. The front was divided into three by the introduction of fluted pilasters with minaret-like pinnacles and a fenestration which though Indo-gothic had been rationalised **(12)**.[8] Dance had taken notice of Reynolds's 'hints of composition and general effect' and had employed elements derived from Indian sources. Probably under the guidance of Hodges, who was a neighbour, Dance's attention had been taken by aspects of Mughal architecture and gothic which seemed interchangeable, for instance the pointed arch and cusped arch. The minarets are clearly derived from similar examples shown in Hodges's view of the mosque at Ghazipur, and on the Guildhall they replace what could have been sprocketed pinnacles. His critics found the result highly ambiguous and confusing.

Thomas Malton did not understand it at all while James Elmes, a later critic, thought he detected the influence of gothic but in that case what was one to call the four 'Piers, pilasters or buttresses'. However, astute observers recognised the Indian connection immediately. One of these was James Wyatt. While he admired Dance's abilities Wyatt thought that Dance had 'quitted grammatical Art for fancies' by substituting 'for true gothic something taken from the prints

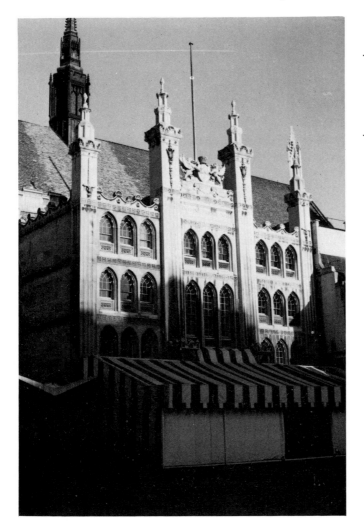

12. *The Guildhall,
London, the south
front of which was
altered by George
Dance in 1788. In this
transformation Dance
employed 'Hindoo'
features to modify a
gothic facade.*

published by Hodges'. Another critic called it 'a Hindoo Gothic deformity'.[9] It was an original and successful experiment in the assimilation of Indian elements with gothic which had important implications for Dance, although these were not apparent for more than a decade. Its design affords a striking artistic parallel to a then current political idea about British relations with India and elsewhere which was encapsulated in the remarks of Lord Grenville in 1789: that the object of the British government was 'to assimilate their constitution[s] to that of Great Britain as nearly as the differences arising would admit'.[10]

In the same year that the Guildhall had taken the 'Hindoo veil', another architect proposed a 'Mughal turban' for a country house in Gloucestershire. The architect was Samuel Pepys Cockerell, a friend of Dance and like him a

member of a family closely associated with the East India Company. The house in question was Daylesford (4), owned by Warren Hastings. Over the years Hastings had been buying up land in the Daylesford area of the Cotswolds to re-establish the family estate. His impeachment and trial in 1787 did nothing to hinder his lifelong dream. On 25 July 1788 he wrote in his diary that he and his wife dined with Cockerell and 'gave Mr C. instr[ns] for y[e] plan of our new house'. Hastings was keenly interested in architecture having planned his house at Alipur near Calcutta. During the ensuing months architect and patron met frequently, usually in London, but sometimes at Daylesford. At what stage, or at whose suggestion the classical building acquired its dome is not known.[11]

My guess is that it was Cockerell's suggestion since he was an architect with an independent aesthetic view. As one of Sir Robert Taylor's favourite pupils he had, upon Taylor's deathbed recommendation, inherited some of his master's important suveyorships, including that of the East India Company. From Taylor he learnt the fundamentals of classicism and developed an inventive attitude to decoration as did another Taylor pupil, John Nash. Many of Cockerell's subsequent commissions were to come from East India nabobs, often friends or business acquaintances of his two brothers, Lieutenant Colonel John Cockerell and Charles Cockerell (who was later knighted). In the absence of his two brothers in India, Cockerell looked after the family concerns in the trading company of Paxton, Cockerell and Trail. Charles had supported Hastings in India, so that it comes as no surprise to find S. P. Cockerell working for Hastings. It was his first important country house commission and the first of several for 'old India hands'. However none of the others erected in the 1790s, showed any inclination to borrow elements from buildings any further east than Italy.

Hastings was always generous in money matters and spent lavishly on the project. By 1797 the cost of the building including the furnishing and landscaping of the garden amounted to £54,000. The exterior of Daylesford, built in golden limestone, was an unusual design even without the dome and like many of Cockerell's buildings owes a debt to French architecture. The interior was magnificent: pink and rose, and shades of green for the cornices and shutters; mahogany sash windows; green silk curtains with Indian silver ornaments for the picture room; the drawing room was in blue and silver, had pale blue satin curtains with silver lace, blue silk cushions on painted chairs and was furnished with Hastings's wonderful collection of ivory furniture comprising sofas, tables and screens all made in Bengal, admired but not for their practicality by a later visitor. The building resonated with reminiscences of India: portraits of friends, scenes by Hodges and Zoffany, Mughal miniatures, Indian armour, Wedgwood tiles and vases, busts of the Prince of Wales and the Duke of York. The Indian furnishings even extended to two fireplaces designed by the sculptor Thomas Banks (who also sculpted a bust of Hastings) which drew heavily on Indian motifs. One shows the goddess Lakshmi with elephants,

a popular deity of good fortune much worshipped by merchants. An appropriate image which Hastings (who was very knowledgeable about Hindu mythology) doubtless selected. The other has a panel depicting a hotch-potch of scenes from court life in India, including musicians and dancers, yogis and others honouring a prince who smokes a hookah. **(13)** The panel is flanked by two Grecianised Indians. Here was a house full of memories for a man who was never again to see India.

Many of the leading architects of the day knew each other well. In 1791 Dance, Cockerell, Henry Holland and James Wyatt founded the Architects' Club in London to promote interest in the profession and discuss matters of mutual concern. Later, in 1795, Dance joined S. P. Cockerell and his family during their summer visit to Dublin. They would have had much in common: their Indian interests, their architectural opinions, problems facing the profession and matters of style. For they were both experimenters and both challenged the accepted standards although their productions differed quite considerably. The 1790s produced no more 'Indian' schemes; it was a period of experiment for both Dance and Cockerell, in their different ways. In 1792 Cockerell designed the first neo-Norman church at Tickencote, Rutland, and continued to apply French ideas to commissions such as Gore Court, Kent and St Martins Outwich, London: Dance on the other hand was very preoccupied with major urban schemes.

The lack of measured architectural drawings was one reason for the lack of projects. This at a time when there was great excitement about India and when there was a large number of nabobs who had fled back to England (in 1785 and 1786). Hodges's drawings were by no means of an archaeological accuracy, he was too much the artist for that. Fortunately both Dance at the Guildhall and Cockerell at Daylesford had produced schemes which did not have to rely upon archaeological exactitude.

The introduction of Indian forms was very dependent upon European drawings of Indian antiquities which came to England. Indeed without these drawings there never could have been an Indian style. This was not true of the Chinese style which had largely developed, as Chambers bitterly complained, from the copying of fanciful 'India' (i.e. Chinese) screens and decorations on porcelain. To remedy the situation Chambers published his *Designs for Chinese Buildings*. There was nothing comparable to 'India' screens in the Indian trade. Only in rare examples do the calicoes, chintzes and shawls contain representations of India's architecture, and the introduction of Mughal miniatures, which often depicted buildings, made no impact. Perhaps following Chambers's strictures about 'Chinese' imitations, architects did not want to be made to appear foolish again, and so decided that they would wait for measured drawings.

These were vital not only for architects who wished to have accurate

elevations to study but also for scholars and antiquarians who were eager to know more about the origin and characteristics of Indian architecture. In 1785 Robert Gough, President of the Society of Antiquaries, London, lamented the lack of such drawings for it hampered his work on the origins of gothic architecture. Throughout the eighteenth century gothic architecture became a subject of increasing interest, so that the architect Edmund Aikin could write in 1808 that gothic was then as much liked as a hundred years previously it had been detested. Theories were put forward as to its origin: if classical architecture had, according to Vitruvius, developed from the primitive hut constructed of logs and branches, gothic, according to the Frenchman H. le Blanc, had developed from forest groves. William Warburton, Bishop of Gloucester, thought gothic cathedrals had resulted from the imitation of avenues of trees. In 1713 Sir Christopher Wren had supported the idea that gothic 'should with more reason be called the Saracen style, for these people wanted neither arts nor learning; and after we in the West lost both, we borrowed again from them'. Such theories of the Eastern origin of gothic or its

13. An 'Indian' chimney piece at Daylesford, Gloucestershire by Thomas Banks, showing a scene from Indian life the details of which were probably taken from Indian miniatures in Warren Hastings' collection. Two Grecianised Indian ladies flank the central panel.

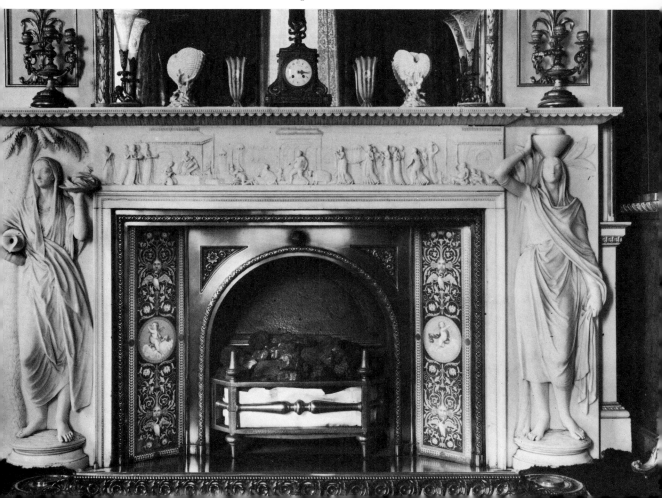

derivation from Celtic groves were heatedly debated throughout the century, emphasising the need for more drawings and more archaeological information about Indian architecture. From this research developed not only the re-appraisal of gothic but the acceptance of Indian architecture, at least as a worthwhile object of study.

Some, however, took their study further. Investigations by members of the Asiatic Society of Bengal and others into the literature, language and customs as well as the ancient temples of Elephanta, Ellora and Kanheri revealed a culture far older than that of the Greeks. In an age concerned with antiquity India may yet prove to have, as the historian Alexander Dow thought, a culture older than any other.[12] In an introduction to Charles Wilkins's translation of the *Bhagavad Gita* published in 1785, Warren Hastings reiterated this idea when he referred to India having a culture 'of an antiquity preceding even the first efforts of civilis-ation in our own quarter of the globe'. These claims not only threatened the authority of biblical chronology but they challenged the authority of classical antiquity as a symbol of eternal perfection.

At the end of the eighteenth century the study of India's architecture had become more than a scholarly preoccupation. Her ancient cave temples were no longer the object of derision and could be appreciated within the aesthetic of the sublime and the beautiful. In 1786 Hector Macneill, who was then stationed in Bombay and later became a renowned Scots poet, thought that the caves of Kanheri 'must ever be considered by the man of taste as an object of beauty and sublimity, and by the antiquary and philosopher as one of the most valuable monuments of antiquity'.[13] Even the great Hindu monuments of South India, not normally admired, found a persuasive and enthusiastic advocate in Dr Adam Blackadder whose paper on the architecture of Madura was read to the Society of Antiquaries in 1789. He found the great temple and the choultry of Tirumal Nayak most impressive: 'remarkable monuments of the Hindoo taste and grandeur'.[14] The claims of classical antiquity to a unique place in the culture of the world had been challenged. The result was cultural and aesthetic relativism.

This idea was proposed by none more strongly than Sir William Jones the prodigiously gifted and immensely sympathetic scholar and High Court judge of Calcutta. In his opening address to the Asiatic Society of Bengal in 1784 he had been the first person to put forward the idea that Indian architecture could, perhaps, lead to modifications of existing Western architecture. Although the address was not published until 1789 when it appeared in the first volume of *Asiatick Researches*, it is just possible that Reynolds may have known of Jones's remarks from mutual friends and acquaintances in Bengal, so closely linked are the two exhortations. Similarly Jones thought that translations of Indian and Persian texts could enrich the literature of Europe by extending its scope, since for years it had been too heavily influenced by the plots of classical literature. When Jones's translation of Kalidasa's Sanskrit play *Sakuntala* was published in

1790 it created an immediate sensation and was praised by all the leading literati of Europe including Goethe. It was also considered for the subject of a 'Hindoo' opera by Schubert. Throughout the nineteenth century and twentieth century it has continued to attract the attention of sculptors, poets and composers. Music too, Jones considered would benefit from the improvements which a study of Indian music may suggest.[15] Collections of songs were made by many of the leading amateur musicians in India and sung both in their original languages and in translation. Several were transcribed for harpsichord, while others found their way into English songs and operas of the late eighteenth century. Using scenery derived from William Hodges's views of India, Indian melodies provided a note of authenticity for the Asiatic spectaculars which had become such a feature of the London of the 1780s and 1790s.[16]

It was into this atmosphere that two weary artists stepped when they returned to England in 1793. Their names were Thomas and William Daniell, they were uncle and nephew and they had returned after an absence of nine years.[17] Their work was eagerly awaited by men such as Robert Gough, and members of the Royal Academy including Joseph Farington. It was not to disappoint. After two years in Calcutta trying desperately to earn a living by publishing aquatints of the town, the Daniells had managed to save enough money to journey up-country in 1789. At Rajmahal, one month's journey up-river they were particularly struck by a 'new stile of building'. This was the Muslim architecture of the once famous capital of Bihar. The realisation of the splendours of the Muslim architecture of the region provided the spur to an enthusiasm which had previously been dormant. They were later to appreciate the widely differing qualities of Hindu architecture with the same degree of excitement.

William Hodges's aquatints of India appeared while the Daniells were in Calcutta and it is clear from their reactions to those views that they were not at all impressed. They were especially critical of Hodges's depictions of architecture which they thought highly inaccurate. Everywhere they went they sketched and drew with great precision, taking measurements, elevations and sections of all that interested them. They were as astounded as others had been before them by the Taj Mahal and Akbar's tomb at Sekunderabad. The monuments of Fatehpur Sikri and Delhi astonished them. With the help of local people they were able to establish the dates of erection and gradually to elucidate the various styles of architecture. They continued up to Hurdwar and were the first Europeans to enter Srinagar. They also visited the South, including the towns of Madura, Tanjore and the West Coast.

According to Joseph Farington the Daniells brought back 1,400 drawings 'including black lead pencil outlines'. These were to provide them with the material for their aquatint series entitled *Oriental Scenery* which was published betwen 1795 and 1808 in six volumes of twenty-four aquatints each, and other views **(14, 15)**. Their exotic subject matter and superb craftsmanship

established Thomas Daniell's reputation as an authority. There had never been such a distinguished set of views of India before, nor had the subjects been portrayed with anything like the Daniells' accuracy. Their work was greeted with much critical acclaim. A reviewer in *The British Critic* wrote that 'The plates are at once a profound study for the architect or antiquary and a new source of delight to the lover of the picturesque'. In 1800 an Indian, Mirza Abu Taleb Khan on a visit to England recorded in his journal that 'as many of the English had an opinion that there were not any buildings worth looking at in India, I was much rejoiced that Mr Daniell had by his skill, enabled me to convince them of the contrary; and I insisted upon several of my friends accompanying me to his house, to look at these pictures, which they could not behold without admiration'.[18] The Society of Antiquaries elected Thomas Daniell a Fellow. In 1796 he was elected an Associate of the Royal Academy and in 1799 a full Academician. From 1795 onwards both Thomas and William regularly exhibited their views of India. They were admired by many including J. W. Turner, and in France by the Duc d'Orléans who became the first President of the Société Asiatique in 1822.

Oriental Scenery became highly influential in the realm of architecture and taste. In 1798 Mazzinghi and Reeve's opera *Ramah Droog*, derived from an episode in the Mysore Wars, was performed with scenery 'based on drawings of Indian scenery by Thomas Daniell'. The published score has as its cover a copy of the aquatint of *The Fort at Trichinopoly*. From this period also date the many jugs and plates from Staffordshire which have blue and white transfer prints based upon views from *Oriental Scenery*. The views are often a curious assemblage, elements were taken from different aquatints and all combined to form one montage. Motifs from the aquatints found their way into the design of wallpapers both in Britain and abroad. The influence of the *Oriental Scenery* aquatints on architects was extensive: S. P. Cockerell, Repton and Nash are known to have consulted them as did Edmund Aikin who, in 1808, acknowledged his indebtedness to 'the correct delineations of Mr Daniell'. Soane too mentions them with approval in his lectures. As to their value to architects Repton wrote: 'Architects who have access to them can be at no loss for the minutiae.'

Mirza Abu Taleb Khan had come to England in the hope of earning some money by teaching Persian to members of the East India Company but he was disgusted when he found everybody so apathetic. Instead, because of his princely title, he found himself with a mass of social engagements and introductions to the high and mighty in the land as well as visits and introductions to old India hands and Indian ladies who had accompanied their English husbands back to England. During his time in England (he left on 7 June 1802) he frequently met King George III and the Queen who were most kind to him and gave him money at the end of his stay. He was also well received by the

Prince of Wales at Carlton House. He dined with 'Prinny' on many subsequent occasions when, he records, he was always treated with the 'greatest kindness and condescension'.

In reading his *Travels* it seems as if he met every person of note, including Lady Hamilton and the wealthy banker and connoisseur Thomas Hope with whom he dined on several occasions. He also mentions his friends. Among these was Sir Charles Cockerell, 'Had I been his brother, he could not have behaved with more kindness. He liberally supplied me with money for my drafts on Calcutta, and offered to advance any other sum I required: he also escorted me to all the places of public amusement, and invited me once every week to dine at his table, there I had the opportunity of meeting some of the handsomest women and the most agreeable company in England.'[19] In the summer of 1801 he travelled with Cockerell to his estate of Sezincote in the Cotswolds. There he stayed at the recently completed house which his brother, S. P. Cockerell, had designed for Colonel Cockerell who had died in 1798.

He spent two days in 'this delightful spot' after which he proceeded to Warren Hastings's house at nearby Daylesford where he remained for a week, during which time he was treated with the utmost kindness and attention. At the end of the week Cockerell invited him to stay again at Sezincote but Abu Taleb wanted to return to London, since he had been 'pierced by one of Cupid's arrows' and

14. *'The Taje Mahel, Agra' published by Thomas Daniell as an aquatint in 1801. Thomas and William Daniell had visited the Taj Mahal in 1789 and had fallen under its spell. Over the years the gardens had become overgrown but were no less romantic.*

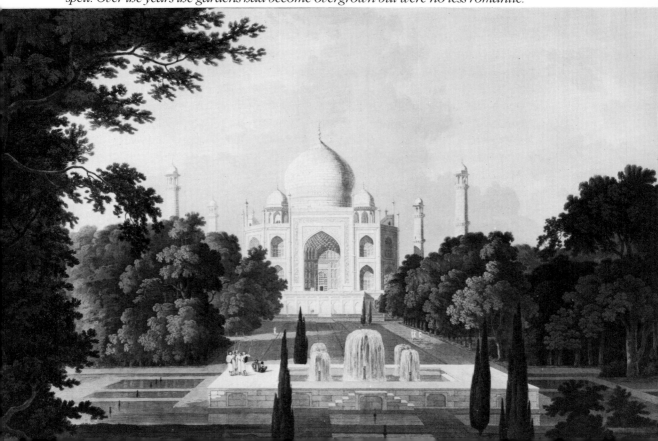

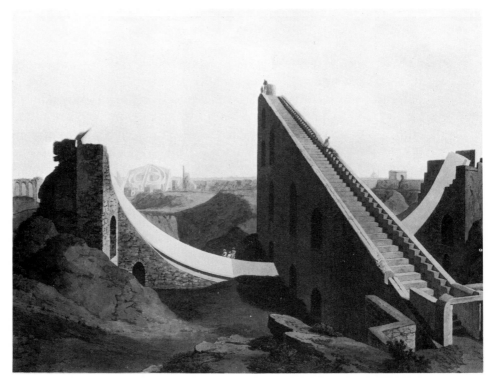

15. *'The Observatory at Delhi' an aquatint by Thomas and William Daniell published in 1808 from the series* Antiquities of India. *The Jantar-Mantar was erected in about 1724 by Maharajah Jai Singh of Jaipur and it is clear from the Daniells' remarks that they were fascinated by 'the singularity, as well as the magnitude' of the observatory.*

could not resist the desire to see his 'fair one'. In London he was also invited by Sir Joseph Banks to attend the weekly meetings of artists and scholars held in his house. Here he met the Sanskritist Charles Wilkins. Arthur Devis and James Northcote were among the artists to paint his portrait. With his dashing good looks, polite manners, winning conversation and exotic costume he was the very personification of the Indian style. It is just possible that his presence acted as a catalyst.

There had been a lull in the Indian scene for a decade and then suddenly several projects were contemplated. One of the reasons for the lull must have been the lack of clearly defined models (such as Strawberry Hill had been for the Gothic) and the lack of distinguished patronage for 'Indian' schemes. It was still a 'hairbrained' idea to have a country house designed in the style of a Mughal palace, although in the next few years such ideas were to receive royal assent. With the arrival of Thomas and William Daniell's sketches, architects had access to details of all styles of Indian architecture. What was needed now was an

influential patron and entrepreneur with an awareness of the possibilities in this architecture and a desire to promote it. Thomas Hope, a connoisseur and banker was such a person and he had a vision of what the arts could become if given sufficient encouragement.[20] He was the neo-classicist aesthete par-excellence: he had travelled in Italy, Turkey and Egypt and had a collection of classical sculptures to which he added some from India in later years. The neo-classicist strove to investigate all antiquity irrespective of religion or continent and it was from the development of this neo-classical ideal that cultural relativism emerged.

Thomas Hope bought his Duchess Street mansion, London in 1799 and proceeded to alter it so that it became a vehicle for his ideas. In August he commissioned a large composition picture from Thomas Daniell.[21] It contained representations of all the different traditions of Indian architecture: the Taj Mahal, the *gopuram* or temple gateway from the temple of Trichengodu, near Madras and examples of Shiva's trident and the quoit of Vishnu. Scattered

16. *The Indian Room at Thomas Hope's Duchess Street Mansion, London from an engraving in Hope's* Household Furniture and Interior Design, *1807. A Pannini classical capriccio is on the left, and three paintings of Indian architecture by Thomas Daniell can be seen on the other walls – the only 'Indian' elements in an otherwise not very 'Indian' room.*

between these examples were bits and pieces of ancient architecture and, rather curiously, an Indian procession wandering aimlessly in time and space. It would appear that at this moment Hope had not considered the possibility of an Indian room to stand alongside his Egyptian room and classical galleries. The composition picture, in reality an Indian capriccio, was merely the companion to a classical capriccio by Giovanni Pannini; the object of this being to juxtapose two of the world's most ancient cultures. During the course of the year Hope became increasingly enthusiastic about the need to include more paintings of examples of Indian architecture and in July 1800 ordered two more views from Daniell. Perhaps this is where Mirza Abu Taleb Khan comes in. It was at the time of their acquaintance that Hope's so-called Indian room took shape **(16)**. Unlike the Egyptian room there was not very much that was Indian about it. Turkey was more forcefully recalled as was ancient Egypt, and the blandness of the black and white illustration gives a false impression of its richness; the floor was covered by a Persian carpet, the sofas round the walls were of deep crimson, the walls sky blue, the ceiling pale yellow intermixed with azure and sea-green, and gold ornaments. The peacock feathers were at once a symbolic reminder of the exotic East and of Shah Jehan's fabulous Peacock Throne. In all this splendour one cannot help thinking that Daniell's paintings would have been overlooked. But Thomas Hope's interest in Indian culture was genuine and at Deepdene, his house in Surrey, he had another Indian room decorated with views from *Oriental Scenery*. In 1823 he became a founder member of the Royal Asiatic Society and a subscribing member of the Oriental Translation Committee of that Society. The Duchess Street mansion had been finished by 1803 and was open to the public in 1804. Admission was by ticket, after the manner of entry to Walpole's house. In succeeding years there was hardly a person of taste or rank who did not see the mansion. That it created a good deal of controversy can hardly be doubted.

Dance visited Hope's house in March 1804 and admired the freedom of expression and lack of adherence to the normal theories of architecture. He felt that it did not 'excite much idea of comfort as a dwelling', not that, as Dr Watkin has pointed out, Dance was much concerned with 'hearth and home' cosiness either. In reality, as Watkin has suggested, it was 'a high-minded neo-classical compromise between a dwelling and a museum',[22] a fact which did not go unnoticed by other visitors. In April of the same year Sir George Beaumont, one of Dance's' patrons, declared that it was 'more a Museum than anything else', a sentiment which was echoed in 1812 by Lord Lonsdale.[23] In 1807 Hope published his *Household Furniture* which contained engravings of all the rooms and details of the furniture and fittings. The engravings appear to have influenced John Foulston's Devonport scheme of 1823–4 **(17)**.

At Devonport, Plymouth, Foulston put on public display a sample of buildings from what were considered to be all the major cultures of antiquity.[24] Set

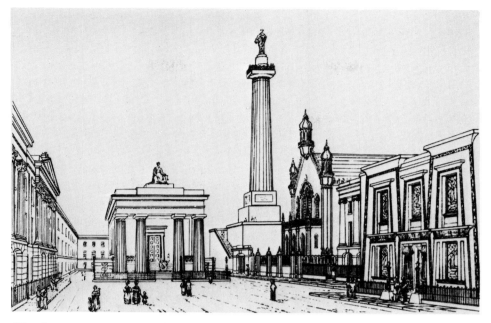

17. *Devonport, Devon, John Foulston's cosmopolitan scheme for a provincial town, built in 1823–4. In close proximity can be seen a Corinthian terrace, Greek Doric town hall, Doric column, a 'Mughal' Baptist Chapel, an Ionic house and an Egyptian library. The Chapel was the forerunner of the numerous Indo-Islamic synagogues built in the last half of the nineteenth century.*

around a square were Roman-Corinthian terraced houses; a Greek Doric town hall and column; a Baptist chapel in Oriental, Islamic or 'Mohammedan' style; a pair of Greek Ionic houses and an Egyptian library. They had been built as an experiment for 'producing a picturesque effect'. It was as if architectural styles had been extracted from a composition painting by Daniell, Pannini or Joseph Gandy and put on display. Like a museum the project was meant to be educative: 'the designs must be considered merely as Models calculated for the atmosphere of a town remote from the Metropolis'. Foulston's friend and colleague George Wightwick wrote at greater length in his book *Palace of Architecture* (1840) about the scheme. He suggested that ancient architecture could be adopted for modern purposes but freed of a 'mixed style (which is) like a monstrous union of the parts of one animal with those of another'.

George Dance and Samuel Pepys Cockerell would have disagreed entirely with Wightwick, since mixing different styles was for them the best way of creating a modern architecture for modern purposes. Throughout the first decade the two architects were intimately acquainted, writing reports on architectural competitions and collaborating on the design of a new Guildhall at Westminster in 1804. It would be expected therefore that each would be aware

of the other's ideas and schemes. Both became absorbed in various aspects of Indian design and both applied its use in remarkably different ways.

For Sir George Beaumont's house at Cole Orton in Shropshire Dance returned to elements of Indian architecture, most noticeably the minaret. Drawings were made in 1803 and in the design process went through chameleon-like changes of appearance.[25] Beaumont finally settled for a Tudor-gothic, two-storey house with porte-cochère. This had minaret-like finials which during the design process increased and decreased in number. Some of the ambiguous features such as the crested merlons of the Guildhall and the capped turrets from Cole Orton were later used in a gateway to Stratton Park, Hampshire in 1808. For Lord Ashburnham's house at Ashburnham Place, Sussex, (1812), Dance worked through a similar procession of ideas but this time added elaborate balconies and parapets. At one moment he proposed a riot of minarets and at another none **(18, 19)**, their place was taken by an Indian

18. *A preliminary design for Ashburnham Place, Sussex by George Dance, 1812, showing an idea in which he explored the possibilities of highly decorative 'Indian' turrets.*

19. *A preliminary design for Ashburnham Place, Sussex by George Dance, 1812, in which the architect had contemplated using a 'Mughal' dome to surmount an austere, classical façade.*

dome surmounting a plain classical building. This was most uncharacteristic of Dance who preferred to mix Indian with Tudor-gothic elements. George Dance was generally considered 'the first Architect of the age' but his work was so personal that he had few followers or imitators. One exception was William Porden, a pupil of S. P. Cockerell. His unexecuted 'Moresco Gothic' design for Eaton Hall made in 1804 relies heavily on Dance's ideas for Cole Orton.[26]

Unlike Dance, Cockerell preferred to mix the classical villa style of his master Sir Robert Taylor with a strong infusion of Mughal architecture. This can clearly be seen at Sezincote in Gloucestershire **(6, 20)**. The Sezincote estate had been purchased in 1794 by Colonel John Cockerell. He intended to live there and had the old Jacobean gabled house modernised by his brother and given a new façade. He died in 1798 before it was completed and his brother Charles purchased the estate. Just when Sir Charles Cockerell decided that he would rather like to live in a Mughal house in the Cotswolds is uncertain. It could be as early as 1801 when he had so hospitably entertained Mirza Abu Taleb Khan. Or did the William Porden design of 1802 for the Prince of Wales' stables at Brighton inspire him? Was it not, after all, a country house for horses?

20. Sezincote, Gloucestershire, c. 1805 by Samuel Pepys Cockerell. This east elevation is dominated by a 'Great Gateway' and highly embellished window surrounds which are different on each storey and which change with the breaks in the facade.

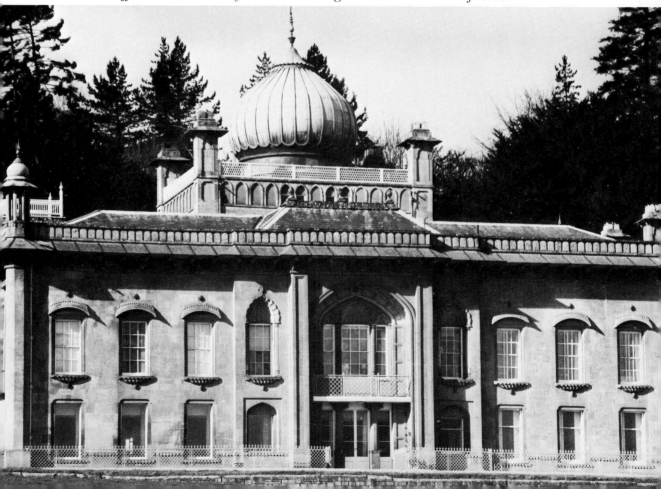

It is difficult to ascertain a precise date for the beginning of the Indian conversion. Humphry Repton in 1806 mentions in *An Enquiry into the Changes of Taste in Landscape Gardening* that when he had first known of the project it was 'then in too early a stage of progress to be referred to'. Repton mentions the scheme again in his *Designs for a Pavilion at Brighton* the manuscript and drawings of which were given to the Prince of Wales in February 1806. In this he stated that a little before his first visit to Brighton in 1805 he had been consulted by the 'proprietor of Sesincot, in Gloucestershire, where he wished to introduce the Gardening and Architecture which he had seen in India'. This makes it clear that the project was already under discussion by 1805 and probably earlier. It is also apparent that the Indian scheme was Sir Charles Cockerell's idea.

In matters of taste he may have taken a lead from Porden's stables at Brighton but he was in any case fiercely confident in artistic matters, on one occasion defending himself publicly,[27] although his brother Samuel had to admit to his son in 1816 that as far as he was concerned in matters of taste 'Sir Chas . . . has not the least knowledge or discrimination . . .'[28] But this did not stop him from indulging his architectural pretensions. With a large house on Hyde Park Corner, Cockerell was in no hurry to begin work at Sezincote, nor could S. P. Cockerell devote much time to it since he was very busy in 1804 and 1805 with other schemes in various parts of the country. Work began on the estate in 1806 or 1807. In 1808 the house was visited by the Prince of Wales, curious to see what an Indian country house would look like. This visit was commemorated on the south front by the insertion of Prince of Wales feathers under the eaves.[29]

Altogether four people were involved in the design of Sezincote; Sir Charles Cockerell, Samuel Pepys Cockerell, Humphry Repton and Thomas Daniell.[30] The tangled strands of responsibility are difficult to elucidate, as is evident from an examination of the remaining archives. Cockerell selected the idea, his brother was put in executive control of the design; Repton had made some suggestions as to the disposition of some of the elements, perhaps in the garden, as a surviving drawing confirms; Daniell was responsible for ensuring archaeological accuracy and agreeing the solutions proposed by S. P. Cockerell. Since at Melchet Park Daniell had already had experience in using the Indian style on a small scale he was given the responsibility for designing the garden monuments. S. P. Cockerell designed the farmhouse and stables while in later years even Sir Charles would have a go at the coachman's house.

Fundamentally Sezincote is based upon the classical villa designs of Cockerell's tutor, Sir Robert Taylor.[31] The east front **(20)** was extended by one bay to give a symmetrical façade either side of a central entrance and the south front was much enlarged so that it would comprise five bays disposed 1–3–1 with a canted bay; a typical Taylorian device **(6)**. Other typical devices

were the wide overhanging eaves and the octagonal patterning on the railings, normally reserved for the windows in Taylor's houses. The interiors of the main house are classical.

Onto this classical structure Cockerell was to drape another 'classic' design, that of the Taj Mahal. It was a building much admired by S. P. Cockerell and Daniell, the former because of its picturesque qualities and the appeal which it held for the imagination without recourse to the use of any of the orders. Daniell had brought out a special folio edition of two plates of the Taj Mahal in 1801 **(14)**, the garden view of which especially depicts it as an enticing, exotic house set amid luxuriant foliage. Only when seen in this context can it be appreciated how Sir Charles Cockerell could live in what was a design derived from a spectacular, romantic tomb! In its original condition the lattice railing which stretches into the gardens on either side of the east front of the house, terminated in stunted octagonal minarets, thereby creating a triangular elevation similar to those S. P. Cockerell had admired at the Taj.[32] What Sezincote lacks is that lift which a pedestal provided and which was so essential a part of the Mughal buildings the Daniells had admired in North India. Nevertheless the designers attempted some degree of authenticity – the dome is not a generalised confection of the kind Nash used so often.[33] They had the brilliant idea of transforming the wide eaves of a Taylor villa into the *chujja* on Mughal buildings. So successful was this that one wonders why it was not taken up more often elsewhere. The 'gateway' which dominates the east front is truly a great dramatic stroke. Surprisingly, neither Repton nor Nash copied this feature for the Pavilion at Brighton. It was not used again until Edward Blore re-discovered its effectiveness for *Aloupka* (1837–40), a rather more Islamic house on the Black Sea he had designed for Count Woronzow.[34]

At Sezincote Cockerell, with the help of Daniell, developed a 'Hindoo order' **(21)**. This was unusual for him since he rarely used columns because he thought they restricted the imagination. But at Sezincote the order follows classical usage. On the ground floor there were simple but bold 'Hindu' forms which reflect the simplicity of the fenestration on the same level and on the first or principal storey the columns are 'Mughal'. This change is reflected in the more elaborate window surrounds; curvilinear hood-mouldings, embellished sills, multi-faceted arches and scalloped recessing. All the details of the decoration whether crenellations, panels, or window details can be traced to Daniell's Indian views.

To Repton's involvement is credited the idea for a conservatory, altering the farmhouse on the hill opposite the south front to a *serai*, the positioning of the octagonal fountain, the gardener's house which was to be constructed like a Hindu temple among some trees, and the siting of a grotto. But his active participation did not last long and it may not necessarily have been his idea to have two curving conservatories ending with fanciful pavilions. The way in

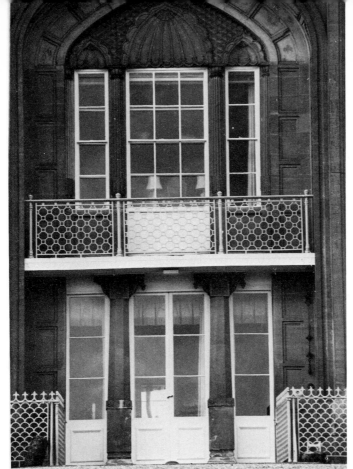

21. The 'Great Gateway' entrance of Sezincote with 'Hindu' columns on the ground floor and 'Mughal' on the first. Great attention has been paid to the details of the panelling all of which were crisply carved by local craftsmen.

which they lead off from the house makes them highly irregular; their positioning is related more to the awkward topography of the site and the alignment of the house than to an aesthetic rationale. One of the conservatories or 'Harliquinades' as Daniell called them, terminated in an aviary, the other on the north side was rather unromantically used as a brew house. The garden monuments were mostly designed by Daniell including a 'Temple of Surya' with a circular pool and lingam fountain, a 'Hindoo' grotto and a 'Hindoo' bridge beneath which was a philosopher's chair from which one could contemplate the mysteries of the serpent fountain. The gardener's house is his design as was a multi-domed summer-house which was never erected.

Over the years Sezincote went through many alterations including an addition to the west wing in 1811 after Sir Charles's marriage. By 1817 the house was complete and the gardens had arrived at a sufficient state of maturity to warrant the brush of an artist to record them. Thomas Daniell made seven large oil paintings of the estate, all of which were exhibited at the Royal Academy. The most striking difference between his views of the house and how it is known today is that in Cockerell's time all the domes and the stable clock tower were painted white to resemble marble and the finials were gilded.[35] Also in 1817

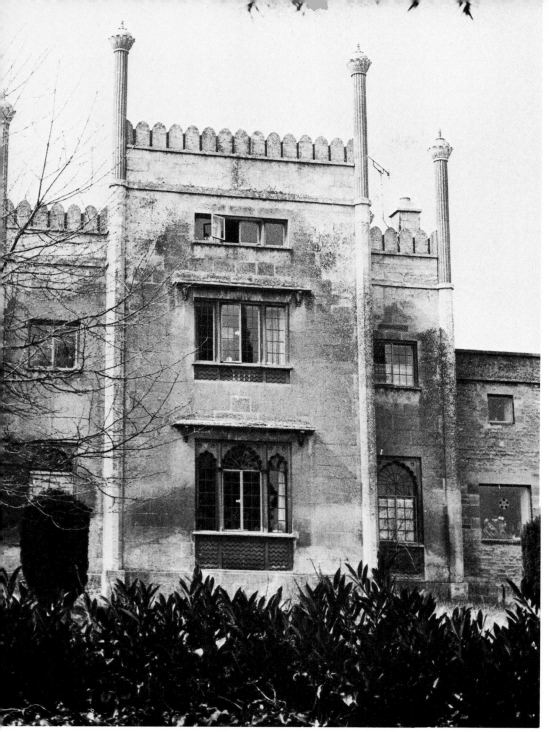

22. *The farmhouse Sezincote part of the farmbuildings were designed to look like a 'serai' which could be seen from the house, for which the farmhouse should have been the 'Great Gateway'. In order to make it suitable for living in windows were inserted on each floor by S. P. Cockerell thereby rendering it less authentic.*

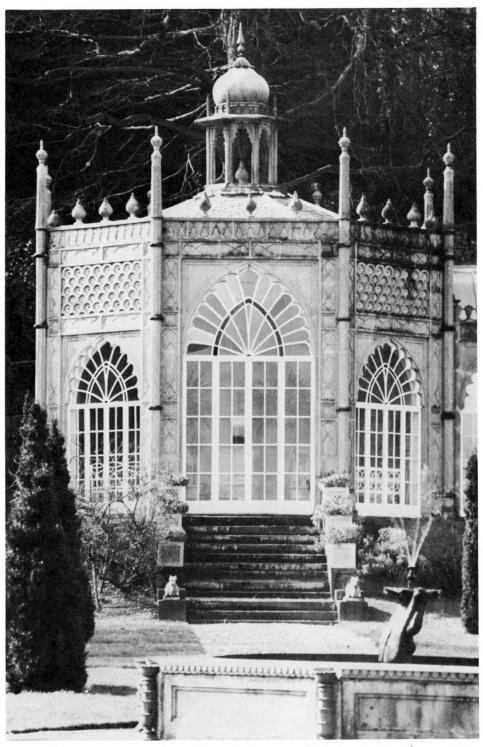

23. *A fantastic octagonal pavilion, Sezincote, which terminates the surviving conservatory, possibly designed by Humphry Repton.*

Sir Charles Cockerell commissioned the young visionary artist John Martin to draw and engrave a series of views of the estate. His notebook at the Ashmolean Museum, Oxford is filled with Indian details some of which he later included in his paintings. For example the serpent entwined around a lingam in the foreground of *Belshazzar's Feast* is a direct crib from the serpent fountain, Sezincote. During the early 1820s Charles R. Cockerell, Samuel's son, was called in by his uncle to complete the 'Indian' character of the estate with a range of buildings providing further guest accommodation to the rear of the house and lodges which were added to the Worcester Road and Bourton-on-the-Hill entrances **(24)**. While the lodges owe a debt to John Nash's Blaise Hamlet scheme near Bristol (one of the lodges was even called Diamond Lodge), C. R. Cockerell's designs were the first buildings in England to have been directly influenced by Bengal huts. Sir Charles was running out of money and damp was already attacking the house. After 1830 he mostly resided abroad. S. P. Cockerell died in 1827, Sir Charles in 1837 and Thomas Daniell in 1840. Thereafter nothing is heard of Sezincote.[36] C. R. Cockerell made sure of that. He did not include it in his list of his father's works published in *Architectural Publications Society Dictionary* – a sure note of censure.

Sezincote's sphere of influence was very limited and did not extend beyond the immediate area. In 1807 a spa house with 'Indian' features was erected at nearby Lower Swell **(25)**, an amateur effort, perhaps even by Sir Charles himself although it was not on his land. For a while water bubbled out of the

24. Lodges on the Worcester Road, Sezincote, designed by Charles R. Cockerell in 1823 in the shape of Bengal huts, complete with curvilinear thatched roofs. In recent years they have been altered.

ground and everybody hoped for the birth of another Cheltenham – then suddenly, it dried up. In 1823 Sezincote was probably responsible for the Indian style of the New Market which was designed by Edward Jenkins and built in Cheltenham a few miles away **(26)**. An 'Indian' dome was even considered in about 1825 to top Toddington Manor in Gloucestershire, a gothic house designed by its enterprising owner Charles Hanbury-Tracy, an architectural enthusiast.[37]

In comparison an 'Indian' scheme supported by the Prince of Wales, later George IV, could have the most far-reaching effects. In 1802 he commissioned a design for stables at Brighton from an architect who had been a pupil of S. P. Cockerell. His name was William Porden. In 1797 Porden had exhibited a 'Design for a Place of Public Amusement in the style of the Mohametan architecture of Hindostan' at the Royal Academy. The drawing has not survived. The inherent variety and intricacy of the Eastern styles encouraged a light hearted atmosphere and a sense of fantasy most suitable for places of amusement. This point was made clearly by a later commentator. Referring to the design of the pump rooms at Bath and Cheltenham, the Reverend Fosbrooke wrote '. . . it is deeply to be regretted that they are in the Grecian style . . . under any circumstances the Asiatic or Arabian styles . . . would have been more fortunate'.[38]

From Nash it is known that the Prince was 'bored with classicism' and wanted something new and picturesque.[39] The choice of the Indian style for Brighton in 1802 reflects his independent taste. What cannot be denied is that it was a bold,

25. *Spa Cottage, Lower Swell, Gloucestershire built in about 1807 by a local builder which uses some clumsily copied motifs from nearby Sezincote.*

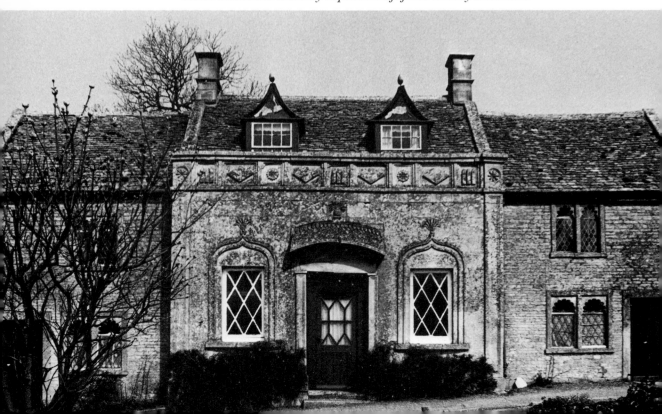

even daring choice quite without precedent. Porden did not disappoint. The vast dome was modelled upon Legrand and Molinos' Halle au Blé in Paris. Work began in 1803 under the supervision of yet another S. P. Cockerell pupil, Joseph Kay, and was completed by 1808 **(27)**. A friend of Porden's, the architect John Linnel Bond, saw the substantially completed building in 1806. While he was to some degree diffident, fearing the novelty of the style was clouding his judgement, he did admire 'the magnificant Dimensions of the Fronts, the Colour and Texture of the Stone and the exquisite Execution of the whole [which] added to the general Composition and the harmonious arrangement'.[40] Many other visitors were even more thrilled by its vast proportions and novel conception.

The Indian style of the stables had two important effects, their scale ensured that the small marine pavilion would have to be enlarged and that any alterations would have to be in an appropriate style. It could be assumed that having selected an Indian style for the stables the Prince of Wales would automatically have extended the pavilion in a similar vein. Apparently this was

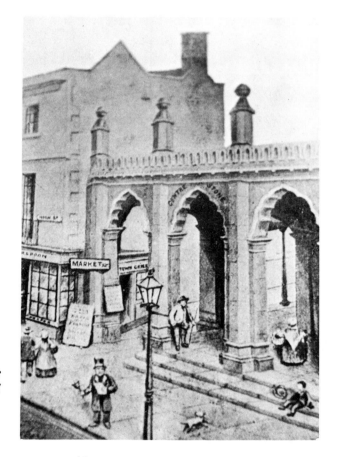

26. New Market, Cheltenham, Gloucestershire designed in 1823 by Edward Jenkins in a 'Mughal' style which was influenced by Sezincote a few miles away.

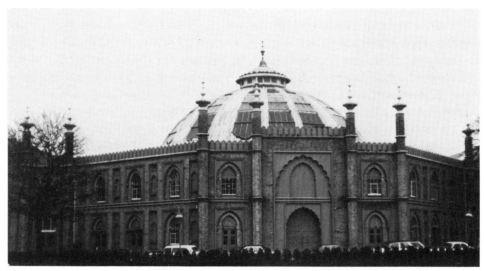

27. *The Royal Stables at Brighton, designed in 1803 by William Porden for the Prince of Wales. It was the first major essay in the 'Indian' style and is remarkable for the skilful way in which Porden integrated the Indian elements.*

not the case because in 1805 William Porden was again called upon to supply a design. Curiously the extant drawings show that the style was to be Chinese not Indian, presumably so that it would conform to the Chinese interior which had been installed in about 1802.[41] Unhappy with the Chinese drawings, in October of 1805 the Prince approached Humphry Repton through the Duke of Bedford. Evidently, Repton's work for the Duke at Woburn had caught the eye of the Prince. The Chinese garment was to be cast aside, to be replaced by an Indian one. When Repton presented his designs to his royal patron in February 1806 he knew that 'Indian' forms were required. Repton was no innovator and had always been against novelty. He would only have altered this attitude to accommodate the express wishes of his illustrious patron.

It is worthwhile looking at his arguments to justify this change of heart. As has been mentioned it was while he worked with S. P. Cockerell, Thomas Daniell and Sir Charles Cockerell at Sezincote that he first came into contact with Indian architecture. While there he even selected some of the forms although the 'architectural department of Sesincot of course devolved to the Brother of the Proprietor'. Repton does not mention the Cockerells by name, a most unusual occurrence for he usually took every opportunity to drop the names of former patrons. Was he afraid that S. P. Cockerell would be called to Brighton and thus rob him of a chance of the crowning achievement of a life's work? From what Repton saw at Sezincote he realised that 'the detail of Hindu architecture is as beautiful in reality as it appears in the drawings'. He had been won over to a new style. Porden's stables greatly impressed him, although he realised that

they were not entirely in an Indian style and therefore only 'in some degree realized the new forms'. Thus there was still scope for improvement in this new style. Nevertheless the stables were magnificent and redounded to the credit of the 'genius of the Artist, and the good taste of his Royal Employer'.

The tone of Repton's remarks in *Designs for a Pavillon at Brighton* (1808) is geared to the inclinations of the Prince. In case he was accused of attempting to

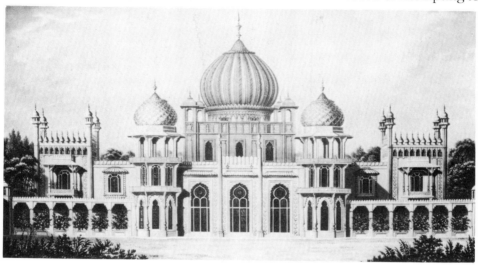

28. *The west front of Brighton Pavilion from a design by Humphry Repton published in his* Designs for a Pavillon at Brighton, 1808. *By employing the same style as the stables and increasing the size of the pavilion Repton not only created an harmonious scheme but also diverted the attention away from the impressive stable block to what is in effect a palace.*

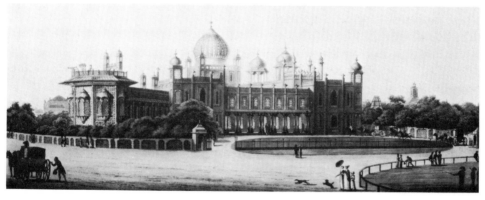

29. *The north and east fronts of Brighton Pavilion from Repton's* Designs, 1808. *The projecting wing ending with an octagonal room is a straight copy from Thomas Daniell's aquatint 'View of the Cotsea Bhaug [Qudsiya Bagh], Delhi'. All the other Indian details were taken from the views of the Daniells.*

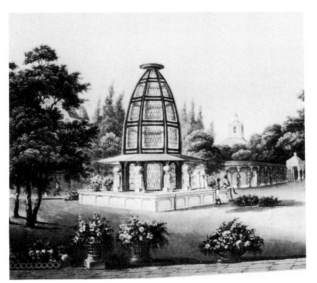

30. *The 'Hindoo' aviary for Brighton Pavilion from Repton's* Designs, *1808. It is a curious mixture of a 'Hindu' temple derived Brindaban surrounded by 'Elephanta' cave-temple pillars and set upon a 'Mughal' pedestal. Such an unauthentic combination would not have been approved of by Thomas Daniell.*

'invent anything entirely new' he considered different styles: the Turkish, Grecian, Moorish, Gothic, Egyptian, Burmese, Chinese, all were rejected. He considered that the Chinese style was only suitable for interiors, an approving reference to the *chinoiserie* interior of the existing pavilion. He did not want to be seen to criticise the Prince's taste. No style was possible other than that of 'Hindustan' by which he meant not one style, but many. To placate his critics who knew him to be against anything new, he justified his use of the Indian style in several ways. He appealed to its great antiquity, emphasising that it was earlier even than the classical period. Like George Dance and William Hodges he speculated that the Grecian style was derived from the East (and hints at this when he refers to the cave temples of Ellora and Elephanta as existing at the time 'Alexander the Great conquered India'). Repton did not want to be seen to be too radical but he knew the neo-classical argument that the greater the antiquity of a style, the greater its authority and hence proposed a new aesthetic model of perfection. It was Europe's good fortune that the drawings of 'Mr Thomas Daniell, and other artists [had] opened new sources of grace and beauty':

Access to the greater variety of forms in Indian architecture would alone justify its use in the West and help to discard the 'rage for what is called SIMPLICITY'. It was known that the Prince thought 'the forms of which Eastern structures are composed were susceptible more than any other (the Gothic perhaps excepted) of rich and picturesque combinations'.

As a general rule Repton suggested that when 'Indian forms' were adopted they should bear little resemblance to either 'Grecian or Gothic' styles – a recommendation entirely at odds with Dance's tendency. The reason for this,

31. An engraving from Repton's Designs, *1808 in which he indicated that it was only a matter of time before the Indian style would become a national style, like Castle and Abbey Gothic, Elizabethan and Grecian.*

Repton asserted, was that otherwise such details would tend to be taken for 'incorrect specimens of well-known forms' resulting in a mixed style 'as disgusting to the classic observer, as the mixture in Queen Elizabeth's Gothic', a style which Dance proposed on several occasions. Repton's comments and S. P. Cockerell's use of Indian forms at Sezincote show that he and Repton were in agreement on this point. Nor should the forms of 'Mosques', 'Serais', 'Hill Forts', or the 'excavations of the East' be strictly imitated, although they could be deviated from or improved upon.

Repton had another surprise in store for his readers. The new style, the Indian, was to become a new national style suitable for palaces and houses and expressing the assimilation of India into the orbit of the country's concerns. The head of this Empire would eventually be the Prince of Wales. Hence the Prince of Wales' feathers crowning a Hindu column in the engraving *Flora cherishing Winter*. The stylistic progression is clearly indicated in an imaginary composition in the *Designs* (31). An hour glass still runs and Time's scythe and a few reeds partially conceal an Indian building from view. The interpretation is self-evident: it is only a matter of time before the Indian style is assimilated into the ranks of the other national styles: Castle-gothic, Abbey-gothic, Elizabethan and Grecian. No other exotic style such as Moorish, Turkish, Chinese, or Saracenic was ever nationalised for the good reason that none of the countries they originated from was under British dominion in the first decade of the nineteenth century. There can be no doubt that Repton was serious. Long after his designs had been turned down he wrote in his *Memoir* 'So ended my Royal Hopes! from which I had proudly prognosticated a new species of architecture more applicable to this country than either Grecian or Gothic'.[42]

Before he flattered the Prince that he would one day be the head of this British-Indian Empire Repton would have made certain that he was expressing royal opinion. This must be why Repton's design, although termed a pavilion, is

in fact a palace fit for a monarch. It would also account for the seriousness of the design, an aspect that it had in common with Sezincote. Perhaps the Cockerells and Repton were working along similar lines, both projects developing and expressing this new national style. Certainly all the participants knew each other well. At first the Prince was absolutely thrilled by Repton's designs and a folio of views was published in 1808. Given their enthusiastic reception Repton must have been confident that the scheme would come to fruition. Alas it did not. The Prince had run out of money, and run out on Mrs Fitzherbert!

Repton's ideas and designs were not without influence. In the year the *Designs* were engraved Edmund Aikin published *Designs for Villas and other Rural Buildings*. He was yet another architect to find in Indian styles a way of modifying established conventions **(32)**. Aikin introduced 'Indian' details perhaps in the hope that Repton's royal commission would stimulate a demand for similar but more modest buildings. Though in his preface to a second edition he indicated that since so many volumes of architectural designs were available 'the pursuit of novelty becomes not merely desirable, but necessary'. Every style was open to choice and according to Aikin there was 'no *prima facie* reason why one should be preferred to another', though each should be considered with sound judgment. Many of his remarks show the imprint of

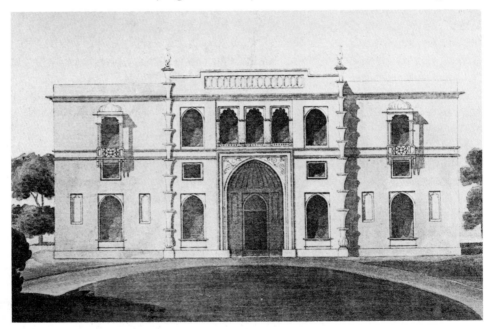

32. *A design for 'a Villa or Mansion' in the 'Mohammedan style' of India, by Edmund Aikin from his* Designs for Villas and other Rural Buildings, *1808. Many of Aikin's designs show the influence of Indian architecture which he admired for its 'light and ornamental character'.*

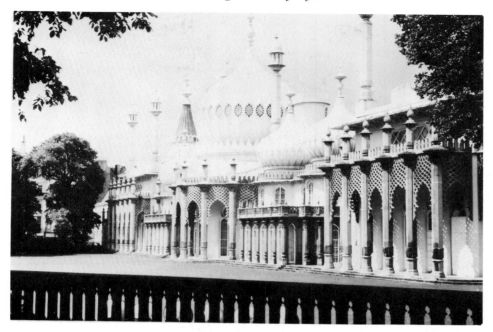

33. The spectacular east front of Nash's Brighton Pavilion, designed in 1815. The riot of domes, minarets and jalis *is in contrast to Repton's sobre designs.*

William Hodges's opinions and those of Repton. His visual ideas he acknowledged were derived from 'the works of Mr Daniell'. Restraint was the keynote of Aikin's work: French classicism embellished with the Indian, 'an economical style of beauty'. The façade dominated by a 'great gateway' may represent the influence of Sezincote, the designs for which he may have seen at Daniell's house.

If Cockerell's designs for Sezincote and Repton's for the pavilion encouraged a flicker of interest in Indian styles, Nash's inflamed the world. In 1812 the Prince of Wales returned to the subject of a new pavilion at Brighton, one year after he had been created Regent and received another transfusion of money. Initially James Wyatt, the famed gothicist and Surveyor-General, was approached but he died as the result of an accident in 1813. The Prince next approached Nash who was already busy on the new schemes for Regents Park and Regent Street, London and who was a member of his Carlton House set. The design of the pavilion was to reflect the light-hearted atmosphere of the peace celebrations which followed the defeat of Napoleon at Waterloo in 1814 after many years of war. What the Prince desired was fun, not a serious essay in the Indian style to remind him of his increasing responsibilities. Nash duly complied.

In the hands of Nash the pavilion changed entirely in concept. It became a fun palace with more than a hint of the disreputable contained in its efflorescence

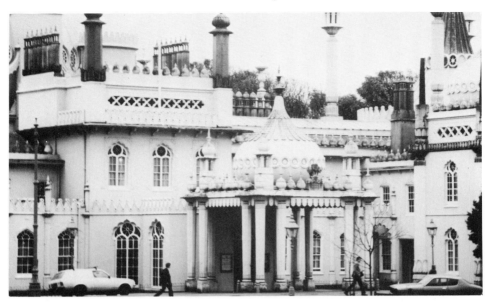

34. *A partial view of the west front of Nash's Brighton Pavilion showing the ingeniously varied forms by which Nash successfully diverted the attention of the viewer away from Porden's stables.*

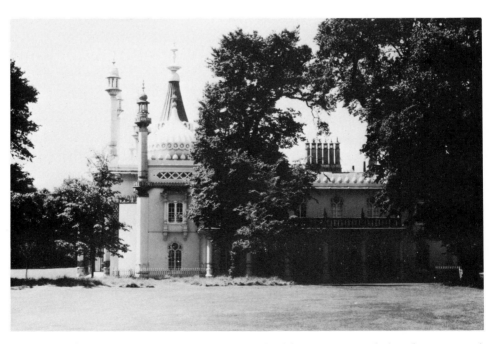

35. *North front of Nash's Brighton Pavilion which borrows several ideas from Repton's designs, including the use of a verandah..*

of swelling domes, lusty minarets and lacey *jalis* **(33)**. It is known that in November 1815 Nash borrowed the Regent's copies of the Daniells' views of India from Carlton House to make drawings for Brighton. However, Nash was more concerned with effect than archaeological accuracy. The exception to this was his use of minarets and the 'wedding-cake' merlons on the west front which are similar to those found on the great gateway of the Jami Masjid, Delhi and the mosque gateway at Pilibhit. **(34)**. Some of the features Nash clearly borrowed from Repton. Especially noticeable is the similarity between the north front of Repton's design and that by Nash **(35)**. Nash evolved a rather curious 'Hindoo' order for the pavilion which on the east front is in warm, exposed Bath stone. All attention on this front is on the sighing and heaving of the various domes. But even these cannot disguise the fact, and Nash has skilfully tried to conceal it, that the building is too long and too low. This is more evident on what was the less public west front.

What Nash provided for his patron was a wonderful evocation of fantasy. In order to achieve this he drew upon many sources, mostly Eastern. This was intentional and the result of consultations with the Prince who wished to divert attention from Porden's massive stables to the house. At the time of the consultations the pavilion was still very much as Henry Holland had designed it, a rather mean classical house with a shallow dome. According to Nash, it was the Prince who decided that if a 'Hindoo' style of architecture were adopted, its 'turban domes' and 'lofty pinnacles' would produce 'glittering and picturesque' effects which would attract and fix the attention of the spectator.[43] In terms of design Repton's palace would have been more successful since it was more imposing in bulk and extent than Porden's stables. However the Prince could not afford such radical additions to the pavilion. Such changes which were to take place would have to be superficial and rely on the diversion of attention from the stables to the house, not through any serious application of forms, but by eye-catching tricks and illusions. In this Nash succeeded brilliantly and he did so by applying all the known fantasy styles, especially gothic, 'Hindoo' and the Chinese.

It is because the same forms still appeal to our imagination that we are still transfixed by Nash's theatrical vision. Although the Prince of Wales probably did agree with the concept Repton proposed and genuinely (at the time) found it pleasing and innovative, yet Repton seriously miscalculated the character of his patron. He only wanted a pavilion not a palace. Repton could not know that his idea for a 'new species of architecture' would be prophetic and that it would emerge as a major style in the Imperial India of the late nineteenth century.

The pavilion was finished by 1821 and decorated in great style by the interior designers J. F. Crace and Robert Jones. No expense was spared and no mythology was secure from the cunning ravages of the designers: dragons,

36. Indian gateway at Dromana, Co. Waterford, Eire erected in 1826 to celebrate the happy return of a honeymoon couple.

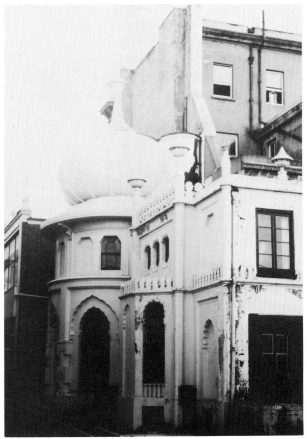

37. Amon Henry Wilds' miniature version of Brighton Pavilion at Western Terrace, Brighton. It was erected during the 1820s for the architect's own use.

lotuses, palm trees, elephants, exotic birds and plants, 'Indian' columns, Chinese wallpaper, Indian ivory furniture. The decorations of Jones and Crace cost £45,057 and the furnishings at least £101,123. One writer in the *Monthly Magazine* for October 1819 realised with unusual acumen that even this eclectic pavilion had its political overtones. While a glance at the building would immediately remind the observer of the 'fairy palaces of the sovereigns of Hindustan . . . [yet] it may be presumed that the Regent, who must be led to consider himself as virtual sovereign of the East, deemed it respectful to his Eastern dependencies to exhibit a palace in conformity with their notions of architectural perfection'. He continued, 'Be this as it may, his Royal Highness has unquestionably placed on British ground the most original and unique structure in Europe'.

Naturally, the Prince became closely identified with Brighton and its oriental pavilion. When he visited Dublin soon after his coronation as George IV in 1821, the civic authorities erected a 'Moorish Palace' at a cost of £5,000 for the formal dinner.[44] This occasion must have inspired the Villiers-Stuart family of Dromana, County Waterford to erect an 'Indian' gateway in 1826, to greet Henry Villiers-Stuart (later Lord Stuart de Decies) as he returned from his honeymoon: a romantic conception for a romantic occasion **(36)**.[45]

The writer of the *Monthly Magazine* was absolutely correct, such a unique and original building erected under the auspices of the Prince was bound to have repercussions. The first ripples were felt, not surprisingly, in Brighton itself. A local architect, Amon Henry Wilds, who worked with his father Amon Wilds and his partner C. A. Busby, for a time enthusiastically took up the style.[46] His own house at Western Terrace was a mini-pavilion erected during the 1820s **(37)**. Afflicted with delusions of oriental magnificence which his purse could not fulfil he settled for a pavilion of modest proportions. Across the road was a gothic house which he had designed with his father and Busby in the early 1820s. Next to it he built an elegant classical terrace, the most interesting features of which are the ammonite capitals, a pun on his name and an idea originally derived from George Dance. The small complex of different styles is reminiscent of the picturesque arrangement of Foulston's Devonport scheme (1821–4).

A local botanist and landscape gardener, Henry Phillips asked A. H. Wilds in 1825 for designs for a new oriental garden to be erected in nearby Oriental Place but the project came to nothing.[47] However, Indian conservatories became fashionable and J. C. Loudon, taking his cue from the pavilion, designed in 1822 an Indian house with an appropriately designed conservatory **(38)**. So popular did Loudon think the Indian style would become that he also proposed an 'Indian Gothic' cottage **(39)**. In the conservatory of Sydney Smirke's Bazaar and Pantheon in Oxford Street, London, Charles Bielefield introduced a 'Mughal' screen in 1834.[48] Over the years orientalisms made frequent appearances in

38. J. C. Loudon's design in his Encyclopaedia of Gardening *1822 for an Indian house and conservatory inspired by Nash's pavilion at Brighton.*

glasshouses but occasionally there are direct Indian quotations such as the 'Mughal' dome and interior of the conservatory at Pfauinsel, Berlin designed by Albert Schadow and built between 1829 and 1831 **(40)**. There were several versions of that scheme and both a preliminary design and the completed version paid close attention to Indian details.[49] Conservatory chimneys were occasionally turned into minarets. One of these was constructed at Alton Towers, Staffordshire and another at Laeken, Brussels.

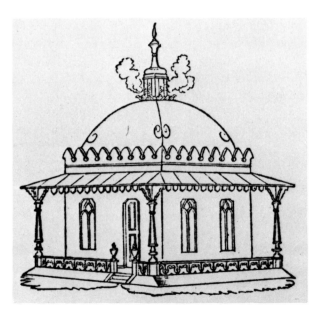

39. J. C. Loudon's 'Indian Gothic' cottage illustrated in his Encyclopaedia of Gardening *1822. It is more in the spirit of Nash's Brighton Pavilion than S. P. Cockerell's Sezincote.*

Wilds was also involved in an ambitious river-side scheme in London. In 1835 someone of entrepreneurial skill had the idea that Gravesend, on the Thames, could, with some help from an architect, become a fashionable watering place. As Wilds had been at work on the nearby new estate of Milton, he was asked for an elevation for a new river frontage and baths. His scheme was exhibited at the Royal Academy in 1835. It was very ambitious, Nash-like terraces were set back from the river, on either side of a central pier **(41)**. Again the Indian style

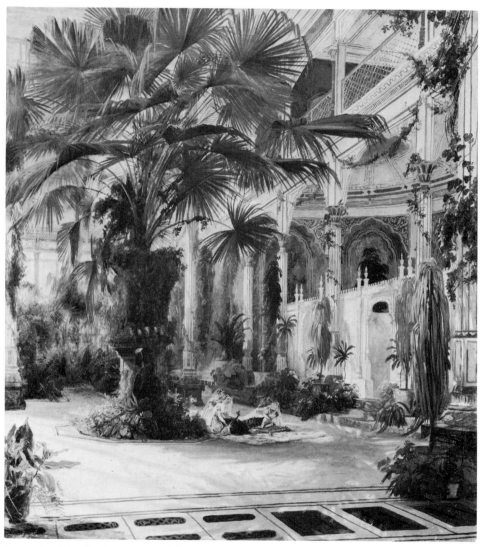

40.　*The 'Mughal' interior of the conservatory at Pfauinsel (Peacock Island), Berlin designed by Albert Schadow in 1829. This oil-painting of it by Karl Blechen of 1834, complete with European harem and palms evokes the languid atmosphere of India.*

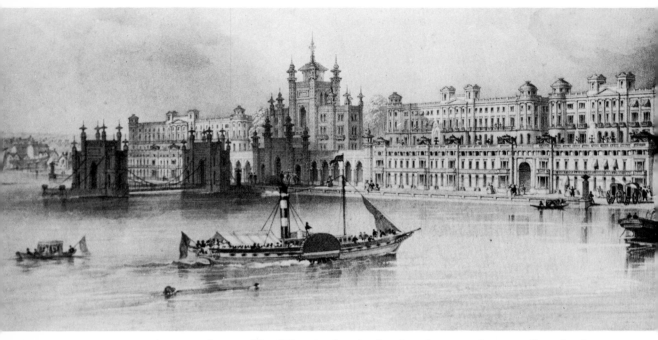

41. *'A General view of the Clifton Baths, pier, hotel and terrace, Gravesend' on the river Thames by A. H. Wilds, 1835. A more modest scheme was finally adopted which closely resembled the bathing ghats of Benares.*

seemed appropriate. It was not built in this grand form, and the final version was an Indian *ghat* like those in the sacred city of Benares: a mixture of domes, octagonal turrets and pillars derived from examples at Elephanta which led down to the banks of the sacred Thames.[50]

By the 1830s interest in the experiments at Brighton were to extend to Germany and the United States. Royal precedent for the eclectic style gave Queen Adelaide's brother, the Duke of Saxe-Meiningen the courage to consider an Indian style for his new villa. At the Queen's suggestion the architect Sir Jeffrey Wyatville who had prepared another potent symbol for George IV at Windsor, was asked to make drawings in 1836. Several versions were considered, classical and gothic. None satisfied the Duke. In July of the same year Wyatville made a drawing for an oriental design while staying with the Queen at Kew. Two Indian designs, one in 'Dlehi' (sic) style, the other 'Hurdwar' were presented for the Duke's inspection in 1837. For the details he may have consulted the ageing Thomas Daniell. Neither of the designs is 'pure Indian', both employ gothic and classical elements. The general impression of the 'Dlehi' (sic) elevation, with its gateway entrance and dome mounted on a platform, strongly recalls Sezincote. But, neither these designs nor one for an Indo-Chinese stable were put into effect, probably through lack of money

and the death of Wyatville in 1840. The fact that the Duke even considered an 'Indian' house at a time when it was still unusual was clearly intended as a tribute to the English Royal Family to whom he was related, to Brighton, and to the taste of George IV.[51]

The 'glittering and picturesque' effects of the pavilion were not lost on the imagination of another showman, the American circus owner P. T. Barnum. In 1846 he had visited Brighton and was 'greatly pleased with the Pavilion'. He thought it the only specimen of oriental architecture in England and thinking that the style had not been introduced into America decided to adopt it for his new house at Bridgeport, Connecticut. He had drawings of the pavilion made in London and upon his return to the United States in 1847 asked the young architect Leopold Eidlitz to prepare a similar design. The result was Iranistan – a fantastic display of verandahs, cusped arches and spectacular 'Mughal' domes **(42)**. There were stables, outbuildings and conservatories; the grounds were landscaped and appropriate furniture was made, 'regardless of expense'. He moved into the completed house In November 1848. Only a few years later, in 1857, it was completely destroyed by fire.[52]

The influence of English ideas was very potent in East Coast America from the eighteenth century onwards. However, it still comes as a surprise to find the Indian style being advocated in that country by an architect. In 1847 William H. Ranlett published *The Architect, a Series of Original Designs for Domestic and Ornamental Cottages and Villas . . . adapted to the United States.* Many of his ideas and the reasons for their adoption can be traced to the published works of Hodges, Repton, Aikin and even Ram Raz, all of whose works he could have seen at Ithiel Town's library in New York, the greatest architectural library in the United States. He was rather confused about the origins of Indian architecture but boldly declared it 'a pleasing and tasty style'. Its proportions were important

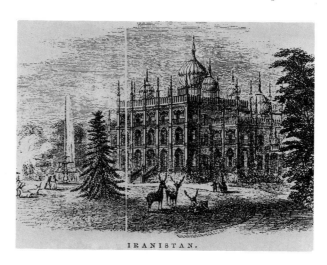

42. Iranistan, Connecticut, built for the American circus owner P. T. Barnum in 1847, modelled on Nash's Brighton Pavilion at Barnum's request by the American architect Leopold Eidlitz.

IRANISTAN.

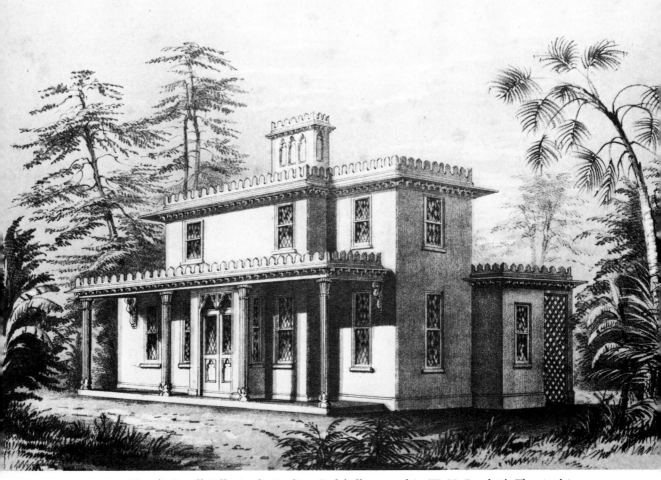

43. 'A Small Villa in the Indian Style' illustrated in W. H. Ranlett's The Architect, a Series of Original designs . . . adapted to the United States, 1847. It is an example of an American architect adapting English ideas and was built on Staten Island for Colonel Barrett.

and he quotes from Ram Raz 'woe to those who lived in houses that were not well proportioned'. The Indian style is economical to use (Repton), appropriate for plain edifices (Aikin), and appropriate for small cottages, villas and public buildings, (Aikin however excluded its use on public buildings). Ranlett's example was erected on Staten Island for Colonel N. Barrett **(43)**.

By 1845 Henry Austin was already using Indian details in his Tuscan villas.[53] ·Austin was a pupil of the famous architect Ithiel Town, whose library of 11,000 books and 25,000 prints was an outstanding reference source for East Coast architects. Here he could have seen Nash's views of the pavilion as well as Hodges's views of India and Repton's designs. For most of his career Austin worked in New Haven, Connecticut which, during the 1840s and 1850s was a

44. *Willis Bristol House, 584 Chapel Street, New Haven, Connecticut by Henry Austin, 1845. Austin has unashamedly borrowed ideas from Nash's Brighton Pavilion and added others of his own such as the elaborately bracketed wide overhanging eave, to dress-up a Tuscan villa.*

45. *Nelson Hotchkiss House, 607 Chapel Street, New Haven, Connecticut, attributed to Henry Austin, 1854. 'Indian' details abound on the porch, balcony and under the eaves. A very 'fancy' design enhanced by the two bays and originally, a roof balustrade.*

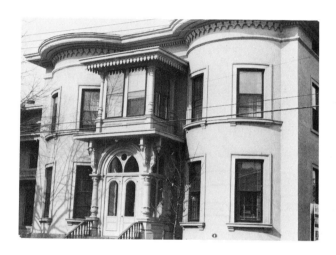

46. *A detail of the 'Ellora' columns on the verandah of a Tuscan villa, 478 Orange Street, New Haven, Connecticut. Designed by Henry Austin in 1866 it shows that even at this late date his interest in the use of 'Indian' details had not waned.*

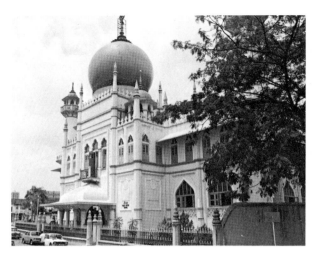

47. *Sultan Mosque,*
Singapore by the British
architects Swan and
Maclaren, 1921. Brighton
Pavilion has exercised a
greater power over the
architect's imagination than
any formal study of Indo-
Islamic design.

rapidly expanding town. Consequently there was a great demand for new houses and many other architects were building in the plain Tuscan style. In order to differentiate his designs from the others he very often included Indian features, as Aikin had done in 1808. This he did for decorative reasons rather than from any desire to create Indian associations. In this exotic style he found a way to expand his stylistic vocabulary, giving his designs distinction and relieving them of a 'contemptible plainness'.

Austin's first attempt at this new style took place in 1845 – the Willis Bristol house at 584 Chapel Street, part of a new development in New Haven **(44)**. The window designs and the details of the porch owe a debt to Nash's pavilion, as do other villa designs stretching over a period of more than twenty years. In scope they range from the simple addition of 'Ellora' columns on verandahs **(46)** to elaborate Mughal porches like that on the William Burke house, Rochester, New York,[54] and even to one (probably unbuilt) design which employed as its dominant feature a great Mughal gateway, pinnacles, recessed panelling, balconies, brackets and Nash windows. Austin's best known scheme is that for the railroad station at New Haven, a design replete with references to architecture from many sources: China, Tibet and Europe. Much less known is the one-storey 'Indian' railroad station which he designed in 1848 for Plainville, Connecticut when the line finally reached there.[55] In his early years Austin's fame rested upon a superb Egyptian pylon gate to the Grove Street Cemetery, New Haven and he later won praise for his striking gothic design of 1861 for New Haven's town hall, but in his obsessive use of Indian details he was at his most highly original.

Nash's pavilion continued to influence architecture throughout the nineteenth century and beyond, whether it was of the seaside pavilion variety in Nice or in Blackpool, Ostend or Staten Island, or Peacock Alley at the Waldorf-Astoria, New York where Cole Porter used to sing. In looking at the Sultan Mosque, Singapore which was designed by the British architects Swan

and Maclaren in 1921 it is much easier to perceive the influence of the Brighton Pavilion on the architect's imagination rather than that of any formal study of the Indo-Islamic style **(47)**. Of all these later examples there are none which exceed in audacity and skill the Château Vaissier at Tourcoing, near Lille, France **(48)**.[56] In an area where eclecticism was rampant during the 1880s and 1890s Château Vaissier was the largest and the most ambitious. It was designed in 1892 by Charles Dupire-Rozan for an eccentric soap manufacturer, Victor Vaissier. The original idea was to mount the whole structure on the backs of four elephants, but this was soon abandoned as impracticable! Colour played an important role; the exterior alternated red brick with stone and the dome and details of the balconies were in red and Indian yellow. It was a building that could be seen for miles. The inside was no less exotic, the rooms being in different colours; the salon was a rich blue, and another reception room dark green, the dining room red and 'grenat'. A grand staircase made in red marble led to the principal floor, the hall of which was encrusted with bronze sculptures and with Indian gods which clung to the cornices; the furniture, of ivory and ebony inlay, was suitably elaborate. Quite what the locals made of it one would dearly like to know. As the owner was a much-liked local figure it was all probably taken for granted. Its presence in one of the major industrial areas of northern France at least brought something of the magic of India to the lives of its inhabitants.

48. Château Vaissier, Tourcoing, France by Charles Dupire-Rozan, 1892. Built for a wealthy soap manufacturer called Victor Vaissier, with all the glamour and romance which the architect could conjure from a mixture of Bijapuri architecture and Brighton Pavilion.

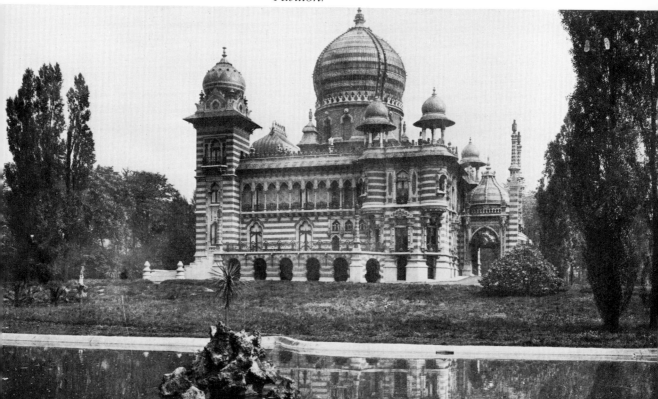

Other Sheep I have [1]

Since the eighteenth century Indians had been arriving in England for temporary residence. Some of these were merchants and emissaries. Others who came in search of employment as teachers of Persian or Hindi at the East India Company's college stayed longer. One such Indian, a Muslim, who came to England in 1799 with the hope of teaching Persian to Company servants was Mirza Abu Taleb Khan. His experiences have already been mentioned in a previous chapter. Two other, earlier, travellers both left written accounts of their experiences. The first was Mirza I'tisam al-Din, who visited Britain between 1766 and 1769 and a decade later composed *The Wondrous Book of England*.[2] The second of these travellers was an Indian Muslim, Munshi Isma'il who left Bengal in December 1771 in the hope of earning a fortune by teaching in England, but returned disappointed to India in 1773.[3] He also left an account of his visit. Sometimes Indian wives would accompany their English or European husbands back to Europe. One of these was Mrs Duccarol who lived in the European manner in London with her three children.

Hélène Bennet, the wife of the French General Benoît de Boigne, lived near Steyning, Sussex.[4] The Prince of Wales had an Indian masseur and hairdresser at Brighton called Sake Deen Mahomed who eventually eloped to Ireland with an Irish woman before returning once again to Brighton.[5] Hundreds of Indian seamen roamed the streets of the East End of London waiting for ships to take them back to India. None of these people left monuments or houses or Indian rooms behind them. It was only later in the nineteenth century that the sojourn of Indians in Britain was to result in monuments and houses and their appearance can be attributed to the increasingly formal relationship that had developed between India and England.

The most important example of this was the suite of rooms at Elveden Hall, Suffolk, commissioned by the dispossessed ruler of the Punjab, Maharajah Duleep Singh **(49)**.[6] Reputedly, Duleep Singh was the last son of the 'Lion of the Punjab' Maharajah Ranjit Singh, an ally of the British who was highly regarded for his firm rulership, manliness and roguish good looks. Unfortunately his death in 1839 resulted in factional fighting amongst his family which eventually led to a Sikh uprising. The British put down the rebellion and removed Duleep Singh from the throne in 1848, a position he had assumed in 1843 at the age of five. His lands were illegally confiscated and the Punjab annexed. Duleep Singh was pensioned off by the East India Company and placed under the tutorship of

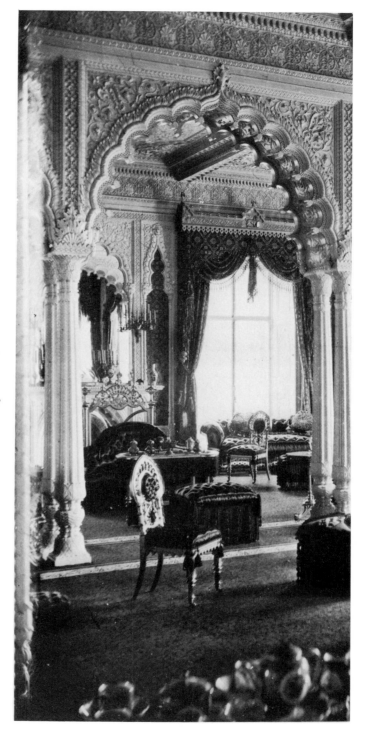

49.	Maharajah Duleep Singh's drawing room at Elveden Hall, Suffolk, c. 1875. The elaborate Indian interior was designed by John Norton who copied the details from buildings in Lahore and Rajasthan.

Sir John Login to whom he remained devotedly attached all his life. Under Login's assiduous guidance Duleep Singh was eventually baptised a Christian at Fatehghur in 1853. Subsequently the Maharajah requested permission to go to England to see for himself what the country he had been told so much about was like. The Governors of India, always fearful that while Duleep Singh remained in India he would become the focus for another uprising among the Sikhs, were only too happy to grant him permission.

Duleep Singh arrived in England in the summer of 1854 and was immediately taken into the maternal care of Queen Victoria. She felt sorry for him, fearing among other things that he would suffer from the cold English climate. She became quite entranced by the handsome, exotic individual who, when dressed in his Sikh costume, appeared as if from the pages of the Arabian Nights and she arranged for him to be painted by her favourite artist Winterhalter. Her affection and concern for the welfare of the young Maharajah was typical of the care she openly displayed for Indians, which the mutiny of 1857 did nothing to quell. Rather, it increased her personal sense of responsibility and impartiality and revealed her obvious lack of racial prejudice. This became evident in the proclamation which was issued in 1858 at the end of the mutiny. While many people, from cabinet ministers to members of the general public, were screaming for revenge, she refrained from any retributive remarks, adamantly refusing to sign a first draft which referred to the powers she could have for undermining the religions and customs of the people of India. Instead, she pledged conciliation, generosity, benevolence and religious toleration, while also offering the benefits of modern technology such as the construction of railways and canals to relieve the burden of poverty. From this time onward she rarely appeared in public without at least two Indian attendants.[7] There is no doubting the fact that Duleep Singh benefited from her concern and patronage, a concern which prevailed even when in his later years he rebelled against his westernized upbringing and recklessly flaunted his claims to the Punjab. She protected him from his fiercest critics and she was later to do the same for Abdul Karim, her mischievous Indian secretary.

In due course the Maharajah developed a conspicuous love of country sports, especially shooting. He bought Hatherop Castle in Gloucestershire and rented grandiose estates in Scotland expressly for this purpose. He became a favourite with Queen Victoria's children and was frequently sketched by her. When Edward, Prince of Wales, a keen sportsman and gambler, bought Sandringham, Norfolk, in 1863 it was therefore not at all surprising that the Maharajah, as one of the Prince's Marlborough House set, would follow. Thus Elveden Hall on the Suffolk/Norfolk border was bought for £105,000 in 1863. It was to be the future home for himself and his intended bride Bamba Müller, a half-Abyssinian, half-German girl from Egypt whom he married in the same year. This year, also, his mother Rani Jindan Kour died in London and he took her

body back to India for cremation, this being only the second visit he had made to India since leaving in 1854.[8]

Elveden was a plain Georgian house which was converted for the bride and bridegroom's use while the couple were on their honeymoon in Egypt and Scotland. They took up residence in 1864. There is nothing to suggest that much building was undertaken until 1869. According to *The Builder* for 18 November 1871 it was in 1869 that the architect John Norton was commissioned by the Maharajah to add a wing to the existing building. Before this could be completed it was decided to demolish everything except two rooms and begin again. The result was an Italianate, E-shaped, red brick building with Ancaster stone dressings; very solid, respectable and dull. To all outward appearances Duleep Singh's house conformed to the prevailing fashion, only the Indian 'minaret' water tower, and a domed pavilion in the garden enlivened the estate.[9]

In his heart this tragic figure who was forced to wander through two worlds was a Sikh – a fact which outer propriety and stone dressings could not conceal, but which was clearly expressed inside the building. For John Norton had been 'instructed to decorate the interior with pure Indian ornament',[10] a request which was fulfilled with evident enthusiasm. The ornamentation derived from the palaces of Rajasthan, Delhi and Lahore, was carried out with the aid of 'careful models prepared by the builders W. Cubitt & Co., the study of Bourne's photographs, objects in the India Museum, and details obtained from a collection of native water-colour drawings, brought by the prince from Lahore and elsewhere'.

Once through the portico the visitor entered another world, the Indian design of the etched-glass lobby heralded a decorative scheme of considerable ingenuity and imagination. Unlike earlier essays in the Indian style by such people as Repton and Nash, at Elveden there is not the slightest hint of frivolity or parody. In their place there is an unexpected sincerity and elegance, the product of a serious investigation of Indian forms. There were many other unusual features noted in *The Builder* including 'ceilings and wall panelling of most minute and elaborate Indian design, together with marble fireplaces, marble inlay and encaustic tiles by Maw & Co'. Only the princess's boudoir remained immune to the Indian scheme being designed in a 'French Renaissance style'. By 1871 the house was still unfinished, *The Builder* announced that the decorator was still painting and gilding the hall and other rooms. Much use was made of colour, the cast iron stair railings were bright red and elsewhere coloured cements were used. Mirrors were frequently used and an English firm experimented with an Indian technique of silvering convex glass which was used on the ceilings. In the library gold Indian shawls hung on the walls, and textiles were also employed in the drawing room. Unlike later 'Indian' schemes such as that at Bagshot Park, all the details were made in plaster rather than in carved wood specially imported from the Punjab. Messrs. Jackson

and Co. who made all the plaster casts for Elveden were later employed at Osborne. As can be seen from the photograph of the 1870s **(49)** the furnishings consisted mainly of sofas and ottomans. No Anglo-Indian furniture seems to have been bought although there were six very extraordinary Bugatti-esque upholstered chairs with 'peacock' backs.

Duleep Singh spent £30,000 on rebuilding Elveden. In its original condition, and some of it still remains, it must have been astounding. Owing nothing to mounting interest in Indian arts and crafts and architecture and exerting no discernible influence elsewhere (except on a later owner of Elveden), Elveden remains an isolated, melancholy reminder of the life of a Maharajah who desperately sought his roots at a time when many Indians were beginning to lose theirs.[11]

Elveden is an intensely personal house and a curiously isolated example. Despite the growing numbers of Indians who came to England after 1857 there

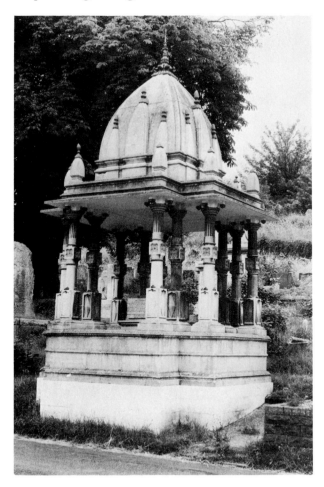

50. *The tomb of Raja Ram Mohun Roy, Arnos Vale Cemetery, Bristol. This celebrated scholar and philosopher died in 1833 while on a visit to England. The monument, designed with great care by William Haldimand Prinsep, is a tribute to the esteem in which he was held by his Indian and English friends.*

is surprisingly little evidence that they directly influenced fashion or taste. However, European sojourns and a growing sympathy for the cultural values of the West did result in some surprising additions to the urban and rural environment. The earliest, and in many ways the most delightful of these, is the monument erected in 1842 at the expense of Dwarkanath Tagore, to the memory of Raja Ram Mohun Roy **(50)**. Roy was a scholar and a social and religious reformer who was never less than controversial among both the Hindu and Christian communities of Bengal. His ideas concerning the unity of all religions and his advocacy of the banning of *suttee* caused him to have many admirers in England. In 1831 he arrived in England as an envoy of the Emperor Akbar II, but after visiting Paris he died in Bristol while staying with some friends in 1833. A carved stone slab temporarily marked his grave in Stapleton Grove. When his friend Dwarkanath Tagore came to England nearly ten years later he funded a more imposing monument for Arnos Vale Cemetery. It was designed in 1842 by the talented amateur artist and East India merchant, William Haldimand Prinsep, probably a friend of Roy from his Calcutta days.[12] Prinsep designed a simple *chattris* with considerable thought for details which were effectively carved by a Bristol mason. It was the first use in Britain of the Indian style to symbolise an Indian's association with India. With its haunting *sikhara* and golden sandstone colouring, its all pervasive modesty is as quiet and as noble as any village *mandapam*, or wayside shrine in India.

Two other monuments to Indians who died abroad are worth mentioning, one in London, the other in Italy. The earlier of the two is to an otherwise unknown Indian called in the Kensal Green Cemetery register 'Daboda Dawajee' who was buried in London in 1861 **(51)**. The monument over his tomb is a carved pillar five feet high on a square base, surmounted by a lotus. The base is carved with tile designs while the pillar has scroll-work, and columns which rise to the top, which is square. Each face of this contains three panels with holes. Carved in red sandstone it is exceptionally finely worked and the design leaves one wondering who could have conceived and executed such a curious monument.

More flamboyant than Daboda Dawajee's monument is that erected in the Cascine Gardens, Florence to the memory of Prince Rajaram Chattrapati, the Maharajah of Kolhapur's heir. While on a tour of Europe the young prince arrived in Florence in 1870 with a large retinue but died suddenly on 29 November. His body was cremated on the banks of the Arno, a scene which caused tremendous excitement among the Florentines.[13] A few years later Major Charles Mant of the Royal Engineers designed an appropriate monument **(52)**. It is a pavilion resting upon an intricately carved base around which are two sets of cast railings. On the base there are inscriptions in Italian and Sanskrit and beneath the curvilinear dome is a bust of the prince by the sculptor G. F. Fuller. The monument was completed in 1876 and inaugurated on 7 June of the

same year. Mant was one of the first of a new breed of engineer architects who became absorbed in the study of Indian architecture. After arriving in India in 1859 he designed the High School at Surat and the Town Hall of Kolhapur, also

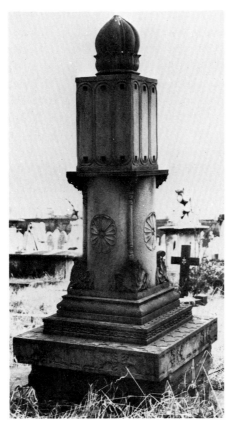

51. A memorial pillar to Daboda Dawajee, an otherwise unknown Indian, who died in London in 1861. It is beautifully designed and carved in red sandstone by an unknown craftsman and is situated in the Kensal Green Cemetery, London, not far from the tomb of the renowned merchant Dwarkanath Tagore.

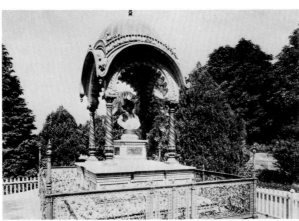

52. A remarkable monument in the Cascine Gardens, Florence dedicated to the memory of Prince Rajaram Chattrapati of Kolhapur who died in Florence in 1870. It was designed by Major Charles Mant, who had worked for the Kolhapur family in India and was completed by 1876. The monument is essentially an 'Indian' version of the Albert Memorial, London.

53. *The 'Indian well' at Stoke Row, Oxfordshire presented as a gift from the Maharajah of Benares so that the people of the village could have an easily available supply of water. Gardens 'after the Indian manner' once existed adjacent to the well. Today, the well is a focus for an international friendship between the people of the village and the present Maharajah of Benares.*

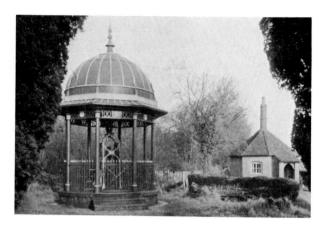

54. *24 Palace Gardens, Kensington, London. The original house was designed in Moorish style by Owen Jones in 1845. The 'Delhi' domes on the roof were added later in the nineteenth century when it became the London residence of the Maharajah of Baroda.*

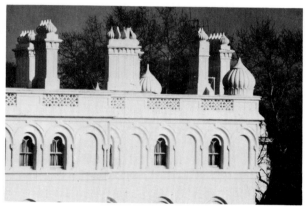

palaces for the Maharajahs of Kolhapur, Baroda and Darbhanga but he died in 1881 before any of them were completed.[14]

By far the most fascinating of the Indian monuments erected in Europe at this time is that presented to the people of Stoke Row, Oxfordshire by the Maharajah of Benares – a village pump **(53)**. This is no ordinary pump for it was established by the Maharajah as a gift to the people of the village so that they might have a free and easily available water supply. It also celebrates the esteem in which he held the people of England, and an old friend Edward Reade of nearby Ipsden House, a one-time Lieutenant-Governor of the North Western Provinces of India. Work began on 10 March 1863, the same day as the marriage of the Prince of Wales. A well was sunk to a depth of more than 300 feet and a superstructure raised 'purposely oriental in design, to, certify its origin to the spectator'.[15] Reade wrote later that since public wells in India had fruit plantations attached to them it was decided to purchase an adjoining orchard. This was done and the fruit sold to subsidise the cost of the well. The rest of the land was turned into a pleasure ground for the village. A pond was dug in the shape

of a fish and called 'Muchlee Pokhra' (fish-shaped pond) a mound (later a bandstand) was raised and named 'Prubhoo Teela' (raised mound), a shady ravine was dug and planted and called 'Saya Khoond' (shady well). The orchard was called 'Ishree Bagh' (Ishree's garden) after the name of the Maharajah. It was by far the most elaborately Indian pleasure garden in England. The well still survives, although disused, and the gardens are overgrown, but a bond was created between Benares and the Chiltern village which actively persists to the present time.[16]

Post-Mutiny years saw a change in policy towards the princes and maharajahs. Hitherto they had been ill-treated by the British but the mutiny forced a reconsideration of policy and they were now seen as possible allies in the re-building of a new country. They were encouraged to study modern methods of administration and to build schools and colleges for the local people. Their armies were now trained in the European manner, and their help sought for the construction of railways and the general improvement of communications. This educative process was to be enhanced by contact with Europe. Many maharajah's had houses in England but only one of these had any Indian allusions in its architecture. This was the house of the Maharajah of Baroda who leased from the Crown Agents Owen Jones's Moorish 24 Palace Gardens, Kensington **(54)**. To this already extraordinary building he added some plump 'Delhi' domes towards the end of the century.[17]

In 1876 Benjamin Disraeli suggested that the Queen should not be merely monarch of Great Britain and her colonies, but should include in her title that of Empress of India. She was only able to claim this title because the old Mughal Emperor Bahadur Shah II had died in 1862 after being sent into exile to Rangoon at the end of the Mutiny. The Queen greeted Disraeli's idea with immediate enthusiasm and she was proclaimed Empress of India in 1876. The famous Delhi Durbar took place the following year. It would be all too easy to suggest that she relished the new title and the power it gave her, simply to satisfy the imperial ideal. The truth is always more complicated; no other colony was granted this degree of recognition, no other colony attracted her own deep and emotional feelings. Could it be that she had succumbed to the legend of a mysterious India. Is this why she was so protective of Duleep Singh and the other Indians in her household? Or did she see herself as the maternal shepherd of sheep of a different fold?

Imperial Sentiment and Anglo-Indian Architecture

British military success in India during the latter half of the eighteenth century and the increasingly active involvement in her affairs by the growing contingent of East India Company officials, favoured the expansion of principal towns such as Madras and Calcutta. As they grew so they took on a neo-Palladian appearance. The gleaming white colonnaded façades of the Palladian buildings in the important thoroughfares of Calcutta and along the seafront at Madras reminded visitors of the Mediterranean and the architecture of ancient Greece and Rome. With some modifications to accommodate the hot climate, neo-Classical styles had found their most appropriate environment. However, one critic of Palladianism in India, Lord Valentia, travelling in India and Ceylon between 1802 and 1806 felt that the high porticos and unshielded loggias allowed too much direct sunlight into the rooms, and too much rain in the monsoon season. He thought a local style such as 'the more confined Hindoo [i.e. the Mughal] or Gothic architecture would surely be preferable'.[1] This attitude was rare. In fact some Europeans, like Thomas Metcalfe at Delhi, did take to living in deserted Islamic tombs, and others had half-European, half-Indian houses built. Major General Claud Martin had such a palace at Najafghar, as well as a monumental house called *Constantia* at Lucknow.[2]

Gothic architecture was introduced relatively late into India but made more headway after the 1813 Act of Parliament which permitted Christian missionaries to enter India for the first time. They had always been excluded by the East India Company because it was feared that their aggressive evangelism would antagonise the Indians and disrupt peaceful trade. Gradually gothic churches were erected in Calcutta and elsewhere and homesick Europeans could find some solace in their Christian pointed arches and spires. To the Indian their presence was a visible reminder of foreign domination. As late as the 1830s, houses in the gothic style were still a rarity, although there were examples in Delhi and Khatmandu.[3] In India architectural styles tended to be introduced at least a generation or more after their appearance in England.

Very few civil architects were employed by the East India Company in India, the names of some are known, like Edward Tiretta of Calcutta and Philip Stowey of Madras, but European buildings were mostly designed and built by the

Company's military engineers.[4] The engineer's multifarious activities included building houses, bridges, roads and fortifications. He would not have been a trained architect and he relied upon plans in pattern books sent from England which he would then adapt to local conditions. In this way the engineer gave Indian colonial buildings a distinctive character. As the years passed India attracted very few properly trained architects and architecture remained the preserve of the engineer. From the 1840s onwards their lack of stylish expertise incurred the vilification of critics at home who demanded an architecture worthy of an imperial power.

During the period following the end of the 1857 Mutiny there developed a deep division of opinion between those who favoured the European styles as a means of inspiring the 'natives' with awe and reminding them of British supremacy, and those who wished to introduce a mixed Anglo-Indian style. The former was the opinion held by the engineers in the Public Works Department and the latter was that of a new generation of trained architects and a few forward-looking engineers. The architects who began to arrive in India at the

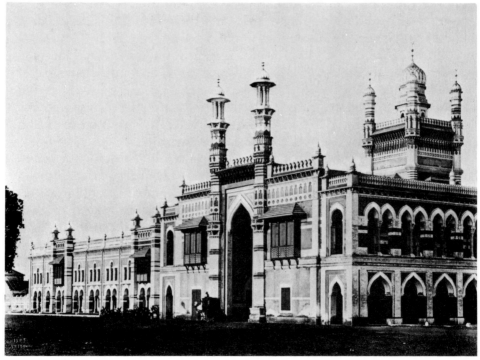

55. Board of Revenue Offices, formerly Chepauk Palace, Madras by Robert F. Chisholm and built during the 1870s. One of the most important of the buildings erected in an Anglo-Indian style by British architects. A well-conceived 'Indian' design with discernible traces of classical and gothic elements.

end of the 1850s and the beginning of the 1860s had been trained in England at a time when Indian craft traditions had won the respect of some of the most influential critics of the day. Under these circumstances it is not surprising to find the introduction of stylistic reconciliation and respect for local traditions.

Two architects in particular paved the way for this mixed style, they were Robert Chisholm and Major Charles Mant of the Royal Engineers. Chisholm in Madras and Mant in Western India came to realise that nothing could be achieved in India without taking into account the Indian craftsmen who were to work on their buildings. Indeed, they both realised that there was only one style available to them in India: that determined by the craftsmen themselves. They had a language of their own which was wholly alien to Western traditions, 'for this reason', wrote Chisholm 'an architect practising in India should unhesitatingly elect to practise in the native styles of art – indeed, the natural art-expression of these men is the only art to be obtained in the country'.[5] Chisholm became Head of the School of Art at Madras and Consulting Architect to the Government of Madras throughout the 1870s. During this time he designed the Egmore railway station, the Post Office, the Senate House of the University, the Board of Revenue Offices **(55)** and many other private and public buildings. After Mant's death in 1881 he took over his work at Baroda. Although he used Indian elements in his designs Chisholm was not an unqualified admirer of Indian crafts and disagreed with those who, like George Birdwood, thought that anything Indian was necessarily a shining example to the West. He did indicate however that if Indian sentiment were to be taken into account aesthetic compromise was not only necessary but the only way forward.

Major Mant was a highly-wrought individual who arrived in India in 1859 and throughout the next twenty years designed an enormous number of private and public buildings **(56)**.[6] He died of apoplexy fearing that an Indian palace he had designed would fall down. Unlike Chisholm, Mant's designs afforded more opportunities for Indian decoration. According to the architect René Phene Spiers who came to know Mant well while the latter was on leave in London in 1874, it was Mant's habit to draw the plans and elevations and leave all the details of embellishment to his Indian draughtsmen. Consequently, Mant's buildings are alive with authentic Indian details which perfectly suit their picturesque outlines. Spiers was of the opinion that if more people in India followed Mant's example 'they might be able to produce a style of which the century might be proud'[7]. By comparison with Mant's work Chisholm's is less concerned with intricate details than with strong, clearly articulated elevations, often embodying a sublimated gothicism which finds expression in a predilection for strong verticals.

Not many followed the lead given by Chisholm and Mant, and by far the greater majority of architects and engineers produced buildings in European styles adapted to the climate. But another contemporary of Chisholm and Mant,

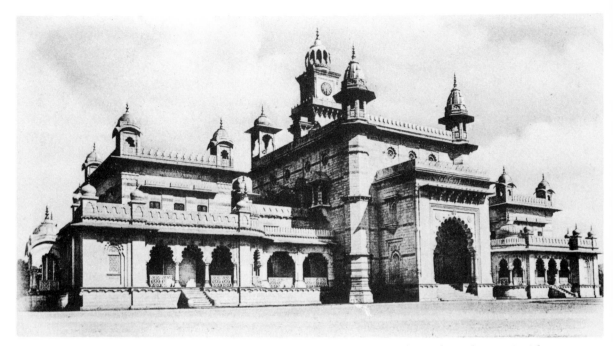

56. *Mayo College, Ajmer a good example of Major Mant's work in the 1870s. The decorative scheme was worked out in conjunction with Indian craftsmen.*

Colonel Swinton Jacob (later knighted) had a long and distinguished career based upon similar ideas **(57)**. In 1867 he became Superintending Engineer at Jaipur, a post he was to occupy with a few breaks for more than thirty years. Throughout his long career he designed churches, colleges and public buildings in various parts of India, and his ability to combine in an elegant way the best of European conveniences with Indian elements made him much sought after by Indian Maharajahs.[8] With the help of a number of Indian draughtsmen he compiled a digest of the architecture of Delhi, Agra and Rajasthan which was published in nine parts from 1890 as *Jeypore Portfolios of Architectural Details.*

Another important figure was F. S. Growse of the Bengal Civil Service who was a District Officer not an architect or an engineer. Firstly at Mirzapur and then at Bulandshahr from 1878 to 1884 he initiated changes to the local architecture **(58)**. This he did, not by making designs, but by giving the merest outline to the local *mistri* and leaving everything else in their capable hands. In this way schools, houses, bazaars, garden buildings, mosques and bathing *ghats* were erected in a traditional manner occasionally bearing the impress of a European idea. Growse encountered an extraordinary amount of opposition both from anglicised Indians and the obdurate engineers of the Public Works Department. When his book *Bulandshahr: or sketches of an Indian District . . .*

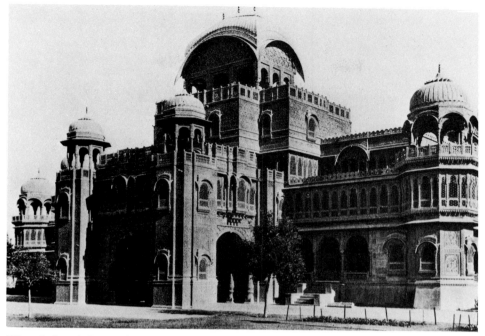

57. *Colonel Samuel Swinton Jacob's palace for the Maharajah of Bikaner built during the 1890s and displaying a characteristically sympathetic synthesis of Eastern and Western forms.*

was published in November 1884 in which he fervently attacked official policy in the area towards his schemes, he was promptly removed to another post 300 miles away, thus leaving his life's work unfinished.[9] In spite of this official attitude to his work he was greatly praised by John Lockwood Kipling at Lahore, who reproduced some of the Bulandshahr buildings in volume one of his *Journal of Indian Art and Industry*. In London also Sir Caspar Purdon Clarke of the South Kensington Museum thought that if anyone ever doubted that the wonders of Indian architecture could be emulated in modern times they should visit the cities of Khurja and Bulandshahr.[10] However, there seem not to have been any imitators.

By the time Sir Caspar Purdon Clarke gave his lecture on Indian architecture to the Royal Institute of British Architecture in 1888, sufficient buildings in the mixed Anglo-Indian style had been erected for him to give warm praise to the effects of these pioneers. He congratulated the architects on persuading European officials and Indians to adopt what was thought of as a more traditional style of architecture. He especially praised the work of Growse, the college buildings in Ajmer by Mant, Colonel Jacob's People's Palace at Jaipur, the work of Mant and Chisholm at Baroda, and the public buildings at Madras. They clearly demonstrated to him 'how much can be done where Indian and

77

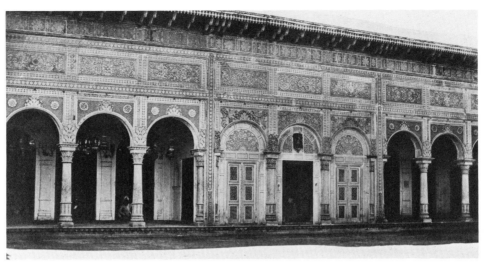

58. *Lala Janaki Prasad's House, Khurja in the district of Bulandshahr from F. S. Growse's* Indian Architecture of Today *1886. Growse stimulated Indian craftsmen to re-discover their traditional crafts and designs which they would happily combine with Western elements if the opportunity arose. Here can be seen a mixture of Renaissance and Mughal features in a building designed by a Brahmin called Dhula.*

59. *A view of Government House, New Delhi designed by Sir Edwin Lutyens, a convinced classicist, who, under political pressure was forced to incorporate Indian details. Especially imaginative is the use of a Buddhist* stupa *and rail in place of a classical dome.*

European work together'.[11] Clarke felt that the adoption of these styles of architecture in the latter portion of the nineteenth century would go 'far to atone for the atrocities in architecture which had been perpetuated all over the country during the past 150 years'.[12] In reality these 'traditional styles' were not traditional at all, but a synthesis of styles which had created an entirely new mixed style of architecture – the Imperial Anglo-Indian. It was used not only by Indian princes eager for Western technology without visibly forfeiting their Indian allegiance but also by the British who by its use acknowledged their Indian territories. With time, Clarke thought, these buildings would all be regarded as much as 'monuments of our rule as the magnificent Gothic edifices with which the Government and the Municipality of Bombay have adorned the Western Capital of India'.[13]

As the century progressed and a new one dawned the aforementioned ideas steadily gathered momentum and they did so at a rate directly proportionate to the awakening nationalism of Indians and sympathetic Europeans. In 1911 when plans were under discussion for building a new Indian capital at New Delhi political considerations were paramount. The Viceroy Lord Hardinge insisted that any design would have to take into account Indian sentiment, which in effect meant that the architect would have to mix Eastern and Western styles.[14] The architect, Edwin Lutyens, felt this imposition as an artistic catastrophe, his associate architect, Herbert Baker, felt it to a lesser extent. For Lutyens it was much more than a compromise of his personal standards, he resented employing Indian architectural elements especially as he felt that Indian architecture had no redeeming qualities. Sir Samuel Swinton Jacob (knighted in 1902) was brought out of retirement to advise the two architects on Indian architecture but Lutyens had nothing but contempt for either the work of Jacob or of Chisholm at Madras. Whatever Lutyens thought about this state of affairs was irrelevant since he was in no position to dictate his stylistic preferences to those in power, and in any case he was desperate to have the commission. The King-Emperor, who hoped that New Delhi would be in the Mughal style, thought it would provide 'a splendid opportunity' to encourage Indian craftsmen. With all its artistic and political implications, Lutyens's New Delhi scheme marks the end of a line of development begun in the 1850s. It is the apotheosis of the Anglo-Indian imperial style which also provides an enduring monument to Indian craftsmanship **(59)**.

Imperial Anglo-Indian architecture could not have developed had there not been an increasing number of publications about Indian architecture. Certainly in the years immediately following the Mutiny few publications had appeared and Indian architecture continued to be seen through the eyes of Thomas and William Daniell. Owen Jones had realised this in the early 1850s. When Major Mant needed to have details of Indian buildings for his own work in the 1860s he had to visit the famous temples and palaces himself and make detailed

drawings and take photographs. This state of affairs was largely the result of the East India Company's apathetic attitude toward the antiquities of India. In 1834 Ram Raz's *Essay on the Architecture of the Hindus* was published by the Royal Asiatic Society and although it was admired by William Wilkins, Charles R. Cockerell and Sir John Soane it made no impression on later architects because all the illustrations were of the 'monstrous' forms of Hindu temple architecture of the south.[15] In 1844 the Royal Asiatic Society had requested that the Company should have the monuments of India properly documented. This stimulated a sporadic and unco-ordinated response from individuals but did not result in official survey work. Eventually in 1870 the Archaeological Survey of India was created and the engineer Colonel Alexander Cunningham was appointed Director-General. It was still only a temporary position and it was the Viceroy Robert Lytton who finally succeeded in establishing a permanent post of Curator of Ancient Monuments in 1881.

The advent of the camera in India revolutionised the recording of Indian architecture and antiquities. Drawings had always been treated with a degree of scepticism because of the long-appreciated effect the artistic imagination had on the way material was portrayed. Hodges's *Views of India* were heavily criticised for this reason. The veracity of the photographic image was unquestioned and it largely ousted paintings and drawings as a means of communicating information. Samuel Bourne was the most famous of the photographers who went to India. He arrived there in 1863 and stayed for seven years. During this time he photographed most of the important Mughal monuments of Delhi, Agra, Lahore and Kashmir. Through exhibitions of his work at the Dublin International Exhibition of 1865, the Paris Universal Exhibition of 1867 and elsewhere, he acquired something of an international reputation. Each plate was numbered and copies of his work could be purchased in London from a catalogue which Bourne and Shepherd produced. Bourne's photographs are known to have influenced John Norton's designs for Elveden Hall.

Books on Indian architecture also began to appear. In 1867 James Fergusson's *On the Study of Indian Architecture* was published and was followed a few years later by his *History of Indian and Eastern Architecture* (1876). While they accomplished a good deal in introducing an hitherto almost unknown subject, the illustrations were not detailed enough for the use of architects.[16] Photographs were important as illustrative material but they could not replace measured drawings and it was only from the 1860s onwards that books using both forms of illustration became available. Lieutenant Henry Cole of the Royal Engineers published two important volumes which were the product of his own survey work: *Illustrations of Ancient Buildings in Kashmir* (1869) and *Illustrations of Buildings near Muttra and Agra* (1873). They both contained photographs, plans and some line engravings and became an important source

for the study of the Indo-Saracenic style which was derived from the combination of Hindu and Muslim architecture. The most famous example of this is to be found at Fatehpur Sikri, built in the late sixteenth century. Like the Anglo-Indian style of the nineteenth century it too had been the product of Indian craftsmen working on an imported style. Cole had plaster casts made of many of the important details of Mughal architecture which he surveyed and they were sent back to the South Kensington Museum and erected under his supervision in the plaster court in 1872. Hence there was established an important consultative source for architects in England. Other important publications to appear were James Burgess's *Reports* for the Archaeological Survey of Western India, Colonel Swinton Jacob's *Jeypore Portfolios* (1890) and Edmund W. Smith's four volume *Survey of Fatehpur Sickri* (1895–98).

Of these, Jacob's *Jeypore Portfolios* were the most important since they were

60. *One of a suite of 'Indian rooms' at the Hotel Cecil, London designed by Joseph Perry in 1891. The massive 'Mughal' columns were encased in polychrome tiles by Doulton & Co.*

the first publications to be produced 'in such a shape as to be of practical use to the architect and the artizan' (sic).[17] The details which were taken from buildings in Delhi, Agra and Rajasthan were published in large format so that they could be used as 'working drawings'. Six volumes were published in London under the auspices of the Maharajah of Jaipur in 1890 and three more followed in 1894 and 1898. They were well received by *The Building News* in London and commended to schools of art and 'students of applied ornament who will do well to acquire access to these portfolios of Indian ornament, for the simple reason that they present an almost endless variety of suggestive detail adaptable for modern uses . . .'[18] The first six parts provided illustrations of copings and bases, pillars, carved doors, brackets, arches and balustrades. The very fine details of the columns, capitals, bases and arches in the Indian rooms of Joseph Perry's Hotel Cecil in London designed in 1891 seem to have been drawn directly from these sources **(60)**. Other details of the rooms, the walls, ceiling decoration and the cornices which fall outside the scope of the portfolios published in 1890 are comparatively poor and unauthentic.[19]

The new Imperial Anglo-Indian style received praise in India and Britain, but national self-consciousness precluded its use for official architecture in Britain. In the late eighteenth century when the East India Company was contemplating proposals for a new building in Leadenhall Street the use of an 'Asiatic style' was rejected unequivocally as being undignified for a building in the City of London, in spite of the precedent created by George Dance in his Guildhall reconstruction. This view persisted throughout the nineteenth century but it did not deter the architect and historian James Fergusson from submitting a brave design which included Indian domes for the Government Offices competition of 1856.[20] Needless to say it was rejected.

Gilbert Scott's gothic design for the Government offices project was selected despite the fact that it had been awarded second prize and that gothic was generally considered entirely inappropriate. However the Commissioner of Public Works had always reserved the right not to employ the prizewinner. This highly prejudiced choice became the subject of an acrimonious dispute in Parliament. The Prime Minister Viscount Palmerston loathed Scott's design and had nothing but contempt for those who thought 'Barbaric' Gothic 'the national style suited to Teutonic nationalities'. Palmerston preferred the civilised values of the Italianate style. In pressing his claim he facetiously remarked that if the theory of nationalities was 'to be carried out in our public buildings, the noble Lord the Secretary for India, in building his new office, should be lodged in a pagoda or a taj-mahal',[21] for which it would be necessary to bring an architect from India. A proposal for a new India Office had been included in the scheme in 1858. Palmerston's insistent view eventually prevailed. For this reason Indian features found no place in the India Office project either in the revised Italianate exterior by Scott or in the interiors by Matthew Digby Wyatt, the India Office's Surveyor.

In 1887 any hint of Indian forms was again excluded from a building whose avowed aims were to 'represent the Arts, Manufactures and Commerce of the Queen's Colonial and Indian Empire'. This was a reference to a project which later materialised as the Imperial Institute at South Kensington. The Prince of Wales was one of the Institute's leading protagonists and the original idea was to build an Empire Museum. This concept was modified to include the modern manufactures and anthropology of each country as well as their arts. It was also hoped to expound the virtues of Victorian achievements so encouraging people to emigrate to the colonies, increase trade and provide a point of unification to a disparate Empire. The Indian Empire was always considered a separate, special entity which the Queen honoured with an imperial title but Thomas Collcutt's prize-winning design introduced no overt references to India among the assemblage of Segovian tower, gables and Tudric cupolas. It was left to the interior designer J. D. Crace (whose father had decorated the Brighton Pavilion for the Prince Regent) to give its Indian room a hint of exoticism. The cross-breeding of Indian and Western architecture had become acceptable, even laudable, in India for official buildings but in Britain it remained *stylus non gratus*.

Occasionally, some architects who returned to Britain found that their Indian experiences could be applied to commissions to advantage. While Major Mant was in England in 1874–5 he designed the Prince of Kolhapur's monument which was erected in the Cascine Gardens in Florence in 1876 – probably the only design he executed in the West. Another officer, the erratic and eccentric Lieutenant Henry Cole, who worked in Mant's office in 1874 also drew upon his Indian knowledge while in Britain. His father, Sir Henry Cole, was Director of the South Kensington Museum and in about 1872 Lieutenant Cole designed a grand house for him at Witley, Surrey.[22] One of its features was very curious indeed. It was an underwater room built on the lake-bed and approached through a tunnel. One wonders if he had got the idea from the underground *tykhanas* in India, especially that dug out of the river bed at Thomas Metcalfe's house on the river Jumna. *Tykhanas* were used by people in the hot season to keep cool and they sometimes extended to a suite of underground rooms. Not, one would think, very necessary in temperate Surrey. Obviously the Coles had suffered a severe attack of whimsy. The construction of the house proved to be so expensive that it had to be sold to pay the costs. Not daunted by this humiliation Lieutenant Cole began work on another scheme, in consultation with his father.

The project was a building for the National Training School for Music (later the Royal College of Music **(61)**, now occupied by the Royal College of Organists) to be situated in Kensington Gore next to the Royal Albert Hall. In his design he felt that Indian details could be usefully combined with a dash of the fashionable Queen Anne style. The result is an unusual street elevation

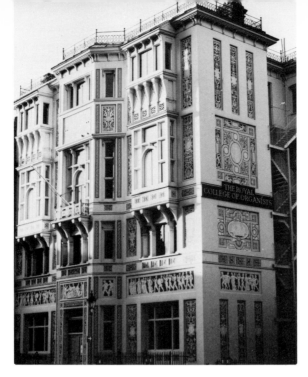

61. *National Training School for Music (now Royal College of Organists) 1874, by Lieutenant Henry Cole of the Royal Engineers who included 'Indian' bays, and a* chujja *in his design. On the roof (out of sight) is a ventilator cover in the shape of a* howdah!

dominated by three bays, two of which are supported on curved brackets and twice break forward at third and fourth floor level. There is an unmistakable hint here of the Indian bays on merchant houses found in the Ahmedabad area. The roofline is clearly a *chujja* topped by an elegant arabesque balustrade. On the roof there is an extraordinary ventilator cover in the shape of a *howdah*! The sgraffito panels were added in 1878 by F. W. Moody. The main elevation contrasts strongly, as it was intended to, with the ample girth of the Royal Albert Hall across the road. It was finished in 1875 and formally opened by the Prince of Wales in May of the following year by which time Cole had arrived back in India.

At the request of the new Viceroy Robert Lytton, Cole prepared designs for the Viceregal Lodge at Simla. Cole was very much part of Lytton's set at Simla where many people became infected with the Viceroy's immense energy and tempestuous but generous character. He shocked the stuffy middle-class Europeans by his unconventional behaviour and breezy style of administration but had a loyal coterie of people eager for his friendship. As a literary and cultured man he gradually came to admire India's historic monuments. He it was who secured for Cole the curatorship of ancient monuments in 1881.

The height of Lytton's career was undoubtedly the 1877 durbar when his theatrical temperament found its grandest outlet. At Delhi in December amidst silk banners and pavilions sparkling in gold and red, white and blue he presided over the durbar at which Queen Victoria was proclaimed Empress of India. It was not therefore surprising that Lytton would wish to commemorate the event. In expansive mood he embarked upon a building scheme at his ancestral home,

Knebworth, England. Knebworth was a picturesque gothic pile, the result of rebuilding in the mid-nineteenth century, which had almost concealed its Tudor origins. To this romantic house a third storey was added to the east front, an office wing between 1878 and 1883 and an Indian extension to the north front was to have completed this scheme of 'imperial' expansion.

The existing drawings and a model show precise details for the extension which was to house Lytton's Indian collection.[23] Several quite different designs were produced by Cole at Simla in 1878. There were two for an 'Indian' extension to the library which led out into a domed conservatory. The first of these was estimated to cost between £3,000 and £3,500. Three further drawings, two without conservatories, dated 18 June 1878 show modifications. Neither of these satisfied Lytton and another elevation was drawn in September. On this drawing Cole identified his sources and they can be traced to his survey work. All the Indian buildings quoted from were in the north (Cole did not see the great Hindu monuments of the south until after 1881) and all except a *chattris* at Gobardhan, were associated with rulers of India. The details were to be made in plaster, panels were to have been painted to resemble Mughal pietra-dura work and the ceiling was to have been painted in imitation of the Diwan-i-khas at Delhi. Unfortunately this grand scheme came to a dismal end when Lytton, on the point of leaving India in 1880 discovered to his profound consternation the precarious state of his financial position. If it had been built it would have been the only 'Indian' scheme erected in Britain by a Viceroy.

Sir William Emerson, a pupil of William Burges, was another of this new generation of properly trained architects who went to India in the years after the Mutiny. There he worked on several important projects including the Crawford Markets at Bombay, churches, Allahabad University, and Lucknow Cathedral. In England his design for Liverpool Cathedral won first prize in 1886 but was never built because the proposed site was changed. Emerson was more interested in gothic forms than Indian although he thought buildings in India should at least attempt an aesthetic rapprochement. His most famous building, the Victoria Memorial Hall, Calcutta, best illustrates his attitude and answer to that problem. After he had returned to England he designed two houses, Nos. 178 and 179 in Queen's Gate, London. No. 179 was built in 1889 for Sir George Allen, a member of a firm of East India agents and a newspaper proprietor who had lived in Allahabad and founded the *Allahabad Pioneer* and the *Civil and Military Gazette*. On an otherwise Jacobean façade Emerson introduced a curious cupola over the entrance porch. The interiors were much more noticeably 'Indian', especially the billiard-room and the saloon.[24]

Of the returning architects Robert Chisholm was the most interesting. In 1903 he had drawn upon his experiences in Madras for his design for a Christian Science church near Sloane Square, London. The treatment of the roofline and the tower display ideas he had employed in India. In 1910 he was asked to

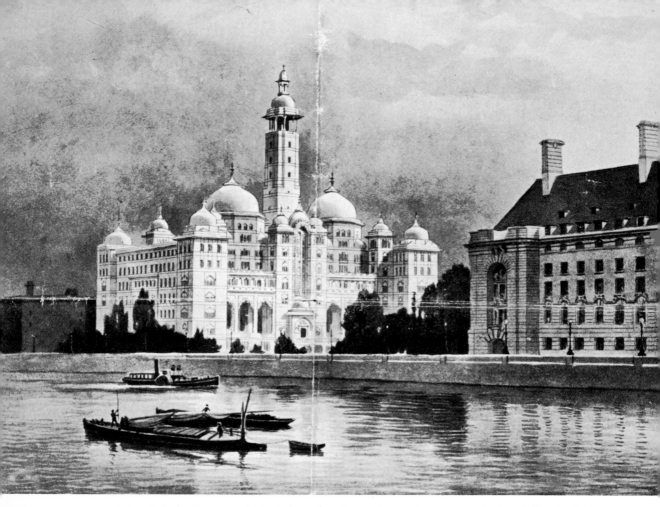

62. *Robert Fellowes Chisholm's design for an India Museum on the South Bank of the Thames, 1910, illustrated in* The Sphere. *It was rejected when the patrons found they did not have the support, the money or the courage to erect such a building in London.*

produce a design for an important official building in London, the long-awaited India Museum **(62)**. It was to have been dedicated to the memory of Edward VII (who died in 1910) and whose enthusiasm for India was well-known. The proposed museum was yet another attempt to bring together all the collections of the old East India Company that had been dispersed throughout the British Museum, South Kensington Museum (now renamed the Victoria and Albert Museum) and the Imperial Institute. The scheme was vociferously supported by the ex-Viceroy Lord Curzon, Lord Roberts, Rudyard Kipling and many others including the Royal Asiatic Society. Unfortunately it was bitterly and vehemently opposed by Sir George Birdwood who could see no sense in the project at all, and who would have disapproved of Chisholm's design since he was against the introduction of Indian styles into Britain as they would 'adulterate English architecture'.[25] A site had even been allocated on the South Bank next to County

63. Sir Herbert Baker's India Office (now Indian High Commission) in the Aldwych, London. It was designed between 1928 and 1930 and incorporates Indian elements in a half-hearted, unconvincing way.

Hall where the old India Stores had been, but the high cost (estimated at £800,000), the bitter wrangling among what should have been a united fraternity, the onset of the First World War and finally the death of Chisholm in 1915 put an end to all hopes for an India Museum.[26] Thus Chisholm's striking design with its rationalised use of Indian elements, perfectly suited to 'altered conditions' and imposing form never got beyond the drawing board, and London still has no India Museum.

The political and artistic pressure which was exerted in India for fifty years after the Mutiny and which resulted in the Indianisation of Lutyens's cherished scheme for New Delhi, finally manifested itself in Britain in the 1920s. Herbert Baker, fresh from his work at New Delhi and his friendship-breaking argument with Edwin Lutyens, provided a few Indian elements in his scheme for a new Indian Office in the Aldwych, London, designed between 1928 and 1930 **(63)**. Unfortunately the dismal Portland stone façade relieved only by whimsical elephant heads and an entrance flanked by faceted columns with bell pendentives, is a failure. If he had looked at Indian architecture (Hindu and

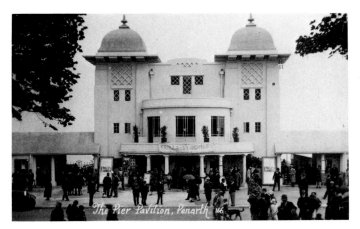

64. *The pier pavilion, Penarth, South Wales designed by M. F. Edwards in 1927 and clearly showing the influence of Lutyen's New Delhi scheme.*

Mughal) just a little more seriously he could have learned a 'thing or two' from people who had been masters of the relationship between form and surface decoration for centuries. Baker might even have learned something from Mr M. F. Edwards whose 'New Delhi' pier pavilion designed and erected between 1927 and 1928 at Penarth, South Wales is much more integrated than Baker's building **(64)**.

Perhaps the 'durbar' hall at Elveden Hall erected between 1899 and 1903 is the only interior in Britain of any consequence to have been influenced by Anglo-Indian architecture **(65)**. It was designed by Caspar Purdon Clarke, Keeper of the Indian Section of the South Kensington Museum, an architect well acquainted with Indian architecture and a champion of the Anglo-Indian style. Although he had built nothing in India, he had designed many of the Indian pavilions for international exhibitions which took as their starting point the results of experiments in Anglo-Indian forms conducted in India. At Elveden he appears to have been heavily influenced by the work of his friend Sir Samuel Swinton Jacob, who had built extensively in Rajasthan and whose *Jeypore Portfolios* he had used as a source for his 1900 Paris pavilion design and also for Elveden.[27] For details he also consulted examples of Hindu and Mughul architecture in the South Kensington Museum. But the overall impression is remarkably reminiscent of Anglo-Indian interiors commissioned by Indian princes, especially Jacob's interiors at Jaipur and the palace at Bikaner which were designed during the 1880s and 1890s. Clarke was against the use of Indian features in British architecture, a point he had made in a lecture in 1883, and it must therefore have been the idea of the patron Edward Guinness, 1st Earl of Iveagh who had bought the property from the Government of India after the death of Maharajah Duleep Singh. Iveagh never visited India and it seems probable that his 'Indian' extension was erected as a tribute to his great friend and neighbour the Prince of Wales, crowned Edward VII and Emperor of India in 1902. The carrara marble scheme carved by British workmen at a cost of

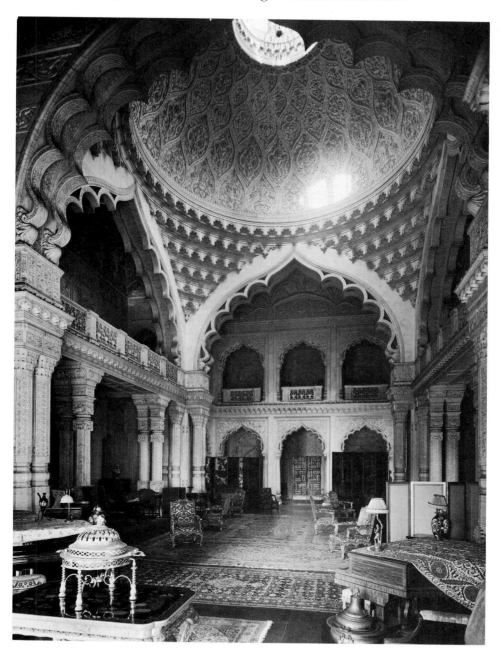

65. *The 'durbar' Hall at Elveden Hall, Suffolk, erected to the designs of Sir Caspar Purdon Clarke between 1899 and 1903 for the 1st Earl Iveagh. The Hindu and Mughal details of this vast hall were carved in Carrara marble which made it about as cosy as a trip to the arctic!*

£70,000 abounds in imperial references to Hindu and Mughal majesty, not least of which are the two fireplaces based upon the Emperor's throne in the Diwan-i-Am, Delhi which must have sent a warming, imperial glow into the heart of what was reputedly the coldest room in England.

The concern of Major Mant, Robert Chisholm, Sir Swinton Jacob and others to evolve a new national style in India found unexpected admiration and influence in Hungary. Hungary was firmly under the imperial control of the Hapsburgs. Not only had Hungary's sovereignty been subjugated to foreign domination but to a large extent her culture had also. However, during the latter half of the nineteenth century there arose a new nationalist movement, which sought Hungary's roots and a traditional language of expression based upon her ethnic origins. Jozsef Huszka, a Transylvanian teacher, published several works in which he compared Hungarian folk art with that of the Middle-East and India. This was the artistic corollary to the racial theories then current among ethnographers concerning the origins of the Hungarian people in Central Asia and Northern India. Architects too wished to rid themselves of foreign domination. Between 1884 and 1887 Gerster Kalman designed the Deak Mausoleum in Budapest which had a dome on a square base with sloping sides which strongly recalled the monuments of the Middle-East and N.W. India, especially the early fourteenth century tomb of Ghiyath ud-Din at Delhi.[28]

One architect especially looked toward India, and surprisingly to Anglo-India. Odon Lechner (1845–1914) had studied in Budapest and Berlin, travelled to Italy and spent four years in Paris (1875–9).[29] He had strong eclectic proclivities which sometimes led him astray, as when he attempted to combine French Renaissance architecture with Hungarian ideas in his Drechscer Palace building of 1883. Despite this failure he had no intention of putting his trust in a return to neo-historical styles since his overwhelming aim was the creation of a new national style. Like George Dance in England a century earlier Lechner had a natural gift for decoration and he found a way of using Indian ideas to revitalise his vocabulary.

In 1889 Lechner and his friend Vilmos Zsolnay (1828–1900), the owner of the Zsolnay Porcelain works at Pécs, visited England for the first time. They studied the Indian and Persian collections of the South Kensington Museum and Zsolnay's productions subsequently became heavily indebted to Persian ceramics. Lechner would have seen the plaster court with its examples of Indian architecture but what impressed him most during this visit was the use of English vernacular features in contemporary architecture. He especially noticed features such as ceramic claddings, pinnacles, decorated roof tiles and irregular outlines and subsequently adopted them in his own buildings. His second visit to England in about 1890 was both longer and more important since it was at this time that he first saw illustrations of the Anglo-Indian architecture of India. It is surprising that his attention had not been drawn to

these buildings before since Chisholm's drawing for a railway station at Madras and photographs of several official buildings at Madras had been exhibited at the Vienna exhibition in 1873. In 1890 the discovery of Anglo-Indian architecture came as a revelation to him and in 1892 in an autobiographical note he wrote what amounted to a personal architectural credo:

> My second and much longer study tour of England, however, made a far deeper mark on me. My interests were focused on English colonial buildings. For I began to realise that when the English built anything in the Indian colonies, they took great care to adapt the taste of the native, and, so to speak, to build in the Indian style.
>
> If these English people, who possessed so great a culture were not ashamed to investigate the indigenous relatively inferior cultures of their colonies, which they partly adopted, and combined with their knowledge, how much more should we Hungarians study our own folk culture and blend it with European culture! The study of Hungarian folk art really showed me the way to the art of Asiatic people, since there was evidently an undeniable relationship between the two. This Eastern relationship, evident in Persian and even more in Indian art, obsessed me all the more, since I hoped to find in the work of these people [the British] whose art was already developing monumentally [in India], a sign-post to point to the ways in which one could translate vernacular elements into monumental architecture. Therefore I devoted myself with passion to research into oriental art.[30]

In architectural terms the immediate outcome of his obsession with Indian and Anglo-Indian art was the Museum of Decorative Arts, Budapest, designed in 1891 and completed in 1896. Externally, the building is predominantly Venetian-gothic **(66)**, like Budapest's new Parliament buildings and has a decorative scheme that becomes more and more ornate, the higher the building, so that the outline of the roof is dominated by fantastic attic windows, turrets, crenellations and domes. According to Lechner the front elevation was influenced by the Calcutta railway station but this must be a mistake since in many ways, not least its mixture of gothicism and orientalism, it resembles F. W. Stevens's Victoria Terminus, Bombay which had been completed in 1888. In no way is the spectator prepared for the incredible 'Mughal' interior which is designed around a central 'durbar court' **(67)** off which lead corridors, arches and stairways **(68)** decorated with elaborate and extraordinary details, some reminiscent of Garnier's Paris Opera House which Lechner must have seen. These became more exaggerated in Lechner's later work, such as the Post Office Savings Bank at Kecskemet (1900–01).

By the turn of the century Lechner's interest in Anglo-Indian architecture and his obsession with texture and decoration that had largely been the product of

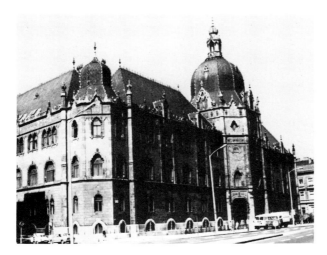

66. *Museum of Decorative Arts, Budapest designed by Odon Lechner in 1891 in a Venetian-gothic style which intentionally recalled F. W. Stevens's Victoria Terminus, Bombay.*

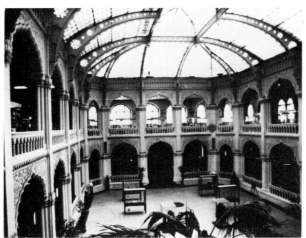

67. *The 'Durbar Court' of Odon Lechner's Museum of Decorative Arts, Budapest, 1891, erected in a 'Mughal' style.*

his studies of Indian art coalesced to form the basis of increasingly complex and abstract decorative schemes. These schemes had a markedly 'Art Nouveau' character such as the Geological Institute of 1899 **(69)**. In contradistinction a compatriot, the unjustly neglected architect Istvan Medgyaszay, (1878–1959), a pupil of Otto Wagner, had visited India and openly acknowledged a debt to Indian architecture. He utilised his studies of Indian art to rationalise his system of decoration.[31] This is particularly evident in the theatre he designed at Veszprem (1908). In this use Medgyaszay was closer to another 'Art Nouveau' architect (before he turned 'Futurist'), the Italian Sant Elia, who extensively quoted from Hindu temple architecture for his Monza Cemetery design of 1912.[32] Both Medgyaszay and Sant Elia were heavily influenced by Oldbrich's work in Vienna which laid more emphasis on clearly differentiated forms than surface decoration which was probably why Lechner was so critical of what he

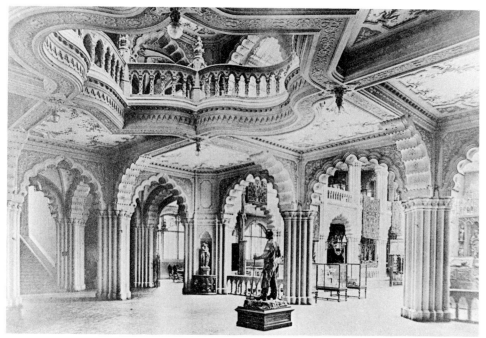

68. The foyer of Odon Lechner's Museum of Decorative Arts, Budapest, 1891, showing his unrestrained use of 'Mughal' arches and other Indian details, from a photograph c. 1910.

termed Oldbrich's 'Assyrian' buildings. Despite the apparently ever-increasing dissolution of 'Indian' elements in the work of Lechner and Medgyaszay, Hungarians continued outwardly to acknowledge their supposed Indian origins and find in the appropriation of Indian forms a direct way of asserting their own nationalism. Thus the Imperial Court of the Hungarian Exhibition held in London in 1908 was dominated by an 'Indian' pavilion.[33]

The Anglo-Indian style was predictably influential in other countries such as Malaysia which had a similar climate and population as India. When Kuala Lumpur was developed during the 1890s the architects chosen for the task implemented ideas which had been worked out in Bombay and Madras during the 1870s and 1880s. The Secretariat building designed by A. C. Norman in 1891 shows this very clearly **(70)**. Originally it had been designed in the classical style but Norman's ideas were rejected by C. E. Spooner the State Engineer, who suggested that an oriental style would be more appropriate. With this modification building work finally began in 1895.[34]

69. A staircase, decorated with polychromatic tiles in Odon Lechner's Geological Institute, Budapest, 1899, in which the 'Indian' details have developed *an* Art Nouveau *character, from a photograph* c. *1910.*

70. *Secretariat, Kuala Lumpur designed by A. C. Norman in 1891 shows the influence Anglo-Indian architecture of Bombay and Madras had on other tropical colonies.*

Indian Crafts and Western Arts

Another phase of 'Indian' design in the West has its foundation in the concomitant advocacy of the Indian craft tradition and the growing realisation that India had an artistic tradition as valid as that of Europe. At a period of decline in art manufactures in Europe which was credited to the effects of industrialisation and mass production, the handicraft tradition of India became a stimulating source of inspiration to many in the West such as William Morris, Sir George Birdwood, and Sir Henry Cole. This was despite the threat which Indian crafts were themselves under as a result of cheap imports from Europe.

In 1851 the long awaited Great Exhibition finally came to fruition. It had been the dream of Prince Albert to bring together in one place all the modern manufactures from as many different countries as cared to participate. Essentially, it was a celebration of the modern industrial world. Paxton's immense Crystal Palace, the design of which was the direct result of new industrial processes, was erected in Hyde Park and provided a greenhouse atmosphere in which to view the world's productions.

Of all the items exhibited it was the 'gorgeous contributions' of India[1] which caused the greatest excitement. Whereas Europe offered products whose novelty and ornamentation derived from the 'copying and misapplying of the received forms of beauty of every bygone style',[2] India and particularly Islamic India displayed unceasingly varied forms of decoration, while achieving a unity of design, skill and judgment in its application and refinement in its execution. These characteristics had already been appreciated in similar work from Moorish Spain, Tunisia and Turkey. In his *Grammar of Ornament* (1856) Owen Jones, the pioneer of the use of Islamic decoration in Britain, drew attention to the difference between Europeans and Indians in their approach to design. The former endeavoured to imitate nature as closely as possible thereby destroying the integrity of the surface; the latter did no more than indicate a general idea but in the most elegant manner; the result was a masterly ability to integrate decoration and surface. This was achieved through the ability to balance form and colour in such a way as to perfect a 'neutralised bloom', whether in metal work, textiles or carpets. For centuries it had been this outstanding ability to

71. *A plate illustrating Islamic decorative motifs from Owen Jones's* Grammar of Ornament, *1856.*

72. *A plate illustrating Hindu decorative motifs from Owen Jones's* Grammar of Ornament, *1856.*

organise colour and design that had attracted European merchants, and made Indian textiles so sought after in Europe.

Jones divided the Indian section of the *Grammar of Ornament* into two chapters: chapter 12 was concerned with Islamic decoration **(71)**, chapter 13 with Hindu **(72)**. Jones was favourably impressed by the Islamic designs but he reserved judgment on the type and quality of the 'Hindoo' because of the lack of published information. Ram Raz's *Essay on the Architecture of the Hindus* (1834) was admired by Jones for its detailed account of the construction of Indian temples, but it was of little help in assessing its decoration.[3] It is more puzzling that he made no reference to Thomas and William Daniell whose work was well-known and some of whose aquatints clearly show Hindu decoration.[4] Perhaps in view of the distortion which had characterised the early published views of Egyptian monuments, he was not willing to accept the authenticity of their aquatints.

However, there were other sources available to him of which he was obviously unaware. James Tod's *Annals and Antiquities of Rajasthan* (1829, 1832) had several fine plates illustrating Hindu decoration at the temples of Chandravati and Barolli. In publishing them Tod had explicitly hoped that 'these masterpieces of sculpture and architecture ... would furnish many new ideas and rescue the land sacred to Bhavani ... from the charge of having taught nothing but deformity'.[5] Nor does Jones seem to have been aware of the hundreds of detailed drawings of South Indian Hindu monuments which had been purchased in 1823 by the East India Company from the estate of Colonel Colin Mackenzie, Surveyor-General of India. A catalogue of the collection was published in 1828 but the drawings were inadequately described and this may have led to their neglect.[6] The publication of reliable views, rather than the study of detailed drawings, was the only way, Jones thought, of determining whether Hindu decoration was 'a fine art, or whether the Hindoos are only heapers of stone, one over the other, adorned with grotesque and barbaric sculpture'.[7] This statement suggests a lack of sympathy for Hindu decoration and ornamentation, a common prejudice in England at the time, which may explain why Jones took so little trouble to seek out appropriate examples.

The importance of Jones's *Grammar* lies in the way he compiled, at a moment of crisis in Western design and craftsmanship, a digest of all the then known motifs from many countries, including the Middle and Far East, and North Africa, the intention of which was to draw attention to the need to search elsewhere for fresh inspiration. His *Grammar* provided a relative assessment of universal design which he compared to 'an ever gushing fountain', and clearly he felt that Britain and Europe needed to quench their thirst at this pure spring.

India's productions at the 1851 exhibition were purchased for a new Museum of Ornamental Art to be situated at Marlborough House, London. This collection, together with the collections from the old East India Company

Museum and items from the Royal Asiatic Society later formed the basis of the South Kensington Museum (later renamed the Victoria and Albert Museum). The object of the Museum of Ornamental Art was to provide students of industrial design with examples of quality to study. Henry Cole (later Sir Henry Cole), a co-director of the 1851 exhibition, was its principal. Cole was a staunch supporter of Jones's ideas as was the artist Richard Redgrave. When the school of industrial design was founded Redgrave became Cole's deputy. Thus there developed a strong forum for these views and a recognition of the importance of the Indian handicraft tradition.[8]

There were of course detractors, chief among whom were John Ruskin and Ralph Wornum. Wornum especially found nothing of merit in Indian designs: 'Much of the design is put in to fill a space, the whole thing generally only an infinite combination of minute portions of different colours, aiming at a purely general effect.'[9] For Wornum it was obvious that 'the best shapes remain Greek'. Surprisingly Ruskin could find more to admire in India's craft work than in her 'monstrous' architecture and sculpture. In a lecture given in 1859 at the Museum of Ornamental Art he observed that Indian craftsmen are 'almost inimitable in their delicate application of divided hue, and the fine arrangement of fantastic line',[10] but in this insidious subtlety they were, he thought, as devious as in their superstitions, gross sensuality and despotic cruelty. For Ruskin art and morality were inextricably linked, and since Indians were immoral and cruel (had not the Mutiny revealed this?) their art had no validity. However, Ruskin and Wornum were soundly trounced by the opinions of Henry Cole, Richard Redgrave and Owen Jones. As Partha Mitter has remarked, because these people occupied positions of power and influence in the schools of industrial art, their opinions of the superiority of Eastern decorative art over that of the industrialised West, of the integrity of surface decoration over Western illusionism, of the general importance of the craft traditions in non-European countries, profoundly influenced design in the second half of the nineteenth century.[11]

The British craft tradition had suffered irrecoverably from the onslaught of industrialisation, but Indian crafts were just as vulnerable. Even as India was receiving widespread praise from foreign as well as British critics, her handicraft traditions were under seige from the introduction of cheap imports. To rectify this situation Sir Charles Trevelyan proposed in 1853 to establish schools of art in India based upon their British counterparts. His aim was to help threatened industries, and cultivate 'those branches of art that still remain to them'.[12] Accordingly schools were set up in Madras, Calcutta, Bombay, Lahore and elsewhere. It soon became apparent that this policy concealed yet another process of Europeanisation or cultural imperialism on the sub-continent. While British schools of art were encouraging the aesthetic principles of the East, in India the schools were encouraging their students to draw classical figures and

copy gothic decoration and do everything but nurture Indian traditions. This short-sighted policy was not helped by the considerable official apathy with which the scheme was received by government officers who felt it was nothing but 'an expensive fad'. Its progress depended largely on the personal opinions of succeeding Governors and Lieutenant-Governors not to mention Directors of Public Instruction. Far from producing work which would encourage Indian crafts along traditional lines the result was a decline in traditional design and in its place the production of Grecianised statues and paintings which were nothing but copies of European styles.

The deterioration of Indian crafts had become embarrassingly evident by the time of the Paris Universal Exhibition of 1878. Sir George Birdwood, a civil servant who had resided for many years in India and was Director of the India Museum, wrote a handbook to the Indian Court.[13] In it he scathingly condemned British policy in India, and those Indian princes who would rather emulate their European masters than patronise Indian work. He dreaded the introduction of machinery into India in case it would encourage the same social and moral ills which had accompanied its use in Europe and America. These ideas he further elaborated in his *The Industrial Arts of India* (1880) **(73)**. Birdwood was congratulated on this 'independent and courageous' stand in a letter jointly signed by the leading artists, architects, administrators and

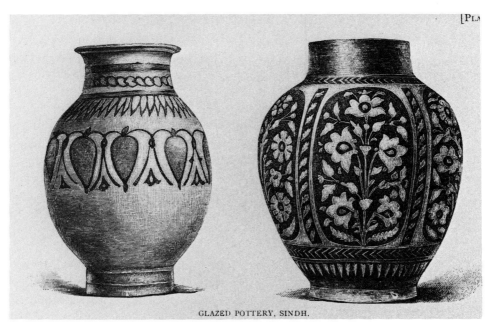

GLAZED POTTERY, SINDH.

73. *Two glazed pots from Sindh illustrated on plate 72 of George Birdwood's* The Industrial Arts of India, *1880. The book did a good deal to stimulate interest in the crafts of India.*

orientalists of the time. They thanked him for his apposite remarks concerning Indian crafts and their recent fate, pointing out that '... all men of culture will agree with us in thinking the welfare of the arts in question is important both to India and to Europe, and that the loss of them would be a serious blow to civilisation.... We cannot conceive that any thoughtful person will deny the responsibility of England on the matter, or the duty which a great country owes to the arts of exercising foresight and patience lest, for an apparent commercial gain, she and the world in general should lose industries which have for ages made India famous, industries whose educational influence on the arts of the West is so universally acknowledged by all students of art and history.'[14]

This *cri de coeur* from the most influential people of the day provides us with one of the most important documents on attitudes to Indian handicrafts at the time and succinctly summarises prevailing opinions and feelings. The problem of what could be done to conserve and promote Indian crafts still remained. Was there anyone in India who cared enough to attempt to resolve it? In the 1850s there was not a single important figure, thereafter two people arrived in India who were to become highly influential in revitalising the Indian craft tradition. They were John Lockwood Kipling (Rudyard's father), and, later, an American, Lockwood de Forest. Their encouragement of India's handicrafts was to have important aesthetic consequences in the West, especially in America.

John Lockwood Kipling had become interested in crafts and art manufacturers after a visit to the 1851 exhibition.[15] There followed a period as a designer and modeller for a Staffordshire pottery which lasted until about 1858 when he became apprenticed to the sculptor J. Birnies Phillips. In this capacity he may well have worked on the new South Kensington Museum, where the artist John Griffiths was also working.[16] The two became friends and when vacancies occurred at the Bombay School of Art in 1865 they both left England. It did not take them long to realise that the art policies which were being pursued in India were not only counterproductive in commercial terms but they undermined the traditions of the country. Kipling quickly perceived that his most able students were those who had come to him straight from the villages. From their subordinate positions there was little that Kipling and Griffiths could do to alter policies but for ten years they did their best to improve the situation. It was as a result of their actions that students were allowed to work on some of the public monuments which were then being erected in Bombay.

In 1875 Kipling was invited to become principal of the Mayo School of Art at Lahore. Here at last he would occupy a position in which he could implement his own ideas, the most important of which was changing the purpose of schools of art. Instead of trying to produce artists they would concentrate on developing craftsmen. It was unfortunate that the 1878 Paris exhibition came so soon after his appointment, twenty years of inept education were not going to be rectified in three. Kipling and his son Rudyard later visited the exhibition.

The unfavourable critical reaction, already mentioned, combined with Birdwood's comments, would not have passed unnoticed by Kipling and his re-introduction at first hand to the ideas of William Morris and the English craft-revival may well have forced Kipling to focus his own thoughts. He returned to India with renewed determination. What was needed was more government and private patronage for the arts.

It was at this time that an American artist with very similar opinions arrived in India. His name was Lockwood de Forest.[17] Born in New York he had early fallen under the spell of the East as cast by the American orientalist artist Frederic Church. Church's Islamic house on the Hudson, *Olana*, was a testament to his interest in the Near East which he had visited from 1868 to 1869. De Forest studied painting with Church and travelled in the Near East during the 1870s. In 1878 he came into contact with the designer and artist Louis Tiffany, the artist Samuel Colman, and the textile designer and embroiderer Candace Wheeler. Together they formed a design studio in New York called Associated Artists.[18] Each member of the group was allotted a special area of responsibility, Tiffany for glass, Colman colour, Wheeler textiles and embroideries and de Forest carving and wood decoration. Their ideas were strongly influenced by Owen Jones and the English craft-revival but their *raison d'être* was to establish a new approach to interior design in America which hitherto had always been reliant on slavish copies of European styles. Between 1879 and 1883 when Associated Artists was disbanded, they worked for some of the most influential patrons in the United States.

According to de Forest it was Tiffany who first drew the attention of the group to Indian carvings. While in England in 1879 he had visited the British Museum and had seen there Indian carvings which he felt certain could be safely employed within the context of their own ideas.[19] As de Forest was responsible for the integration of carvings he was the natural choice for an exploratory buying trip to India. De Forest, like William Morris and George Birdwood, was no admirer of modern Western culture and he sadly deplored the effects that modern ideas had had on the older cultures of North Africa and the Middle East. Having heard so much about Indian crafts he was eager to visit India to see for himself the famous workshops and legendary architecture.[20] His talent as an artist did not preclude an astute business sense which proved to be useful in his dealings with Indian craftsmen.

In November 1880 he left New York accompanied by his wife, and arrived in Bombay at the beginning of the following year. It soon became apparent that the type of decorative carving which he sought could no longer be bought in Bombay, so he proceeded to Ahmedabad. Here he made more progress. After being introduced to Muggenbhai Hutheesing **(74)**, a member of one of the leading Jain families of the area which had its own workmen, de Forest entered into a formal agreement to set up a woodcarving business. Hutheesing, whose

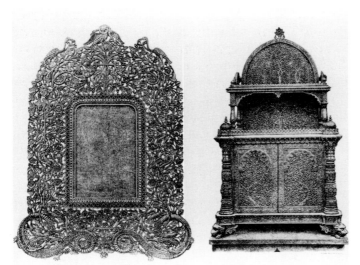

74. *A carved cabinet and a picture frame made by Muggenbhai Hutheesing and other craftsmen at the Ahmedabad Wood Carving Company, organised by the American artist and decorator Lockwood de Forest. This piece was exhibited at the 1886 Indian and Colonial Exhibition and illustrated in the* Journal of Indian Art and Industry *no 11, 1888.*

own business was in some financial difficulties owing to cheap imports of American cotton, gratefully accepted de Forest's offer to pay for workmen's tools, materials and salaries. Thus the Ahmedabad Wood Carving Company was created. Once the agreement was completed de Forest, Hutheesing, and the chief carpenter or *mistri* walked over the entire city of Ahmedabad selecting examples from buildings to be copied, not only its wooden balconies and bays but also details from stone monuments such as the tree-pattern in the double-arched window of the Sidi Sayyid Mosque, panels in the minarets of the Shanpu Mosque, the Rani Sipri, the Shaikh Hasan, Mohammed and Muhafiz Khan Mosques, and the brass doors on the tomb of Shah Alum. These panels would later be used in the decoration of American houses.[21] As well as Indian designs de Forest also provided his own for chairs and sofas based on ideas from Cairo and Damascus. One day he saw an Indian pass him with a lot of paper patterns for tin foil work which was used to decorate houses during religious festivals and wedding celebrations. De Forest promptly bought the lot, ordered some more and had them made in thin brass. In 1882 and 1883 some of these were used to line the ceiling of the East Room of the White House, Washington during a redecoration by Associated Artists.

Feeling satisfied that his work was proceeding well, de Forest and his wife set off for Jaipur, Delhi, and Lahore where he met Lockwood Kipling. They had much in common, a love of India and her crafts and a desire to promote them. They became lifelong friends and after Kipling's retirement from India in 1893 both he and his son Rudyard visited de Forest in the United States. During 1881 Kipling organised an exhibition of Indian arts which was held in Lahore in December of the same year. Eager for publicity, de Forest managed to have

some of the first productions of the Ahmedabad Wood Carving Company exhibited. This, de Forest told Tiffany in a letter, was a most worthwhile exercise. When Sir Caspar Purdon Clarke, appointed keeper of the embryonic Indian Section of the South Kensington Museum in 1883 bought a number of the Ahmedabad pieces from the exhibition de Forest felt this to be most auspicious for the Associated Artists project as a whole.[22] He wrote to Tiffany saying that he felt that he was in India at an historic moment when they were poised to take a lead in the sale of Indian manufactures and to give Associated Artists a world-wide reputation. His enthusiasm was confirmed, he thought, by the reactions of some of the Government of India officials. Instinctively he felt that there would be a surge of interest in India crafts. Enormously encouraged by the reactions of the cognoscenti in India de Forest returned to the United States, via Paris, in June 1882, having first visited other areas of the Indian sub-continent including Nepal, Srinagar, the chief cities on the Ganges and Calcutta, as well as Madras and the South.

In his absence abroad the Associated Artists had already completed several important commissions and although obviously not present de Forest was nevertheless in direct correspondence with Tiffany over many aspects of their design. One of de Forest's responsibilities was to make sure that the wooden panels and furniture were made to the correct specifications. It was probably Tiffany who took the lead in establishing the overall 'look' and harmony of the designs, indicating to de Forest the kind of decorative work he wanted. Associated Artists' first domestic commission was for a saloon at George Kemp's house on Fifth Avenue in 1879.[23] It was largely Islamic in character with geometrical ceiling decoration, Moorish columns in the bay, panelled walls containing Persian and Japanese-style fabrics, Japanese imari vases and Persian carpets. The only Indian element occurred in the use of furniture which must have been bought through an importer, since de Forest had not yet visited India.

Indian carved panels make one of their first appearances in the Hamilton Fish room of about 1882 where they were used as a surround to an Indian style mirror **(75)**.[24] In general this was how the wood panels were used either as mantel or fireplace surrounds, often in conjunction with pierced brass work as in the John Taylor Johnson room.[25] For the Johnson room Tiffany designed some coloured glass in imitation of the wood work. One of the most impressive applications of the pierced-wood panels was in the hall of the house of William S. Kimball (*c.* 1882–3) of Rochester, New York **(76)**. Here the panels, themselves copies of those to be found in the stone screens of the Sidi Sayyid mosque at Ahmedabad, were arranged to form a screen between the hall and the stairs not unlike those in that mosque. This device served to create an 'impression of great distance and of mystery'.[26] For in America at least the lattice screen had become an indispensable part of modern design. As the *Decorator and Furnisher* for January 1885 noted, many artists and designers had used

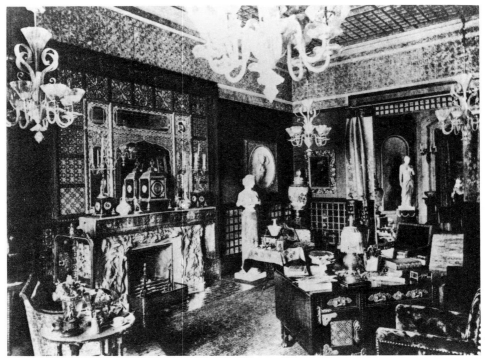

75. *Hamilton Fish's drawing room, New York designed in 1883 by Lockwood de Forest, Louis Tiffany, Samuel Colman and Candace Wheeler, all members of Associated Artists. The room makes use of Indian motifs including Indian carved panels around the over-mantel and was illustrated in* Artistic Houses, *1883.*

them because they admitted light 'and those behind can enjoy a view through them, while to others in front they form a well nigh impenetrable screen'.[27] The lattice screen or partition became an essential component of the oriental alcove of the kind produced by Liberty & Co. in London and were much in demand. Yet in the Kimball hall what impresses is the creation of a unified scheme, even the furniture with more than a hint of the exaggeration of Art Nouveau fits perfectly well in this setting.

One of the sources for research into the work of Associated Artists is a beautiful, illustrated publication by George Sheldon called *Artistic Houses* (1882–3) in which many of their commissions are reproduced and discussed. Their patrons were highly influential and included well-known names from among the newly rich such as Samuel Clemens (Mark Twain), the art collector James Taylor Johnson, Cornelius Vanderbilt and Tiffany himself. Tiffany had ordered carvings from Ahmedabad for his own flat on East 26th Street, New York where, as Sheldon described, 'the spirit of the unity is delicacy' achieved by bringing together 'a simple suggestion of the ancient Moorish style' with 'a

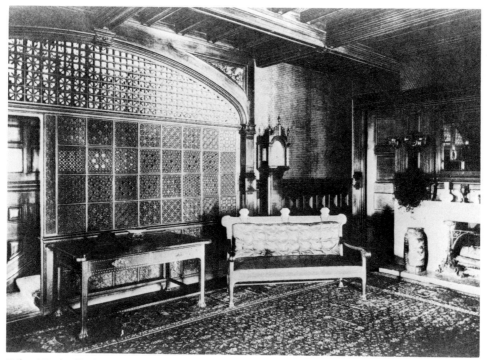

76. *The hall of William S. Kimball's house at Rochester, New York from a photograph in* Artistic Houses, *1883. Designed by Associated Artists and making daring use of pierced wood panels made in Ahmedabad which were traditionally found in the mosques of that town.*

dash of East Indian, and the wall paper and ceiling papers are Japanese . . .'[28]

Delicacy and subtlety remained the keynotes of the work of the members of Associated Artists even after the formal arrangement between them came to an end. Tiffany's influence on the domestic work of de Forest was still evident in the library **(77)** which the latter designed for the Carnegie family, (1899–1900).[29] The barely disguised Jacobean buffet, the chair and the intricately carved door-surround were all the products of the Ahmedabad company and would not have looked out of place in a Jacobean revival setting. Indeed it can easily be appreciated that within the fashion for heavily carved wood interiors and decorated plaster ceilings of the Jacobean and Queen Anne revival styles, Indian carvings would be acceptable, while evincing a distinctly original appearance, which to the untutored eye had little to do with traditional Indian crafts. Delicacy was hardly a feature of de Forest's personal interiors in which he appeared to be aiming at a more symbolic utterance: an affection for India and at the same time his equally obvious disaffection with the modern Western world. De Forest's loft apartment on 333–35, Fourth Avenue was little more than an

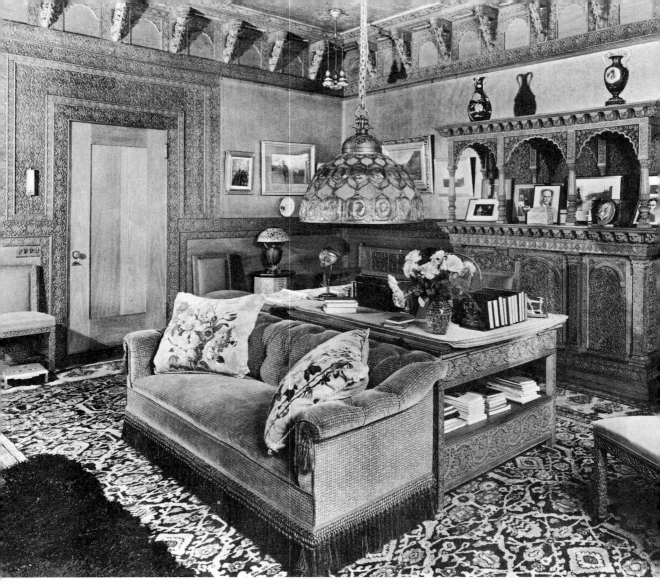

77. *Library of the Carnegie Mansion, New York (now the Cooper-Hewitt Museum).*
One of two rooms designed by Lockwood de Forest in 1899–1900 using carved
woodwork made in Ahmedabad to his own specification.

Indian bazaar. A copy of the Bhadr window divided in two the space in which
Indian furniture was displayed. The walls were covered with Indian panels and
textiles and rugs arranged like divans. He opened this studio to the public in the
Autumn of 1882 only a few months after his return from India. The textiles and
nearly all the pieces of furniture were sold immediately. He was, however, a
little disappointed with the response from architects, although one frequent
visitor until his death in 1886 was Henry H. Richardson. The anti-modern
opinions of this pioneer of the Romanesque revival would have found favour
with de Forest and it is known that Indian materials were incorporated into at
least one of his projects, the Franklin McVeagh house in Chicago (1885–7).[30]

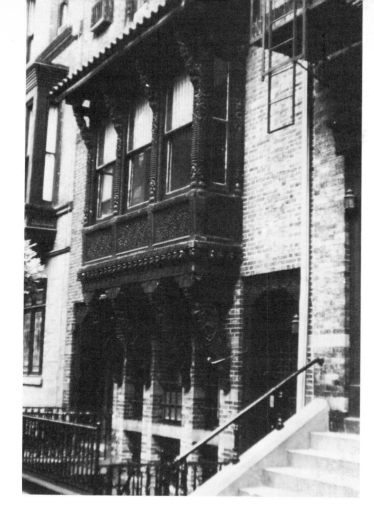

78. Part of the exterior of Lockwood de Forest's house on East 10th Street, New York designed by him in 1886. The carved bay window made in Ahmedabad in traditional style contrasts strongly with the otherwise severe facade. De Forest's house at Santa Barbara, California also made extensive use of Indian woodwork on the exterior.

After 1883 when the Associated Artists each went their own way de Forest moved his showroom to 9 East 17th Street and set up on his own. His new studio was described by one contemporary writer as an Aladdin's cave rich in 'rugs, silk tissues shot with gold, kimcobs of gorgeous hue and texture, chain armor, spears and swords ... hammered and cut brass, copper vessels overlaid with silver, carvings of great skill and artistic excellence in wood and stone, highly glazed tiles [and] here and there an antique vase'.[31] It was a staggering array and it made him reflect on the humiliating comparison between 'the feeble effort of our designers and carvers ... and these works'. De Forest moved yet again in 1885 to a vacant site in East 10th Street where he contemplated a more ambitious project, the design of his own house.

Lockwood de Forest's house in Greenwich Village was no Brighton Pavilion of onion domes and asparagus minarets unlike other ostentatious 'Indian' houses in the West, instead it was a monument to his belief that East and West could co-exist (78). Despite the fact that the main feature of the façade is an intricately carved bay window copied from an example in Ahmedabad, its

79. *Interior of Lockwood de Forest's house on East 10th Street, New York from an old photograph showing the elaborate Indian carved decorations.*

'Indian' character is hardly noticeable to the casual observer. Even the more common decorative devices which he used in the door and window trims are so well integrated into the whole that the façade emerges as an harmonious and unified conception of unexpected originality, rather than an eclectic oddity. The interior was more overtly 'Indian' and de Forest ordered columns and lattice work carved panels for the overmantels and carved furniture **(79, 80)**. On the ceiling in the drawing-room there were brass reliefs such as had been used in the decoration of the White House. The walls were hung with his own paintings of the Middle East and India and his collection of arms and armour, and the hall was covered from floor to ceiling with Damascus tiles.[32] This was to be the base of his operations for many years until in 1915 he sold up and moved to Santa Barbara, California where he constructed a similar house.

During the intervening years the productions of his Ahmedabad Company won prizes at the Indian and Colonial Exhibition in 1886. He worked on an extension to Frederic Church's house *Olana* from 1888 to 1889 and received a steady stream of commissions to build complete rooms from Indian materials. One of these was a carved teak room for displaying the carpets of the Chicago

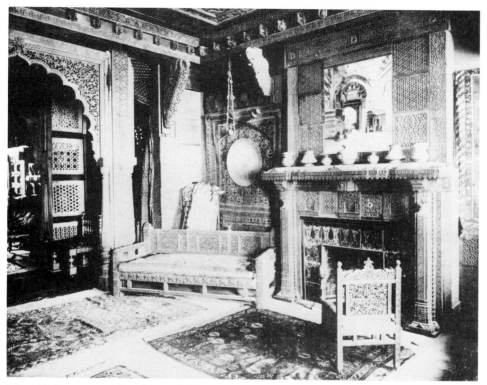

80. *Sitting room of Lockwood de Forest's house on East 10th Street, New York from an old photograph. The wood was left in its natural honey-coloured state.*

firm of Marshall Field in the 1893 Columbian Exhibition. His carvings won another medal, and a commission from Timothy Appleton Chapman for one entire room of arches, pillars, panels and furniture.[33] There followed the Carnegie commission and the Deanery of Bryn Mawr which he felt to be his best scheme.[34] Others were rooms in the Charles Yerkes and J. D. Pile Houses of New York, the Ellsworth House in Chicago and the Flood House in San Francisco.[35] In the 1890s he also designed 'Indian' wallpaper for Warren, Fuller and Lange of New York. There followed a trip to India from 1892 to 1893 to renew old acquaintances. By the beginning of the first decade of the twentieth century the demand for Indian carvings was waning and de Forest found himself with a stock which he no longer wanted, since he also wished to spend more of his time painting. After some protracted negotiations Tiffany took over the running of the Ahmedabad company in 1907.

In later years de Forest became much more absorbed in his painting than in any other activity, finding that rural California often reminded him of India. His house at Santa Barbara was very similar to that in New York and he evidently kept a connection with his old company, for the Frank C. Haven house

Wildwood built between 1908 and 1913 at Oakland, California, contained a copy of the Bhadr mosque window and carved panels.[36]

Lockwood de Forest and the Associated Artists may have been the first in the field to realise the importance of Indian craftsmanship in Western design but they were not alone in wishing to promote it. John Lockwood Kipling at the Mayo School of Art, Lahore, felt much the same but his commitments made him less mobile than de Forest and, unlike de Forest, he was neither an entrepreneur nor a member of a highly influential design team. In the early 1880s Kipling gave further thought to the problem of how best to promote Indian crafts, especially that of the Punjabi woodcarvers whose work he may have begun to re-evaluate as a consequence of his meeting with de Forest at Lahore in 1881. It is very doubtful if he had himself thought of the kind of application of Indian crafts which de Forest and Tiffany had devised in the United States. One of the main problems of increasing the use of woodcarvers on more ambitious projects was the cost: in ordinary circumstances the craftsmen did not equate time and money, what mattered was the finished product no matter how long it took.[37] Unfortunately this approach rendered their work far too expensive for the European market. De Forest had solved the problem by setting up his own company with a respected Indian to oversee all the work, fixing the rates, controlling the output and having a certain amount of duplication of mouldings and panels. These mouldings were made in various lengths and cut to appropriate sizes in the United States. Kipling had a similar ambition for the Punjabi carvers who had become especially famous for their *pinjra* or lattice work. It was very decorative and was used effectively in the making of European-style cabinets, tables and display-brackets.[38] Kipling thought the *pinjra*-work brackets particularly suitable for the display of small silver and porcelain objects. In this form Indian crafts were palatable to the British residents of India.

Kipling had higher hopes for the woodcarvers than that they would just produce wooden knick-knacks. In 1886 he wrote, probably influenced by de Forest's ideas, that the 'best use to which this and other varieties of Punjab woodwork . . . can be put is undoubtedly in the larger and bolder forms of domestic architecture'.[39] In India expansion was considerably hampered by the apathy of the Indian and British communities towards Indian craft traditions.[40] In order to counteract this apathy and promote a wider knowledge of Indian craft products both in India and elsewhere, the Government of India was prevailed upon to adopt a resolution for the improvement of art and ordinary manufactures and to undertake their promotion. This resulted in a Government of India Resolution dated Calcutta 14 March 1883,[41] the aim of which was to facilitate and co-ordinate the mounting of displays at international exhibitions, to improve the standard of all manufactures by widening the scope of the industrial schools and to build new ones. It hoped to enlist the support of

local Indian princes to sponsor such buildings and themselves patronise traditional crafts which had hitherto been ousted in favour of European manufactures. The Government realised that no renaissance of Indian art was possible without the sympathy of the Indians themselves. One of the proposals was to increase knowledge of Indian art by publishing, annually or quarterly, a journal of Indian art which would act as a shop-window for Indian products and attract correspondence from those who wished to know how Indian crafts could be adapted to European requirements.

The first number of the *Journal of Indian Art and Industry* was published in October 1886 and appeared every quarter thereafter. It contained articles on various aspects of Indian handicrafts and an extended preface by Edward Buck. In this preface Buck, Secretary to the Revenue and Agricultural Department, elaborated a point of the Resolution which was crucial to the further development of the use of Indian arts in the West: To what extent could 'Eastern designs and workmanship be applied to Western forms'? It was obvious that articles like hookah-stands and water-pots were only useful as fireside ornaments, and Indian anklets and nose-rings were hardly going to be worn by ladies of fashion in Europe. It is clear that Tiffany and de Forest were already well ahead in their appreciation of how Indian crafts could be adapted with profit and originality.

An unexpected commission from Arthur Duke of Connaught gave Kipling the chance to put his own ideas into practice. The Duke was a kind, reserved man and because he spent most of his life abroad as a servant of the Empire, he was probably the least known of all Queen Victoria's children.[42] He could hardly have been impervious to the influence of India since his childhood was permeated by the exotic presence of the young Maharajah Duleep Singh. Queen Victoria sketched the young Prince Arthur (he was created a Duke in 1873) playing with Duleep Singh and a little later he and his brother, the Prince of Wales, were photographed together in Indian costume.[43] He developed a fondness for Duleep Singh which survived even when the latter had fallen foul of the authorities for he was invited to the Duke's wedding at Windsor in March 1879. The Duke's wife was Princess Louise Margaret, the lively and cultured daughter of Prince Frederick of Prussia.

Their home was to be Bagshot Park, Surrey, an estate which had been purchased for the Duke in 1875.[44] The old house was demolished and a new Tudor-Gothic building was erected to the design of Benjamin Ferrey, an architect with a respectable list of country houses and gothic churches to his credit. During the 1830s Ferrey had re-designed the sea front at Bournemouth with a development that included a pleasure garden containing a 'Chinese' and an 'Indian' pavilion. Another of his designs was the curious 'elephant' chapel at St Swithin's, Wickham in Berkshire. Bagshot was completed in 1878 and altered slightly in 1879 for the newly-wedded couple.

81. Billiard-room of
Bagshot Park, Surrey,
1884–90, from an old
photograph c. 1900. The
room was designed by John
Lockwood Kipling and the
panels carved in Lahore
under the direction of Ram
Singh. Natural history motifs
predominate and no two are
alike. The 'Hindoo' billiard-
table was made in London,
in the background to the
right is the entrance to the
smoking-room.

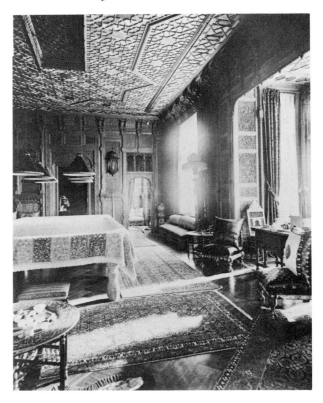

82. Lattice brackets, made
in Lahore, decorate the
corridor which leads to the
billiard-room.

The Duke was an officer in the British Army and in 1882, much against his mother's wishes, he took an active part in the Egyptian Campaigns. During his stay in Egypt he developed a taste for the Orient which led to a desire to visit India as his brother the Prince of Wales had done several years earlier. As a consequence of this request he was tranferred to the Indian Army with the rank of Major-General. After taking some lessons in Hindi he and his wife left for Bombay in November 1883. From Bombay they travelled overland to Allahabad and Calcutta, before returning to Meerut, where the Duke was to be stationed, via Benares and Lucknow. The Connaughts took an immediate and active part in the promotion of Indian culture. Princess Louise, especially, was forthright in her condemnation of the all too pervasive apathetic attitude toward Indian culture. Both she and the Duke warmly supported Kipling's new venture, the *Journal of Indian Art and Industry*, and hoped that its appearance would succeed in dispelling the 'don't care' attitude which the Duchess felt was gaining ground in India.[45] It would appear that as a result of a chance meeting between the Connaughts and Kipling at the Calcutta exhibition held during the winter of 1884, an idea for decorating a billiard-room at Bagshot Park in the Indian style emerged **(81)**.[46] Finding that the Indian princes wished to give the Connaughts a belated wedding gift, Lt. Col. Howard Elphinstone, the Duke's comptroller, suggested that they should sponsor the construction of the new room. This they readily agreed to and all matters of cost were therefore put aside. If there was ever a temptation to indulge in an Indian extravaganza it was resisted in favour of a room which would bear witness to royal patronage of India's crafts, especially the Punjabi woodcarvers. The surviving correspondence between Kipling and the Connaughts clearly indicates that they were not passive patrons, being as eager to propose their own ideas as to accept those of Kipling.[47]

Plans were well ahead by the Autumn when the Connaughts on a tour up-country visited Kipling at Lahore. Here they scoured the bazaars for curiosities and *objets d'art* which were supplemented by generous gifts from Kipling's own collection. The Bagshot room was much discussed and Kipling proposed the idea of covering the walls with carved panels and the ceiling with geometrical panels. The ceiling of the corridor was to be treated in a similar way and its walls were to be hung with *pinjra* or lattice-work display brackets **(82)**. Off the billiard-room there was to be a smoking-room with a carved ceiling which, at the suggestion of the Duchess, should resemble those to be found in the temples at Mount Abu. In addition there were to be carved and inlaid doors, carved fireplaces with elaborate overmantels, skirtings and cornices. All were to be made in Lahore, although there was a suggestion that perhaps they could have been made in England, presumably by Indian craftsmen such as those who were coming over for the Indian Village exhibition in Battersea Park, London in 1885 or by those who were going to the 1886 Indian and Colonial Exhibition.[48]

In the event the panels were carved in Lahore between 1885 and 1887 by Ram

Singh, Master Craftsman at the Lahore School of Art, probably assisted by his students. There were 241 panels altogether, each one differently decorated. Unlike the more abstract designs which Lockwood de Forest favoured, those from Lahore were rich in imagery from natural history, not all of Indian origin: tulips, irises, carnations, daffodils, roses, palm-trees, woodpeckers, peacocks, hoopoes, paddy birds, parrots, snakes and elephants, even the brass door handles were cast in the form of flying birds. Two vertical panels emblematically represented the Duke and Duchess: the Duke's contained a throne with yaks' tails or *chauris*, symbols of royalty, above which there was a hookah-pipe, vase and ewer and beneath, two elephants; the Duchess was represented by her initials and a coronet, a seated *ganesha* or elephant god, the hindu deity of wisdom and good fortune, above there was a vase and beneath two rabbits, European – not Indian – symbols of fertility. The imperial symbolism was self evident.[49] In 1888 the panels were sent to Bagshot and probably erected with the help of Mohammed Baksh and Juma, two Punjabi craftsmen who had stayed on in London at the close of the 1886 exhibition. The billiard-table itself was made in London and Kipling was asked to give the brass cue-holders and the marker an 'Indian' rendering. Finally a carpet came from India and the smoking-room was papered in 'Indian' wallpaper by Walton & Co. The room was finished by 1890 and it was seen by Queen Victoria in the company of Kipling in August of the same year.[50] She expressed her great delight with it and wanted one for herself.

At the time of its conception in early 1884 the Bagshot Park project provided a unique opportunity for Kipling to explore the uses to which Indian crafts could be put. It would be difficult to account for its unique nature and its acceptance by royal patronage not noted for innovation in artistic matters at this time, were it not for several factors. Firstly, the prevailing fashionable Queen Anne revival style with its ebullient use of decoration favoured the appraisal of similar techniques in India. It is not surprising therefore, to find that Richard Norman Shaw, chief exponent of the style, was an ardent supporter of Indian crafts. Because of the similarity between the two techniques the interchangeability of architectural features was also considered. In answering a question about adapting Indian features into English architecture, Purdon Clarke at the end of a lecture given in 1883, advised that were it not for the fact that the gothic oriel already existed in Western architecture, its counterpart, the deep bay window of India, would probably have been employable in England.[51] Within this context the use of Indian panels at Bagshot does not seem so extraordinary.

Secondly, the billiard-room more than any other had become susceptible to a certain latitude, or lapse of taste in its decoration. By the last two decades of the nineteenth century smoking and billiards had become socially more acceptable, although still a male preoccupation, and billiard-rooms were not infrequently decorated in outlandish, often Eastern styles. There were many

'sultan's dens' in England, one of the earliest being Scrivener's at Breadsall
Priory of about 1861. Matthew Digby Wyatt had designed another at 12 Palace
Gardens, Kensington in 1864. Glasgow has a superb room dating from the 1870s
which has walls of painted and gilded embossed leather, and a recessed 'throne'
with a peacock surround.[52]

Smoking-rooms too had become very Orientalised – there were some
splendid examples both in England and the United States, for example the J. D.
Rockefeller room of 1885 and another for William Vanderbilt. But Bagshot
differed from all the other billiard- and smoking-rooms in that it was the result
of a royal commission to actively promote and demonstrate how Indian wood-
carver's work could be used in England. It was the forerunner of Lord Brassey's
'Indian' room at Park Lane, London and the inspiration for Osborne. There was
also probably the hope that it would encourage Indian princes and the British in
India to follow suit.

The Queen was very enthusiastic about the Duke's new extension and it was

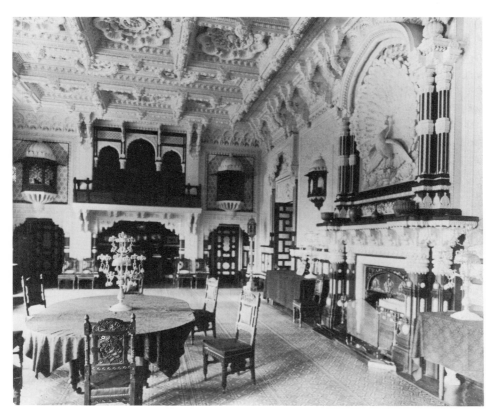

83. *Dining-room of Osborne House, Isle of Wight made for Queen Victoria to the
designs of John Lockwood Kipling and Ram Singh between 1890 and 1892. The
photograph taken c. 1900 shows the room in its original condition.*

115

just as well that Kipling was in England during the summer of 1890 for, having seen the 'Indian' rooms at Bagshot, she was determined to have one of her own **(83)**. The first intimation of this came in a letter of 18 August 1890 from Sir Henry Ponsonby, the Queen's secretary, to Kipling requesting that they meet to discuss the possibility of an 'Indian' decoration for a new dining-room then being built at Osborne.[53] Unlike the Bagshot rooms which were paid for by some of the Indian princes, the cost of the decoration of the room at Osborne was to be borne by the Queen. The compromises that resulted as a means of keeping the costs down meant that there would be little use of real wood carvings from the Punjab. In their place there were to be plaster enrichments. It is clear therefore that from its inception the Queen's room, unlike the Duke's, was no monument to India's craft traditions, even though Ram Singh was brought over from the Mayo School of Art, Lahore, where he taught, to carve the models for the plaster enrichments. The Queen insisted that an Indian be used for she and Princess Louise very much doubted that a British plasterer would be able to evolve an authentic Indian decoration. They seem not to have seen the work at Elveden Hall.[54]

Princess Louise with her invaluable experience of 'Indian' design gained through the Bagshot scheme, played an important role at Osborne. The first sketches which Kipling had sent to the Queen were not much liked. In a letter dated 1 November 1890 Ponsonby elucidated the Princess's criticisms: the fireplace was too narrow, a sideboard design was not liked, the cornice she felt was too ornamented and would tire the eye. Her suggestions were taken up including a proposal for a sculpted peacock over the fireplace, set within two columns and an arch, a fashionable reference no doubt to the craze for anything to do with peacocks. In this context however there may be an allusion to the peacock throne of the Mughal emperors which had become legendary in Europe through the description in J. B. Tavernier's *Les Six Voyages de Jean Baptiste Tavernier* published in 1676. It was to be another symbol of the Queen as the heir of the Mughal emperors. King Ludwig of Bavaria, with less justification, had seized upon this symbol of absolutism, and had the architect Franz Seitz design an extravagant version of a peacock-backed throne set within a Hindu pavilion surmounted by a dome and two peacocks, two elephants and exotic fans, and dripping with jewels. Is it merely a coincidence that it was designed in 1877, the year Queen Victoria was acclaimed Empress of India in Delhi?[55]

At the time Kipling was re-working his designs for the Osborne room, preparations were already in hand for having a master craftsman brought over from the Mayo School of Art, Lahore. At first the Queen felt that he should wait until the summer when the weather would be warmer, but assured that this did not matter since he would be given warm clothing and fuel for a fire, arrangements went ahead. He was to be paid £5 per week and £100 for the return fare. A cottage was assigned for his use at Cowes, near Osborne, and he

was to look after himself, thereby obviating all the inevitable culinary complications.

It was Ram Singh's first trip abroad and one can well imagine the mixture of trepidation and excitement that he felt when taking leave of his family. He must have wondered if he would see them again. One of his sons did in fact die while he was away. He arrived at Osborne on 16 Feburary 1891, stayed for two days to sort himself out, and returned to Kipling's residence at Earl's Court, London. At the end of March Kipling wrote to his friend Lockwood de Forest that Ram Singh took a very lively interest in London life but was bewildered by it. So he worked hard with Kipling on the Osborne designs, which were soon completed, except for some details, to the satisfaction of the Queen and Princess Louise. He made use of what he termed a Hindu-ised version of the architecture of the sixteenth century Mughal period. At the suggestion of the Queen and the Princess he made a design for a music gallery at one end of the room, to be made of carved wood and plaster. Messrs. George Jackson of Rathbone Place, London, were asked for an estimate for the building and plaster works.[56] They must have felt especially suited to this commission in view of the work they had done at Elveden Hall for Duleep Singh. The enrichments on the ceiling were made in fibrous plaster, the pagodas on the walls were made partly of wood and partly of carton pierre.[57] The music balcony was made in Honduras mahogany and the carved panels were brought from Lahore. The complete scheme was to cost £2,250 and Ram Singh was to be given a studio at Rathbone Place where he would carve the models for the enrichments.

Work proceeded throughout 1891. Kipling went back to Lahore in September leaving Sir Henry Ponsonby to wonder how on earth he was going to communicate with Ram Singh. Despite the special pleadings of the Queen and Ponsonby the work was not completely finished by December and to make matters worse Ram Singh had fallen out with the people at Jacksons'. This dispute was resolved and work continued. In December 1891 the Queen invited Ram Singh down to Osborne for five days over Christmas, during which time she told him how beautiful she thought the room was and gave him a signed portrait and a gold pencil case. In 1892 the Queen commissioned a portrait of Ram Singh from Rudolph Swoboda which now hangs at Osborne, alongside other portraits of Maharajah Duleep Singh, Hafiz Abdul Karim, Sir Purtab Singh, Ahmed Hussain an Indian servant and Mohammed Hosein a metalworker from Delhi. Princess Louise insisted on some changes to the doors opposite the music gallery and Ram Singh in the absence of Kipling was asked to re-design them. He also designed the ventilators, lampstands, a hanging lamp for the bay window, firedogs and a grate. What a pity he was not asked to design the chairs! At the suggestion of Princess Louise it was decided to have the decoration in white and gold only, since any other colouring she considered too 'common'. The room was finished in early 1892 but even then the weary and

homesick Ram Singh was not permitted to return to Lahore until some more work had been done at Bagshot Park.

What a contrast of expression and chasm of desire there is between Queen Victoria and her 'Indian' room which is so contained that it does not even ruffle the exterior of the Italianate house, and the monuments of her contemporary, King Ludwig of Bavaria. On the one hand, a Queen who ruled half the world, on the other a king who, deprived of his divine right to rule absolutely, withdrew into a world of megalomaniac, absolutist fantasies. With money and architects at his disposal he commanded buildings to appear at will. His eternal fantasies were given temporal embodiment in the form of buildings inspired by cultures and historical periods renowned for their despotism: from Europe the ambiance of medieval feudalism and the *ancien régime* of Louis XIV; from the East the mosques, Turkish pavilions and scenes from the mighty Himalayas. He commissioned elaborate stage settings for 'Indian' operas like Massenet's *King of Lahore* which were put on in his own theatre. Unlike Queen Victoria he knew a good deal about Indian literature in translation and for many years he tried to persuade Wagner to write an opera on the subject of the life of the Buddha.[58] His last stage production in 1886, shortly before his death, was of the Indian epic drama *Urvasi* by Kalidasa. The Queen had no need of such despostic fantasies to bolster wounded pride. If she did harbour residual fantasies about India, and there is some evidence to suggest that she did, they found an adequate, if not a dazzling expression at Osborne.

Marble Walls and White Reflections

In the late nineteenth century exhibition pavilions, constructed in the styles of the various countries involved, became an important means of establishing a national identity at a time when even countries in Europe were uncertain of their own cultural and historical backgrounds. The expression of nationalism became a considerable force in other arts including poetry and music. How much more true was this of countries who though under a colonial yoke were wanting to express their own individuality. In this as in other aspects of the Indian style story, the creation of Indian pavilions at international exhibitions was largely the work of one or two people, often as dedicated to the concept of empire as to the recovery of an Indian nationalism in art and architecture. The paradox perplexed only a few and it was resolved through historical processes. Two such people were J. Lockwood Kipling and Caspar Purdon Clarke, particularly the latter, and between them they were responsible for the appearance of Indian architectural styles at international exhibitions. It is no coincidence that this occurred at a time when there was more information about Indian architecture and there was an upsurge in Indian national feeling.

Many international exhibitions followed after the success of the 1851 jamboree, but the directors of the Paris Exhibition of 1867 were the first to propose the idea that each participating country should have a separate pavilion. Before this, all countries' manufactures were displayed in a vast 'mother' house, the design of the host country. It was at the same exhibition that an 'Indian' building was used for the first time though for functional reasons rather than a need to indicate a national identity. Inspired by the photograph of the Sayyid Osman Mosque in Ahmedabad, illustrated in Theodore Hope's *Architecture of Ahmedabad* (1866) an Indian-style boiler house was erected for heating the English court; its domed colonnade was perfect, or so it was thought, for the display of boilers since the open structure allowed adequate ventilation **(84)**.[1] An adjacent minaret acted as a chimney. It did not occur to anyone that instead of exhibiting English boilers the 'mosque' might have been used more appropriately to house Indian manufactures!

The association of an architectural style with a related product was by no means new, although it was twenty-seven years before the first exhibition

pavilion was designed in an exotic style. To the contemporary it seems obvious to relate a product to an appropriate image. It was not so obvious to former ages. For instance, despite the great number of years that Britain had been trading in Chinese tea it was only in 1822 that a Chinese façade was designed for a tea wholesalers. The design, by J. B. Papworth for the merchants F & R Sparrow of 8 Ludgate Hill in the City of London, influenced other merchants for fifty years.[2] In 1840 Nathaniel Whittock brought out a volume of shop front designs in which he strongly advocated the use of an 'Indian' exterior for shops which traded in Indian goods, especially textile shops, but also for those which sold tea and sugar. One of the reasons for this new departure was undoubtedly the manufacture of plate glass which allowed the façade to be treated with greater freedom than hitherto.

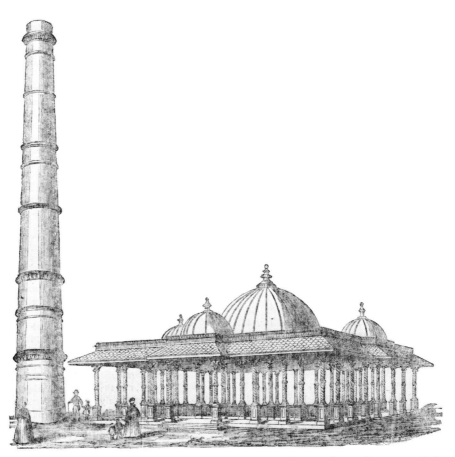

84. *The 'Mosque' style, English boiler exhibition pavilion at the 1867 Paris Exhibition inspired by the Sayyid Osman Mosque at Ahmedabad which was illustrated in Theodore Hope's* Architecture of Ahmedabad *1866.*

Whittock complained that ordinary architects and builders chose Greek or Roman architecture for shop fronts whereas if a grocer required a style which would distinguish his front from those of the draper or ironmonger 'any person other than an architect would direct his attention to producing a design something in the Chinese or Indian style of decoration'.[3] Traders in Indian goods should especially look to India for a front which could be selected from any one of 'the gorgeous temples and pagodas that grace the banks of the Ganges'.[4] For such an establishment Whittock produced an exotic design 'taken from the Sheven Pagoda at Mahabaliparram, the columns from a temple at Delhi'**(85)**.[5] Whether his idea was taken up, it has proved impossible to discover.

The East India Company made no attempt in their museum, which also acted as a manufacturers' showroom, to emulate the architectural forms of India. Probably, in Whittock's words, the directors feared that 'sugar and tea would lose their flavour if they were not sold beneath a Grecian entablature . . .'.[6] It was not until 1855 that pressure on space in the museum caused by an influx of exhibits from the Paris exhibition necessitated the erection of an extension. Matthew Digby Wyatt, the Company's surveyor, was called in and he proposed the conversion of the tea sale-room into a pastiche 'Mughal' Court. However, the attenuation of the columns caused by the height of the room gave it a very 'Moorish' air.[7]

There the idea rested until the French directors of the Paris Universal Exhibition of 1878 conceived the notion of having separate pavilions in different styles. This was probably an extension, in visual terms, of remarks made in the official guide of the 1867 exhibition which stated 'To make the rounds of this palace means literally to circle the earth. All peoples are come together here, and those who are enemies, here live side by side.'[8] Before 1878

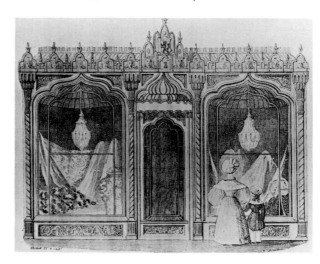

85. Nathaniel Whittock's design 'taken from the Sheven Pagoda at Mahabaliparram, the columns from a temple at Delhi' for a shop selling Indian goods, illustrated in Whittock's On the Construction and Decoration of Shop Fronts, *1840.*

each country was in a 'court' and India's productions were huddled together within the British section. Pressure on space for the 1878 exhibition necessitated the construction of separate buildings for each country and, although the Indian Pavilion was still housed in the British section, it nevertheless had its own identity **(86)**.

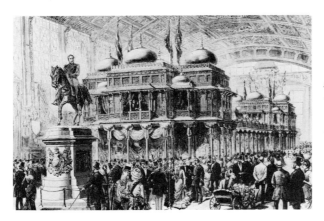

86. Indian Pavilion at the 1878 Paris Exhibition by Sir Caspar Purdon Clarke. It was the first time a special pavilion had been erected at an international exhibition to house the manufactures of India.

The pavilion was designed by the architect Sir Caspar Purdon Clarke who was later to have a very distinguished career in the South Kensington Museum. His father, Edward Marmaduke Clarke, owned the Islamic-style Panopticon in Leicester Square. After training as an architect he worked for a time in Teheran on the new consular building and a Roman Catholic church. The projects at an end he took the opportunity to travel in Turkey, Syria and Greece buying objects for the South Kensington Museum. In 1880 he was appointed to the Indian Department and returned as Keeper after a buying trip to India in 1881–2. Two of his contacts and friends were Kipling and Lockwood de Forest from whom he bought some carved wood manufactures for the Department. For over twenty years he designed or advised on the construction of all the important Indian pavilions. The first of these, for the 1878 exhibition, was designed in what was to become a familiar mixture of styles called the 'Indo-Saracenic' from which he did not waver. Not one of his buildings ever employed Buddhist, or Hindu architecture of the South. The reasons for this may lie with the perhaps inappropriate forms of the latter but perhaps also with the recurring theme of imperial Britain as heir to the Mughal traditions. Clarke's design seems to have been liked. It is one of history's ironies that it was at this exhibition that the full extent of the failure of the Government of India's school of art courses became all too apparent.

At the Calcutta exhibition held during the winter of 1883–4 courts representing different parts of India, and carved in local styles, were used. They were really only carved wooden panels, some even in plaster, held up on pillars so that goods could be displayed beneath them. The idea was taken up and

extended for the 1886 India and Colonial Exhibition in London. There were courts representing Rajasthan and the products of various towns in the region including Jaipur; Central India, Bombay and Baroda; Bengal and Nepal; the North West Provinces with Oudh; the Punjab; Kashmir; Central Provinces, Madras and Mysore, Coorg and Hyderabad.[9] As at Calcutta each court was represented by distinctive screens either in wood, stone or plaster. They stood about ten feet in height and varied in length. They were all carved in India at the expense of the Government of India and brought over to London. Kipling in Lahore went to some trouble to make sure that the Punjab screen was suitable and effective.[10] The Bengal screen was in fact not illustrative of a carving tradition at all since none existed, instead an example of Bengali brick architecture was constructed. Some trouble was taken over reproducing the various styles which led the writer of the official guide to regret that lack of space made it impossible to reproduce a tripolia or three-arched gateway for the Jaipur Court. However, since it was the custom to erect drum houses or *nakar-khanas* over gateways in Rajasthan this at least was put above the screen.[11]

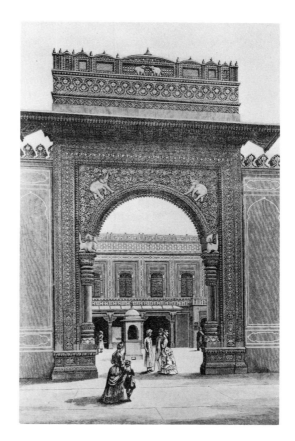

87. The Gwalior Gateway erected at the 1886 India and Colonial Exhibition, London, under the general direction of Major J. Keith with funds provided by Maharajah of Scindia in 1883. The intention was to display the quality of the Gwalior stonecutters and stimulate interest in their once flourishing craft. It was illustrated in Journal of Indian Art and Industry *no. 14.*

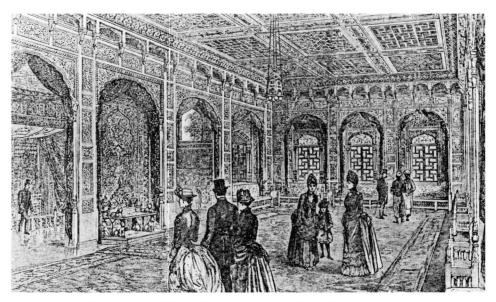

88. Durbar Hall at the 1886 India and Colonial Exhibition, London, taken from the Illustrated London News *designed and carved in eight months by two wood cutters Muhammad Baksh and Juma who were brought to London for the purpose. People were amazed by the virtuosity of the carvers and their unfaltering design sense.*

One of the reasons for reproducing the various styles was educative, the organisers wished to communicate to visitors the diversity of India's architecture. No monument was calculated to do this more than the Indian palace designed by Purdon Clarke which was intended to represent a typical 'Royal Residence' in 'feudal India'. The gateway was no confection but in fact a real gateway given to the South Kensington Museum by the Maharajah of Gwalior **(87)**.[12] It formed the centre-piece of the Indian section. Through the gateway the visitor went into a courtyard where he or she could mingle with the specially imported Indian craftsmen who could be seen at work.[13] On the upper floor of the Indian palace was the Durbar Hall **(88)**, the general design of which was by Clarke but the intricate carving in pinewood was done by the Punjabis Muhammad Baksh and Juma between June 1885 and April 1886. They astonished visitors by their technical virtuosity and by the richness of their invention, no two designs being the same. After the exhibition was finished the Durbar Hall was bought by Lord Brassey, re-designed by Clarke and re-erected at his house on Park Lane in 1887. While attention was paid to authenticity a writer, T. N. Mukharji noted in the *Journal of Indian Art and Industry* that, because of the hot climate of the Punjab plains and the expense woodwork was not used extensively in the buildings of the region.[14]

At the opening of the exhibition the Queen led a procession through all the galleries and exhibition areas to the adjoining Albert Hall. It had taken her one

and a half hours to encircle the earth, her imperial domain. Through this highly symbolic ritual she could legitimately claim to be head of the largest Empire since the time of the Romans. It was also to be the closest that she came to seeing her overseas colonies. At the opening ceremony held in the Albert Hall three verses of the national anthem were sung and out of deference to Imperial India the second verse was sung in Sanskrit in a translation made by Professor Max Müller. The Queen sat on a splendid throne which had once been the prize possession of Maharajah Ranjit Singh, Duleep Singh's father.[15] The anthem was followed by an ode specially written for the occasion by the Poet Laureate, Alfred Lord Tennyson, and set to music by Arthur Sullivan:

> *Sons, be welded each and all*
> *Into one Imperial whole,*
> *One with Britain heart and soul!*
> *One life, one flag, one fleet, one Throne!*
> *Britons hold your own!*

One of the growing features of international exhibitions towards the latter end of the nineteenth century was the presence of 'natives' of the various countries involved. This proved one of the most popular aspects of the Indian and Colonial Exhibition. A specially constructed 'village' was made for them in South Kensington, and some were invited by the Queen to visit Windsor and Osborne. Rather touchingly she was always anxious lest these people from hot countries should be adversely effected by the inclement English weather. At the 1888 Glasgow Exhibition Daniel Santiagoe, the Indian author of a well-known book on how to make curry, gave practical demonstrations, and Indian food could be had served by Indians in the Bungalow Restaurant **(89)**.[16] In this cosmopolitan atmosphere there was no doubt that Indians were themselves living exhibits.

The appearance of indigenous peoples at international exhibitions was part of a process of creating an international city, for this is what exhibitions had become by 1889, the year of the Exposition Universelle de Paris. The greenhouses of former years had given way to the dream city, an exotic street, the *rue de Caire* was built in Paris to accommodate all the exotic nations. On this street was Purdon Clarke's *serai*, the Indian pavilion **(90)**, built in Clarke's by now customary mixed-style. Details were taken from buildings in Ajmer, Ahmedabad, and the Panch Mahal at Fatehpur Sikri.[17] The exterior was to have been stained to imitate the sandstone and marble of the Red Fort at Agra, but in the end an unsatisfactory Venetian red paint was used. Inside there was a domed tea-room off which led a central gallery which contained the exhibitors' stalls. Each dome on the roof indicated a division in the gallery. The stalls themselves were not large and they were crammed with textiles, carvings and other art manufactures.

89. An old photograph showing the Bungalow Restaurant at the Glasgow International Exhibition of 1888, where curries served by Indians could be had.

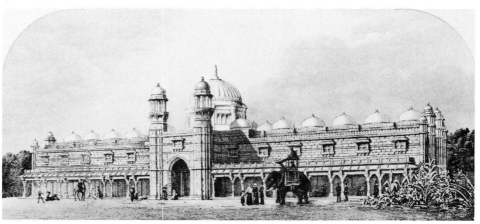

90. Indian pavilion at the 1889 Paris Exhibition by Sir Caspar Purdon Clarke. The verandah was copied from the Panch Mahal, Fatehpur Sikri, the central minarets and arch had been adapted from Ahmedabad originals and the twelve projecting windows had pierced stone screens also taken from Ahmedabad. Each of the domes on the roof marks a separate exhibition space. Beneath the main dome was a fountain restaurant, illustrated in Journal of Indian Art and Industry *no. 28.*

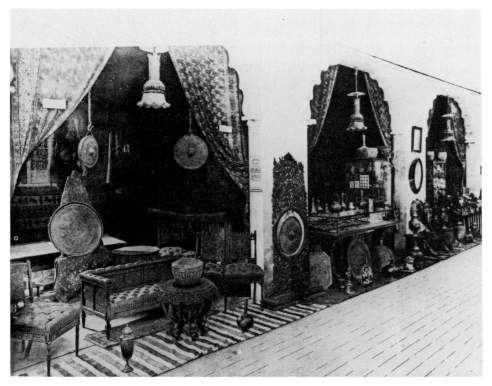

*91. Indian goods on view at Proctor & Co's display at the 1889 Paris Exhibition.
Proctor & Co had a shop at 428 Oxford Street, London where they showed imported
items made in their workshops at Bombay, as well as silks, embroideries, metal ware,
jewellery and musical instruments from other areas.*

Among the exhibitors the famous enterprising Indian importers Ardeshir &
Byramjee, and Framjee Pestonjee Bhumgara were as ever present. Proctor & Co
of 428 Oxford Street, London had a good display of carved furniture **(91)**.
Liberty & Co had become world famous for their specially made oriental
products; their textiles, jewellery and their soft silk *pyjamas* were the thrill of
patrons everywhere. These exhibitors displayed their wares at exhibitions all
over the world. They were often very successful and their presence could create
markets where none had previously existed. The Antwerp Exhibition of 1885
was a case in point. Previously exports to Belgium had been an unbelievable
£14 in 1875, but as a result of the exhibition, sales rose to £2,151,728.[18]
Similarly the Melbourne Exhibition earlier in the decade had quite dramatically
increased the demand for Indian goods in Australia.

As the century came to its close the exhibition plans became more and more
wild, concerned as much with entertainment as manufactures. Chicago's
Columbian Exhibition of 1893 was the first to have all its buildings painted

predominantly white, hence the name 'White City'. Although there was no specially designed 'Indian' pavilion, Indian goods were still on display and were drawn from *objets d'art* in the Maharajah of Mysore's collection. Queen Victoria sent one of her own water-colour portraits of her Indian *munshi*, Abdul Karim. The American public were entertained on the 'street of Cairo' (built in emulation of the one at the 1889 Paris Exhibition) by a throng of exotic inhabitants from Egypt, the Middle-East and Africa. There were many voluptuous displays of sword dancers, candle dancers and 'splendid specimens of oriental beauty'.[19] In the Egyptian theatre could be seen the dance of the veils which perplexed the authorities but delighted the crowds. There was another version danced by an Algerian dancer whose theme was love, 'but it is the coarse animal passion of the East, not the chaste sentiment of Christian lands. Every Motion of her body is an illustration of her animalism.'[20] There was yet more competition from Fatima in the Persian theatre who fascinated young men by her wild interpretation of the *danse du ventre* so much so that it was repressed by the authorities. Such 'coarse' displays were not allowed in Britain.

Imre Kiralfy,[21] inspired by the Chicago Exhibition and the stage designs of Antonio Basoli, saw the erection of a complete 'Indian' city in his Empire of India Exhibition of 1895 in London. Like Purdon Clarke he preferred the mixed form of Indo-Saracenic architecture to the ancient styles. The mosque-like structures were arranged around a large lake, there was a Burmese theatre, 'colossal Indian jungle', illuminated fountains, and a Great Wheel 300 feet high, for exhibitions had also become fairgrounds and art galleries. The whole was illuminated by thousands of electric lights.

The area which these exhibitions occupied was vast but at least all the buildings and pavilions were kept together. However, at the Brussels Exhibition of 1897 pressure of space entailed having the colonial exhibition buildings erected four miles away from the main exhibition halls. This proved to be disastrous and when the French Executive suggested a similar arrangement for their 1900 exhibition it was met with a storm of indignation. Eventually all colonial buildings were housed in the Trocadéro Gardens. Mr Charles Clowes prepared plans under the direction of Purdon Clarke for a pavilion in the usual mode, except that the decoration was much richer **(92)**. This was rejected by the French Committee who envisaged nothing more than light kiosks on the site, but after much persuading they gave in and a new plan was drawn up which was accepted. It is interesting for its acknowledged indebtedness to the magnificent book by Colonel Swinton Jacob, entitled *Jeypore Portfolio of Architectural Details* (1883).[22] It was constructed of wood and iron and decorated with fibrous plaster enrichments taken from details in the Indian museum at South Kensington.

The Indian pavilion was only one of many national styles on parade at the exhibition. All along the banks of the Seine on what was called the *rue des*

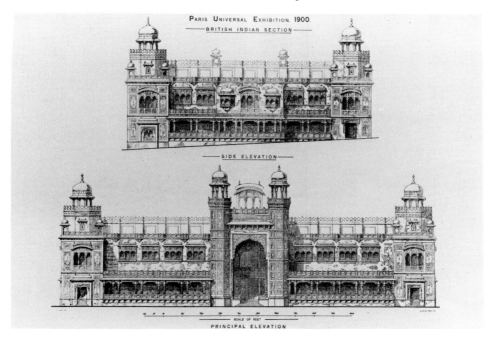

92. *Original design for an Indian pavilion at the 1900 Paris Exhibition by Charles Clowes with advice from Sir Caspar Purdon Clarke. Details were taken from Indian examples at the South Kensington Museum (now Victoria and Albert Museum) and Col. Swinton Jacob's* Jeypore Portfolios, *illustrated in* Journal of Indian Art and Industry, *no. 67.*

nations there were buildings reflecting the house styles of Russia, Italy, Belgium, Norway, England, the United States, Turkey and Germany. If the idea of looking at all these different buildings just made the feet ache and the legs wilt then all these styles could be found in one building, the extraordinary *Tour du Monde*, a conglomeration of 'Hindu' *sikharas*, 'Chinese' pagodas, towers, turrets, bays and mullions built at the foot of the Eiffel Tower **(93)**. It was conceived by the artist Louis Dumoulin and was the product of ten years travel in the East. One observer likened the whole exhibition to a fairy palace made up of historical pastiches and orientalisms, 'Provincial observers are astonished to see rising up before their dazzled eyes more minarets than around the Golden Horn, more cupolas than at Udeypour, more gopuras and stone-lattice-work than at Kombakoroum or Chillambaram'.[23]

There can be little doubt that the apotheosis of the use of an Indian style at an exhibition was to take place at the Franco-British Exhibition, held at Wembley, London in 1908. In this exhibition the imitation of Indian architecture, despite Purdon Clarke's non-participation, was still firmly committed to an Indo-Saracenic or Mughal style **(94)**, rather than to Hindu forms. The Indian Palace in

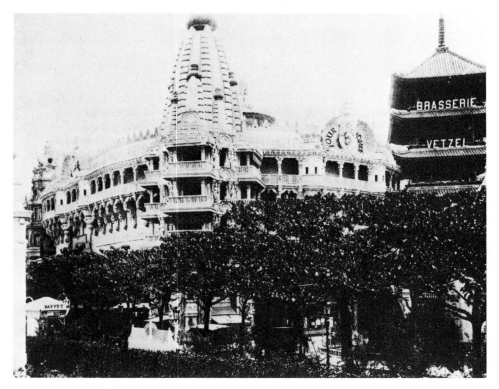

93. *The exotic Tour de Monde made up from a hotch-potch of Eastern styles assembled by the French artist Louis Dumoulin for the 1900 Paris Exhibition. A Hindu tower dominates the facade, illustrated in* Exposition de 1900, L'architecture et la sculpture.

which the industries of India were exhibited was based upon buildings at Agra. Within were displays from the schools of art: textiles, muslins, carpets, rugs, various teas, even motor car bodies.

This was the usual way of employing the Indian idiom but Imre Kiralfy, the organiser, extended its use a stage further than in his 1895 conception.[24] With the help of his French architect, Marius Toudoire, better known for his railway stations, a dreamy White City (after the Chicago model), arose before the eyes of the incredulous population at Shepherd's Bush. Situated around a large lake the 'Indian' pavilions housed the products of France as well as Britain. India, it seems, was all-embracing. Its lake, glistening domes, minarets and cupolas, waterfalls, exotic boat rides and entertainments were proof at last that the *Arabian Nights* tales had been eclipsed by Laurence Hope's *The Garden of Kama*.[25] The atmosphere of the exhibition evoked the passionate fantasy of those erotic verses, perhaps deliberately,

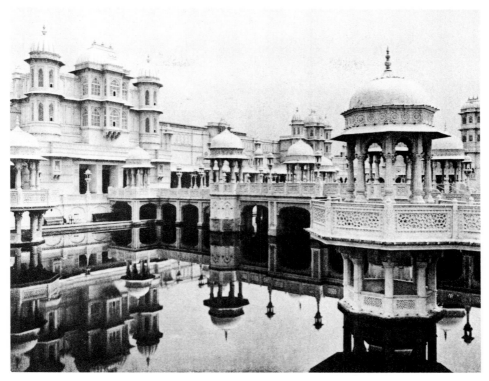

94. *Romance and splendour in the Court of Honour at the Franco-British Exhibition held in London in 1908.*

I sit in the shade of the Temple walls,
While the cadenced water evenly falls,

(REVERIE OF MAHOMED AKRAM
AT THE TAMARIND TANK)

And when the summer heat is great,
And every hour intense,
The moghra, with its subtle flowers,
Intoxicates the sense.

(STORY OF UDAIPORE, TOLD BY
LALLA-JI, THE PRIEST)

The exotic Court of Honour brings to mind another verse of the last poem:

She saw the marble Temple walls
Long white reflections make,
The echoes of their silver bells
Were blown across the lake.

The White City was a purely frothy theatrical fantasy, an iced-cake with industrial ingredients. It was a long way from Prince Albert's conception for the 1851

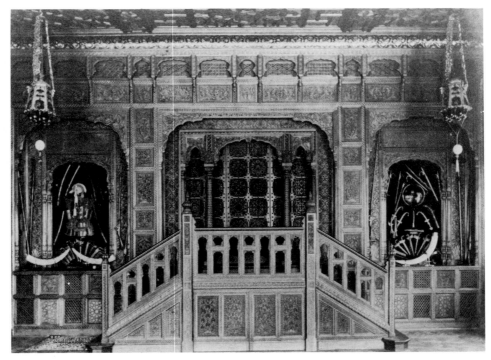

95. Lord Brassey's Durbar Hall (from an old photograph) which he had bought from the 1886 India and Colonial Exhibition and had re-erected at his house on Park Lane, London. It was later given to the Hastings Museum and Art Gallery where it still remains.

Exhibition but how King Ludwig would have enjoyed it! It was an immense success, and not even the British Empire Exhibition of 1924 surpassed it in extravagance. However, the British were intoxicated by the fantasy of India, the fires of Indian nationalism smouldered.

With few exceptions it is difficult to relate exhibition architecture and design directly to the instigation of specific 'Indian' schemes. The Duke of Connaught may have been influenced by the carved screens at the Calcutta exhibition but his room at Bagshot was more the product of a chance meeting with J. Lockwood Kipling and a desire to promote Indian crafts generally. One exception is the Durbar Hall which Lord Brassey, one of the exhibition's commissioners, had re-erected with the help of Purdon Clarke, at his home at 24 Park Lane, London **(95)**. It housed Brassey's collection and was known as the Sunbeam Gallery after his famous yacht of that name. Originally it was in two parts, an upper gallery made from pieces from the Bombay Court, which housed the collection, and the Durbar Hall which was a re-arrangement of the wooden panels and arches from the hall of the same name. In addition a doorway from Lahore was inserted.[26] Since the Durbar Hall merited considerable praise at the exhibition, it would be surprising if Brassey's room was unique especially in

view of the fact that two carvers stayed on in London because, as Kipling noted in 1891, they had so many commissions. The Marquess of Aberdeen's 'Indian' music room designed by Liberty's in 1887 was a more chaste example of an 'Indian' scheme and may have been influenced by the Durbar Hall.[27] The appearance of the Durbar Hall at the exhibition and its subsequent sale must surely have provoked Macfarlane and Co. of Glasgow, the well-known cast-iron manufacturers, to design and cast the 'Mughal' Durbar Hall which was featured in their catalogue *Illustrated Examples of Macfarlane's Architectural Ironwork*.[28] Glasgow was more than usually influenced by the 1888 international exhibition held in that city. Following in its wake, several new buildings sprouted domes and minarets, the most interesting of which was the Botanic Gardens railway station. Its design by James Miller, a combination of half-timbered gabling, verandah, and minarets, augured well for his 1901 Glasgow exhibition architecture.

In the realm of entertainment buildings exhibition architecture was much more influential. The Electric Theatre **(98)** at Paddington and the Globe Cinema **(99)** at Putney, both erected in about 1910 were doubtless inspired by the Franco-British White City. The architecture of the fairgrounds and amusement parks which came to be associated with international fairs was undeniably influenced by exhibition architecture. In the last two decades of the nineteenth century their forms were mostly inspired by the minarets and domes of a generalised East, although some were directly inspired by Indian architecture even if the results were less than authentic: the Kursaal at Ostende, Belgium, with its Hindu towers; Coney Island, New York with its oriental miscellany and gigantic hotel in the shape of an elephant and *howdah*. There was also a 'Lucknow Palace' and music hall at Idora's Park, Youngstown, Ohio; the lido, Santa Cruz, California; the 1891 pier at Nice, France and the pier embellishments at Brighton in 1911, etc., etc. There was of course a tradition of 'fun' architecture at watering places and seaside resorts, but by the turn of the century their former elegant restraint had been undermined by the riotous displays of fantasy architecture at international exhibitions.

Fantasy and Illusion

It was to be expected that a style so much associated with fantasy and illusion would eventually find its way into the theatre, although it is surprising just how long the process of assimilation took. Not until the late nineteenth century was the 'Indian' style employed in theatre decoration in any substantial form and then only in interiors. Henry Holland's Drury Lane Theatre (1791) had an unusual, whimsical gothic interior with elaborate drapes but there were no imitators or substitutions of 'Indian' for gothic as might have been expected at this time. Robert Smirke's Covent Garden Theatre (1808–9) and Benjamin Wyatt's rebuilding of Drury Lane (1811–12) were both classical conceptions as were all the other theatres in England for many decades. This conservatism was partly asccounted for by the classical origins of the theatre, which made plain Grecian seem appropriate. Limitations were also imposed by the managers who wanted traditional decor at modest prices, and although they were more willing to spend money on the interior than the exterior there seems to have been little inclination for innovation. Unlike on the continent, there was no official patronage of the theatre, and England never had buildings of the quality of Schinkel's Schauspielhaus, Berlin (1818) or, at a later date Charles Garnier's Opera House in Paris (1875). With a few exceptions, some noted above, there developed a tradition in England according to which theatre designers tended to be local builders or engineers rather than trained architects. Their lack of professional training led them to eschew the rules of architectural ornament and design buildings of much grammatical confusion, especially during the second half of the nineteenth century when there was a demand for elaborate ornamentation. Hence the integration in the late nineteenth century of alien elements. However, it was John Nash who, with characteristic adroitness introduced some lighthearted gilded palm trees with octagonal trunks to flank the proscenium arch at the Theatre Royal, Haymarket (1820); columns which he had already used at the Brighton Pavilion.[1] It was the only remotely 'Indian' feature in an otherwise old-fashioned interior and was obviously thought suitable to the productions being contemplated there which were 'light comedy, comic opera, and broad farce; tragedy . . . being rarely, if ever performed'.[2]

An engraving of Nash's Haymarket interior was published in 1825[3] and it may have been this view which influenced the design of a more interesting 'Indian' interior in New Orleans in 1842. The original St Charles Theatre, a grand

classical building by Antonio Mondielli, a local scene designer from New Orleans, was burned down in 1839. The New St Charles was built in a less opulent style, but was more original and up to date than its predecessor. Its façade was very plain but the expense saved on the exterior was utilised inside. The originality and beauty of the new building was noted in a newspaper report published to coincide with the opening on 18 January 1843. The report particularly mentioned that, 'In place of the old fashion of painted ornaments around the fronts of boxes, we have an open balustrade producing an effect quite new and beautiful'.[4] It was the 'Hindu' columns which called forth the most comment. Four of them were arranged in pairs flanking the private boxes. They were 'composed of a mixed style of architecture, and copied after those of the celebrated Benares'. This is a clear reference to the architect's source, William Hodges's *Travels in India* published in London in 1793. On page 62 there is a plate of a column of the 'Vish Visha Temple'[5] at Benares which had especially attracted Hodges's attention because of the similarities he discerned between it and Classical examples. The architect of the New St Charles copied Hodges's illustration with much care, only slightly altering the capital. How an architect in New Orleans came to examine a copy of this book is obscure. In 1805 a French edition of Hodges's book was published in a translation made by the orientalist Louis Langlés.[6] It is probable that given the traditional links between New Orleans and France, the architect saw this edition. It is also possible that the architect was acquainted with the new ideas about style then being discussed in New Haven, Connecticut. Certainly there was an attempt to produce something not old-fashioned but 'new and beautiful'.

In neither England, the United States, nor anywhere else that I have been able to discover was there another 'Indian' theatre for nearly fifty years. There was a place of public entertainment in Drury Lane called the 'Great Mogul' (named after the Emperor Aurangzeb), the origins of which went back to the seventeenth century.[7] In 1847 it was called the 'Mogul Saloon' and variously after called the 'Turkish Saloon' and the 'Mogul Music Hall' but it is not known if the theatre in anyway reflected its name.[8] Islamic influence in theatre design had begun to invade the infidel capital early in the nineteenth century. The White Conduit House pleasure gardens in Islington were in the 1820s re-designed in a mixed Islamic style combining cusped arcades, 'Mughal' gateways, Chinese and Gothic pavilions, and shady walks. Here could be had 'hot loaves, tea, coffee, and liquors in the greatest perfection, and milk from cows which eat no grain'.[9] But of all the Islamic designs it was the façade and interior of the Royal Panopticon in Leicester Square, London which attracted the most attention and was the most influential. It was designed in 1851 by T. Hayter Lewis and based upon an idea by Edward Marmaduke Clarke (the father of Sir Caspar Purdon Clarke). The style was suggested only as a 'novelty'[10] and Lewis

felt free to use the Islamic style since 'The Saracens had not been in the habit of building Panopticon institutions'.[11] Eventually all objections were overcome and in the *Illustrated Handbook* for the building the new style was hailed as the beginning of a new era in street architecture. At last it was officially recognised that 'with certain modifications, the architecture of a southern climate' could be adapted for use in London.[12] In its original condition the Royal Panopticon had a motley array of Islamic features, horseshoe arches, minarets and an interior replete with 'Alhambresque' columns, 'Santa Maria del Blanco' arches, balustrades, an organ and a fountain in the auditorium.[13] As a panopticon it was a failure. In 1858 it was converted into a theatre and suitably re-christened the 'Alhambra Palace'. The interior survived the modifications of 1882 until 1912 when it was completely rebuilt as the New Alhambra Theatre. Until that time it retained its Islamic interior and was the forerunner of exotic theatres and cinemas.

Then, suddenly by a curious coincidence, there were two 'Indian' theatres conceived in the same year, but 5,000 miles apart. One was the Tivoli restaurant and theatre in the Strand, London, and the other the Broadway Theater in Denver, Colorado. The latter had the most elaborate 'Indian' theatre interior ever devised in the nineteenth century and was only superseded in the 20th century by Thomas Lamb's cinema designs of the 1920s.

The Broadway Theater was part of the Metropole Hotel complex built for the Windsor Land and Investment Company, a consortium based in England. The architect was Frank E. Edbrooke, a distinguished local architect whose work shows the influence of Louis Sullivan and Henry H. Richardson but who was no slave to their ideas. Edbrooke had designed many important buildings in Denver. One of these was the Tabor Grand Opera House (1881) which he had worked on with his brother Willoughby Edbrooke. The plan and the decor of the opera house were to serve as a model for the Broadway. Several new features had been introduced and the style was sufficiently unusual for the local newspaper to call it misleadingly 'Modified Egyptian Moresque'.[14] This was a reference to the carved 'Saracenic' columns of cherry wood which supported the proscenium arch, and the ceiling which was thought to resemble a 'Turkish Mosque'.[15] An important innovation was the separation of the private boxes from the stage and the balcony thus increasing the sightlines. The boxes were three storeys high and capped by conical domes. In appearance they were very similar to pagodas. At each level of these three-storeyed 'pagodas' there was a semi-circular box decorated with rich carpets, curtains 'of silk plush of a soft sage green, maroon and old gold colours'. The ceilings were composed of tapestry gathered together in a pleated half circle with the overall aim of securing 'imposing yet soft lines and warm colouring without the introduction of anything flashy'. The result was a refined and elegant interior of much distinction.

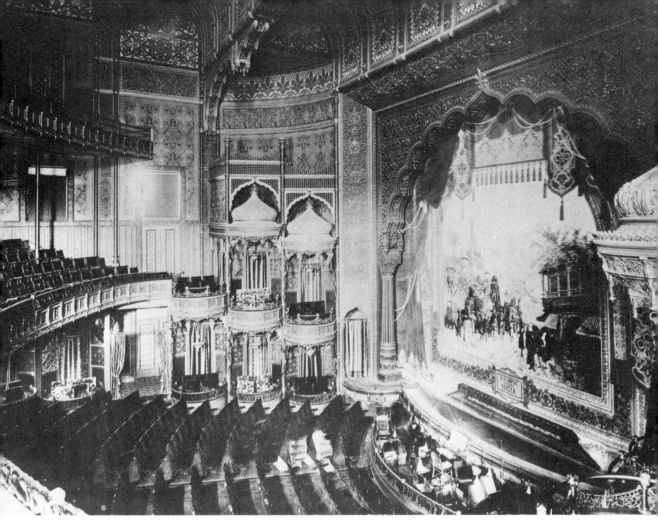

96. *Broadway Theater, Denver, Colorado c. 1900, by Frank E. Edbrooke which opened in 1890. Edbrooke's use of the 'Mughal' elements was dramatic and highly original as was his unusual separation of the boxes from the stage. Demolished.*

Eight years later the same management erected the Metropole Hotel complex (the theatre opened in 1890 and the hotel in 1891). Evidently the management now wanted something more up to date and more 'flashy', if the results are anything to go by. Externally, the building was designed with two towers connected by a semi-circular arch like Edbrooke's Ernest & Cranmer building (1889–90) and his Mcphee Block (*c.* 1889).[16] Some typical Richardsonian elements appear in the façade such as Romanesque, Norman and Venetian-Gothic arches but not a hint of the exoticism within. At the time of its construction it was considered the most modern hotel in the Western States. The theatre **(96)** was approached through the semi-circular arch which led to a 130 feet entrance hall; the floor was composed of imported English tiles, the walls were of polished marble, and the ceilings painted with frescoes. Once inside the auditorium the patron would doubtless have been astonished by the

expansive 'Mughal' proscenium arch, the two-storey semi-circular 'Indian' private boxes, which like those at the Tabor Grand Opera House were detached from the stage. They were surmounted by domes and set with 'Mughal' lattices. The interiors of each box were covered in Indian jute velour and upholstered in deep olive green. The lighting fixtures were also based on Indian designs, as were the details of the balustrades, balconies, boxes, and wall and ceiling decoration. The ceiling was frescoed in blue and sienna by a local artist, Jens Eriksen. The large orientalist painting on the house curtain was done by the Chicago artist Thomas G. Moses.[17] Entitled *A Glimpse of India* it depicted a scene in a bazaar in which a procession of elephants with *howdahs*, camels and people are marching into the distance.[18] On the right were shops and tropical trees 'which wave greeting to the audience'. A palanquin can be seen as can a bird house perched on its solitary column, as well as a mosque gateway. It was a sophisticated scene which could well have graced the walls of a Paris salon, or the houses of the 'fashionable' on the East Coast where views of Moorish Spain, North Africa and the Middle-East were highly desirable.

One is left wondering why the Indian style was chosen for a theatre in Denver, Colorado? In answer one can only speculate since there is no evidence. Edbrooke was an original architect who could transform new ideas through his own ebullient character into something very personal. This is shown clearly in his other work. Like his English contemporary, the theatre architect Frank Matcham, he was not afraid to get cavalier about ornament if necessary. The use of the 'Indian' style may also reflect the preferences of his design team, about whom very little is known. One of them, Franklin Kidder, had trained in Boston between 1882–88 and had arrived in Edbrooke's office in 1888.[19] He probably brought the latest East Coast ideas with him including the latest fashion for Indian interiors then being promoted by Lockwood de Forest. However, the English connection should not be forgotten. The owners of the Metropole were based in England, through this connection, the architect may have become familiar with the various exhibitions which had taken place in London during the 1880s, the most important of which was the 1886 Indian and Colonial Exhibition. Surely it is no coincidence that *A Glimpse of India* contains a bird house, an unusual feature very much like the one which had been constructed for the exhibition in London, and which had been illustrated on page 23 of Frank Cundell's *Reminiscences of the Indian and Colonial Exhibition in 1886.*

Britain had no 'Indian' theatre interiors of the sumptuousness and 'authenticity' of the Broadway. But she did have the Tivoli restaurant and theatre in the Strand, London, designed by Walter Emden and built between 1888 and 1891.[20] During the 1870s Emden, though originally a civil engineer, had begun to make his name as a theatre architect, often with the collaboration of others such as Bertie Crewe and C. J. Phipps.[21] The Tivoli had a façade based upon the Hôtel de

Ville, Brussels which completely belied the eclecticisms inside. There were suites of private dining rooms in a multiplicity of styles, including a Palm Room, Flemish Room, Louis XVI Room, Japanese, Arabian and a Pompeian Room and a theatre which was 'Indian in Style'.[22] Emden probably felt that the liberal use of Indian motifs in the auditorium would be perfectly consonant with other aspects of the Tivoli's conception. There were Hindu gods above the proscenium arch, and in the recessed panelling of the balconies, Mughal arches, and squat Ellora columns with elaborate brackets. What a welcome distraction this 'Hindu' Pantheon must have provided from the drabness of Victorian London. The source for this multiplicity may have been a scheme which was published in the November 1884 number of the *Decorator and Furnisher*. It showed the interior of the Hoffman House Hotel on 25th Street New York. Here, the journal revealed, was a suite of oriental rooms 'doubtless more elegantly and gorgeously fitted up than any other rooms for rent in the world'. The first room was Chinese, the second Indian, the third Persian, the fourth Moorish, the fifth Turkish and the sixth 'Old English'. The whole forming 'a panorama such as no other hotel can offer'. The Hoffman House Hotel had an Indian room with windows 'screened by Metallic trellis work', 'walls of matting brocades', 'Costly and rare Indian vases and ornaments' and the mantelpiece was constructed of hanging mirrors and a carved panel representing 'An Indian shield and armour'. A trip through these rooms was to be considered as an excursion to the Orient, a voyage of discovery 'through a bit of dreamland', for the ultimate destination of this exotic tour was the reality and 'cheerful comfort of the aristocratic Old English room'.[23]

Emden's interest in oriental details was surpassed by the leading theatre architect of the time, Frank Matcham (1854–1920). Between 1886 and 1910 Matcham was responsible for the design of over 150 theatres, about half the total erected in Britain. He was born in Newton Abbot, Devon and moved to Torquay where, after attending Babbacombe School he became apprenticed to a local architect, George Sondon. During the 1870s he moved to London and joined the practice of Jethro T. Robinson, consulting theatre architect to the Lord Chamberlain. After Robinson's death Matcham took over the practice. His extrovert personality and flamboyance were admirably suited to the design of theatres, especially their interiors, for he never really mastered the grammar of external ornament. His careful planning was matched by a bizarre sense of fantasy and in this he was the forerunner of the later cinema architects in the United States. Unlike Emden, Matcham made frequent use of Indian elements, combined with others, to create interiors of amazing virtuosity. He cared little for historical authenticity so he brought together Hindu gods, elephant capitals, boxes surmounted by ribbed domes, cusped arches and elements of chinoiserie; all played a part in expressing Matcham's vision of the mythology of fantasy. His first oriental theatre was the Empire Palace, Edinburgh (1892), followed by

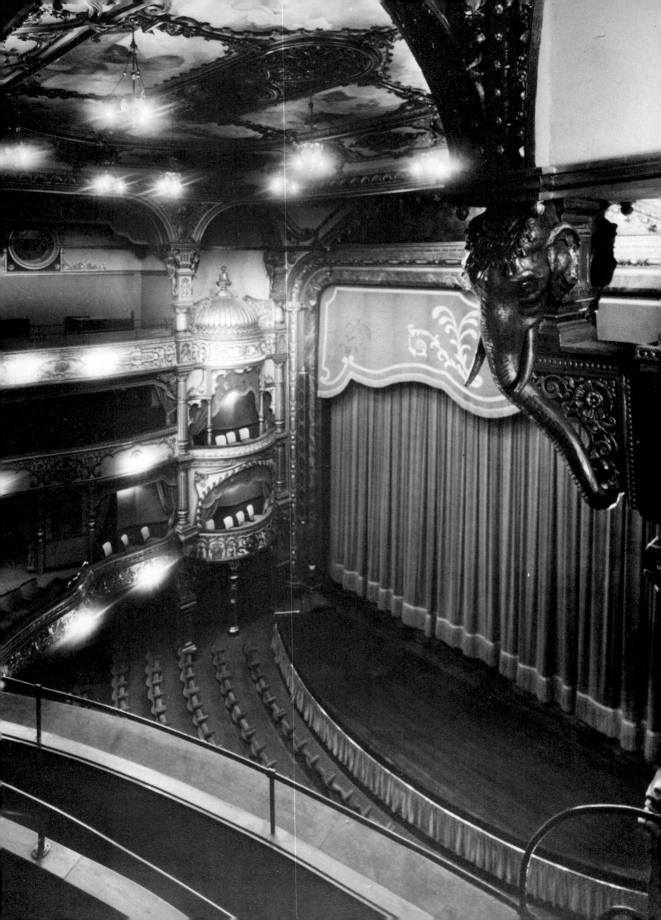

the Grand Opera House, Belfast (1895) and Brighton Hippodrome (1900). In all of these Matcham used elaborate columns, cupolas on private boxes, Moorish balustrades and the by now obligatory elephant capital. Of the above the Grand Opera House was the most excitingly Eastern **(97)**. The *Belfast Newsletter* called it 'a perfect Eastern palace'.[24] The writer remarked on both the style and the luxury with which the theatre had been decorated, the auditorium had handsomely upholstered tip-up chairs, private boxes, a ceiling which was decorated with 'Indian scroll decoration around which were Eastern symbols representing the elements, Indian palms and seated Hindu deities'. The ceiling was supported by 'Indian arches' springing from elephant capitals and Ellora columns. Much use was made of ribbed domes *à la* Udaipur and various forms of Mughal columns. Above the proscenium arch there was a cartouche with 'Indian figures representing music and dancing'. The theatre was immensely successful but there were few imitators and not even Matcham was to produce such an extraordinary interior again.[25]

One of the reasons for this was the gradual change in taste away from the ornate and fussy to a renewed desire for simplicity. In London this became especially noticeable in the design of theatres. After 1900 theatre architects were more influenced by the Adam brothers and refined French baroque than the multiplicity of the 1880s and 1890s. In the provinces, however, the abundant riches of the East could survive a little while longer in the theatres which were still being erected, although the pace had slackened since the heyday of the 1880s and 1890s.

The Indian style survived nowhere, perhaps, more unexpectedly than in Glasgow. Here in 1903 Bertie Crew (d. 1937) who had been trained in London and Paris, created a scheme redolent of burlesque and with an exuberance barely equalled by Matcham.[26] In the Palace Music Hall, 'Mughal pilasters' and elephant head capitals flanked the proscenium arch, above which there were two 'Mughal' *chattris* which framed a painted panel depicting a snake charmer enticing a woman. A wonderfully apt image of the hold which India could have over the occidental imagination. Occidental prejudices were well conveyed by this image, too, which could be compared with a passage from the *Exhibition Illustrated* for June 1901, the guide to the Glasgow International Exhibition. In it there was an Indian theatre fully designed in a 'Mughal' style. The blurb in the guide read as follows 'India is still considered the nursery of the arts of humbug, and the Indian wondermaker maintains his position as the arch mystifier of the world'. This is a reference to a group of Indian players which included a snake charmer among them, who played every day during the

97. Auditorium of the Grand Opera House, Belfast by Frank Matcham, 1895. An elaborate arrangement of cupolas, columns, elephant capitals, Indian arches and Hindu deities which was very popular with the local people.

Exhibition. The *Exhibition Illustrated* for 15 June showed a picture of them. This quote explicitly indicates that behind the prejudices of the British mind there lurked a deep seated suspicion and lack of trust in the Indian, which was doubtless inculcated through frequent readings of Wilkie Collins's famous novel *The Moonstone*, in which a group of Indian strolling players is similarly described, and was fortified by the accounts of the Mutiny of 1857.

If India and Indians were the arch mystifiers of the world, then in the illusionism of the Western theatre Indian mystification would find its shrine. The days of the legitimate theatre appropriating Indian motifs for its own uses were nearly over. But just as it seemed that the Indian style would pass out of the design vocabulary, another form of entertainment, housed in a theatre, was to become an even greater consumer of orientalisms. This was the, as yet, embryonic 'dream machine', the cinema, another purveyor of illusion to the masses with 'low' origins in the seaside peep show and fairground booth. Under the guiding hand of the American impressarios such as Marcus Loew and 'Roxy' Rothafel the 'low' origins would be transformed into glittering social occasions. Especially in America where there was more money, enormous sums were spent on interior decoration. It was realised very early that audiences wanted not only to be entertained by a film but experience a different atmosphere from their ordinary surroundings. Cinemas became the magic carpet to other worlds and this idea was duly exploited by managers and designers.

From the beginning the 'Indian' style had its devotees. In London two of the early cinemas, the Globe at Putney and the Electric Theatre, Praed Street, Paddington were built using Indian details. While the Electric Theatre (*c.* 1910) at Paddington **(98)** is very much a mixed attempt at an 'Indian' style, including as it does on the façade horseshoe Moorish arches, Gothic windows, a *chujja*, and a curvilinear cornice over the entrance *à la* Rasjasthan, the whole surmounted by three pregnant domes of doubtful parentage out of all proportion with the elevation. The Globe **(99)** which was designed by Melville S. Ward and opened in May 1911 was an altogether more serious attempt at reproducing an alien style, and was strongly reminiscent of the Mughal palace at the fort of Rotasgarh, Bihar.[27]

For a place of public amusement the street elevation takes itself very seriously indeed, exhibiting a degree of 'authenticity' not normally associated with such buildings at that time. The reason for the style of these examples may perhaps be attributed to the interest aroused by the stunning Indian pavilions erected at the 1908 Franco-British Exhibition in London. There was to have been another 'Mughal' cinema the Electric Palace at Sheffield, Yorkshire, but it was not built to the original designs.[28]

The interiors of the early cinemas were rudimentary and reflected little of the outer gloss of these superficial structures. Accommodation was primitive, and there was little attempt to glamorise, it being considered unnecessary to

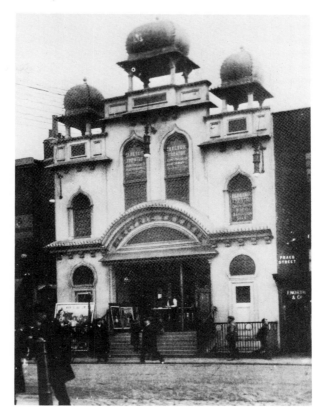

98. Electric Theatre c. 1912, built about 1910 as a cinema on Praed Street, Paddington, London. The Indian details were probably inspired by the success of the Court of Honour at the Franco-British Exhibition of 1908. Demolished.

provide anything other than bare essentials for this as yet 'low class' form of entertainment. The basic plan was taken from the traditional theatre: sloping floors, balconies, foyers, waiting rooms, toilet facilities and a stage on which was placed the, by modern standards, small screen. Although at first these features were little decorated, later they were to afford the designer ample scope for skill and imagination. Soon these structural devices, irrespective of their geographical location, would play host to countries all around the world. Each beam or balcony, foyer or vestibule, even the toilet facilities, would evoke by turns the distant world of China, the 'gloomy' atmosphere of a Hindu cave temple, or Gothic cathedral, the monumental ruins of ancient Egypt or Mexico, the peace of an Islamic courtyard, or the civility of the eighteenth century English classical mansion.

The change from a superficial, to a more permanent structure was precipitated by developments within the film industry itself. The primitive conditions and poor design continued as long as film-makers made 'shorts'. For while the managers of these premises were only able to make profits on a quick turn-over, it was often considered unnecessary even to upholster chairs because of the short time that patrons would be seated. Mirrors, panelling,

ELEVATION

99. Globe Cinema, Putney, London by Melville S. Ward and opened in May 1911. For a cinema design the 'Mughal' features have been used with care and accuracy. Demolished.

some framed prints and a few potted palms were all that were usually to be found to enliven otherwise dreary interiors. These buildings very much reflected their humble seaside peep-show origins, rather than any relationship with the traditional theatre.

Two factors occurred which were to change attitudes to cinema design and which would eventually lead to the highly elaborate eclecticisms of the 1920s. The first was the success of even the short films which was beyond the dreams of the early managers working in the first decade of the twentieth century. This initial success was to provide cinema managers with adequate financial remuneration and enable them to contemplate modifications to or the rebuilding of existing structures. The second factor was the introduction of two-reelers which revolutionised film as entertainment. Full-length feature films and their epic themes received serious public attention and so buildings were needed which would reflect the achievement of the films themselves. Thus developments in the film industry with its widening scope and its growing

claims as a serious new art form directly influenced the subsequent development of cinema design.

The United States led in these new developments. Having attracted an ever increasing film-going public it became necessary for producers to rent large traditional theatres. As a result of this a new conception of film as an art form evolved which placed it on a par with the legitimate theatre. Suitable buildings were therefore needed to complement the grandeur of the films themselves. Lofty subjects needed to be shown in buildings which had the appropriate allusions. Cinema had come of age.

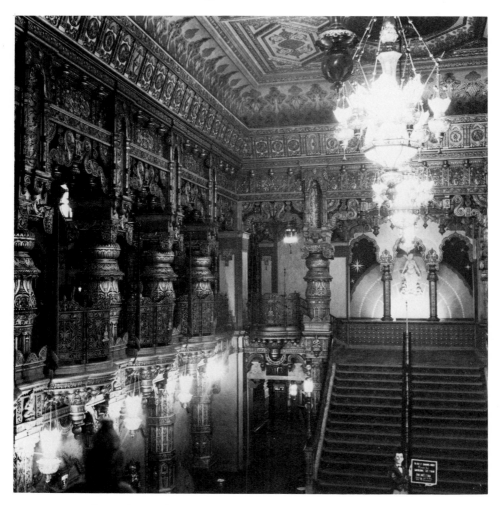

100. Foyer of Loew's, 175th Street, New York by Thomas Lamb, 1930. For this breathtaking interior Lamb and his design team have brought together 'Jain' and 'Hindu' columns in a stunning scheme. Lamb thought that such interiors should be appreciated as works of art and his use of exotic architecture was intended to educate the cinema public.

Initially cinema designs followed the styles of the legitimate theatre of which Adam revival and French baroque were the most favoured. Adam revival was especially favoured by traditionalists including the celebrated architect Thomas Lamb. Lamb was born in Dundee, Scotland, in 1871 and at the age of twelve his family emigrated to America. He graduated from the Cooper Union Institute in engineering. According to one report issued at his death, it was Marcus Loew, founder of the extensive chain of theatres which bears his name, who in 1909 first suggested to Lamb the idea of designing theatres. This Lamb continued to do for the next three decades working on commissions for Warner Brothers as well as for Loew and many other smaller companies. Among the theatres in New York he designed the Capitol, Strand, the Rivoli, the Rialto and Loew's State Building and Theater. He became consultant to the Center Theater, Radio City. In all it is thought that he was responsible for over 300 theatres throughout the world including examples in America, England, Australia, India, South Africa and Egypt. These were predominantly in Adam and revival style. In the last decade of his life when his style of theatre was going out of fashion he turned his attention to other forms of architecture. Lamb was the architect for the Hotel Paramount, New York, the Phythian Temple owned by the Knights of Pythias and many other projects. In 1932 he won an honourable mention in a worldwide competition for a design for the Palace of the Soviets, Moscow. His experience in designing theatres came in useful, since he intended the building to have many exits so that 20,000 people could leave quickly without panic.[29]

The first purpose-built cinema was the Regent, New York built in 1913 which was followed a year later by the famous Strand, the Adam interior of which was luxuriously extravagant and contained an auditorium seating 3,000. Exotic woods which were used in abundance for decorating panels, balconies, furniture, included satinwood and rosewood. Gold leaf was splashed everywhere and antique furniture contrived to make this a very classy interior. At its 'High Society' opening ceremony one critic wrote that '. . . if anyone had told me two years ago that the time would come when the finest looking people in town would be going to the biggest and newest theater on Broadway for the purpose of seeing motion pictures I would have sent them down to . . . Bellevue Hospital'.[30]

The cinema's rise from the 'flea-pit' had been sudden and dramatic. Cinema going was from this point considered 'high class' entertainment, readily available to all. The democratic ideal of this new art form was pointed out a decade later by another of America's important theatre architects, George Rapp of Chicago. The cinema, he observed, is 'a shrine to democracy where the wealthy rub elbows with the people'.[31] He had evidently forgotten that although available to all the size of a patron's purse would determine where he sat and the enforced restrictions were efficiently guarded by an army of ushers.

For a decade patrons and management remained content with the Adam revival style, whether it was at the Empire, Leicester Square, London, or Loew's in Montreal, Capetown, Calcutta, Bombay or Melbourne, Australia. In an article published in 1928 Lamb gave his reasons for adopting the designs of the eighteenth century architects James and Robert Adam. 'This I did' he wrote 'because I felt that this style of decoration most ably reflected the moods and preferences of the American people',[32] whose taste he presumably discerned as deriving from European tradition, especially from England with its 'old' cultural values.

However, after the completion of Lamb's Capitol Theater in New York in 1919, Lamb became aware of a change in the public's expectations. They had begun to grow weary of the somewhat bland architectural backgrounds he had employed. In their place they wanted, he perceived, 'something more gay and flashy'[33] and for these reasons he turned to the ornamental style of Louis XVI, which he used with great success at the Midland Theater, Kansas, and later at the Fox Theater in San Francisco (1928), his last essay in the 'grandiose'. These designs seem to have had as their point of reference the type of baroque extravagance Charles Garnier had produced for the Opera House in Paris in 1875. But Lamb was to outgarnish even Garnier. For theatres like the Fox at San Francisco no expense was spared. The use of an opulent style fulfilled several of the audience's important needs. Firstly, the contrast between the home and the theatrical environment was for most of the audience increased, thereby making it easier for them to make that suspension of belief which is so necessary to the enjoyment of a play or film. Secondly, it detached them from their 'daily drudgery'. Lamb came to realise that the only way this could be accomplished was by creating a general scheme 'quite different from their daily environment, quite different in color scheme, and a great deal more elaborate'.[34] In interiors it was important to use plenty of gold because it encouraged feelings of 'wealth, warmth and coziness'. This change in style also permitted the use of colour which should increase in richness as patrons passed from foyers and lobbies to the auditorium which should be the darkest and richest of all. In searching for styles which would reflect the change of heart in the American public and provide adequate models for the architect, Thomas Lamb turned his attention to the Orient. He realised that the styles of the Orient which had always been 'brightly colorful, emotional and almost seductive in their wealth of color and detail', were especially suitable for making an effective break between home and theatrical environments.[35]

1919 was a bleak year for the United States, whose troops had returned from Europe after Armistice Day to be faced with a disenchanted population. There was a national steel strike, a railroad strike, a police strike in Boston, and race riots in twenty-three cities. America was also disenchanted with Europe for failing to acknowledge her help with due gratitude. At such times the mind of

the individual needs opportunities to redress the balance between the all too prevalent reality of life and an imaginative make-believe world. The American 'dream machine' was already fulfilling such expectations. This may also account for the appearance from the early 1920s onwards of a range of exotic, non-European styles which included the Hindu and Mughal. In Lamb's words which are reminiscent of Fosbrooke's concern with style and the architecture of entertainment in the 1820s, Hindu, Mughal and other Oriental styles were capable of casting an air of mystery over the audience as well as being 'particularly effective in creating an atmosphere in which the mind is free to frolic and become receptive to entertainment'.

In a change of taste not unlike the reaction against 'plain Grecian' at the end of the eighteenth century, various strains of exoticism were employed in America to satisfy audiences bored with 'plain' Adam revival. One of the earliest and finest of these experiments was Sidney Graumann's famous Egyptian Cinema at Los Angeles built in 1923. Later it was copied at Ogden, Utah, where the Egyptian façade strongly recalled the 'Theban' monumental gateway designed by Henry Austin at Yale in 1839 and erected between 1845–48. The use of the Indian style is of most concern here, and compared with Britain the United States was surprisingly rich in examples. After the two exteriors at Paddington and Putney, London, there was an extraordinary Indo-Moorish Palace Theatre at Portsmouth which opened in 1921,[36] but in none of the preceding examples did the 'Indian' style find its way inside, and it is surprisng how few 'Indian' cinemas were erected in Britain.

In the United States nine cinemas have been found which extensively employed the 'Indian' style. The earliest, the Beverly Theater,[37] Los Angeles, was built in 1925 **(101)**. It was remarkable for its ingenious re-working of the Buddhist architecture of Sanchi, in Northern India. The proscenium arch was based upon the Sanchi gateways with their carved pillars, curved architraves and connecting struts, the whole embellished with sculpted scenes in high relief. Each pillar is supported by carved elephants and lions. Many of these creatures were represented or suggested in the Beverly Theater. The pillars which supported the proscenium arch are themselves supported by groups of elephants. The decorative friezes of the original in Sanchi were simplified, while the architraves were reduced in number from three to two, and elongated to suit the proportions of the stage. On either side of the stage there were niches with seated Buddhas, two of which were distinctly 'Japanese' rather than 'Indian'. Some of these features have survived the passage of time although the building is now a boutique. The exterior did not conform to the 'Indian' nature of the interior. Instead of adopting a stupa dome shape, an Islamic style was adopted, probably for the reason that the resulting square plan and vertical walls permitted shops to be erected at street level, their valuble rents subsidising the cinema.

101. Auditorium of the Beverly Theater, Los Angeles, California from an old photograph c. 1930. Built in 1925 it was remarkable for its re-working of the Buddhist architecture of Sanchi. The proscenium arch with its elephants is derived from the gateways of that monument.

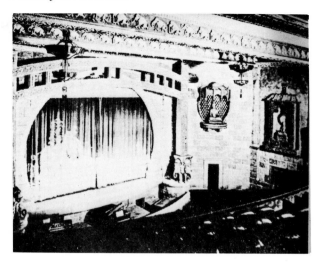

In the same year as the Beverly Theater opened, Denver yet again acquired an 'Indian' theatre based upon the Taj Mahal. This was the Aladdin Theater which opened on 28 October 1926,[38] the brain child of its managing director, Harry E. Huffman, a local businessman who had long wanted to build an oriental theatre. Unusually, the outside was as Indian as its interior with domes and minarets, inside there was an 'atmospheric' auditorium representing Allah's garden complete with fountains. At its opening William Speth's *Allah's Garden of Roses*, specially written for the occasion, was sung, followed by a parade of Aladdin's jewels. *A Dream of India* and several other pieces were played by the resident 'Arabian Nights Orchestra'. The whole combined to 'transport one in the twinkling of an eye into an ethereal land of make-believe, where the fantastic tales of Arabian Nights will come to life'. It still survives and continues to work its magic on later generations.

The Aladdin Theater had a contemporary, the Chicago Oriental, designed by Rapp & Rapp, for the entrepreneurs Balaban & Katz. It was their only project displaying Eastern features. As a contemporary press leaflet noted, Chicago was now the recipient of 'the jeweled splendour of the Far East against a background of soft silks, subtle lights, regal velvets'. The enterprise was enormously successful although the Rapp brothers did not repeat the experiment. As far as authentic Indian detail was concerned there was none, in its place was a mish-mash of decorative devices, cusped arches, elephants' heads, buddhas, exotic animals, more suitable as an illustration for Sir John Mandeville's fictitious travels to the East. It was the kind of exercise which Rabindranath Tagore writing in the *Atlantic Monthly* for 1927 openly criticised. He disapproved of the way such excesses of bizarre ornament appealed to the worst aspects of human nature.[39] Yet such an absurd design could be considered, 'an educational treat in itself as a work of art . . . to study and examine the array of

sculptured detail throughout the theatre is like a trip to the Orient. The auditorium is beyond description with its intricacies of eastern magnificence, grotesque dancers and Indian animal figures, resplendent with lights behind coloured glass around ornate shrine-like niches'.[40] Such a remark shows just how far the cinema had come since the first decade of the century, not only was the entertainment far more sophisticated, theatre-going could even be an edifying experience.

The Chicago Oriental was followed a year later by the Portland Oriental, Oregon, and the Milwaukee Oriental of 1928. Neither was as outrageously decorative as the Chicago but both embodied elements appropriated from the East with no concern for uniformity of style. The Portland was built by G. W. Weatherly, a local dairyman as 'an East Indian playhouse' by architects Thomas & Mercier. In their scheme they incorporated huge dragons in the lobbies as well as elephants; Hindu columns supported the proscenium arch; elephant capitals held up the domed roof; and drapes with Buddhist scenes screened alcoves. Not to be outdone, Dick & Baur's Oriental at Milwaukee, had eight black marble lions in the lobby and elephant and lion headed brackets supported the roof. The niches were a mixture of Moorish, Indonesian, Javanese and Mughal arches, the latter somewhat incongruously featuring seated Buddhas whose eyes glowed red in the dark! It was as if all the Orient could be pillaged to satisfy the western lust for fantasy imagery. There were other schemes too, in western styles such as the Ludwigian Gothic, 'Renaissance' palaces and Spanish baroque. Although these designs were often extravagant and truly amazing, they never indulged in the gratuitous use of incongruous ornamentation to be found in the 'Oriental' theatres. When Western historical styles were employed architects tended to try and be more truthful and specific. In the use of Oriental styles, the Islamic perhaps excepted, decorative schemes were more impressionistic, as if designers were searching for elements which would match Western conceptions of the East and mirror their own interior fantasy. These schemes invariably displayed an appalling ignorance of Eastern architectural styles and usually went uncriticised.

In the same year that the Milwaukee Oriental was in the process of construction, a Hindu *sikhara* or tower was rising on the West Coast of America, at Oakland, California **(102)**.[41] It was not the first Hindu structure on the West Coast, this being the Vedanta Society building in San Francisco erected between 1905 and 1908, but it was certainly the largest and most impressive. It is the only cinema to have a significant Hindu exterior, the inspiration for which must have come from the *sikhara* temples at Khajuraho in northern India. In designing the Oakland for the West Coast Theater chain it was decided to have an architecture quite different from that usually found in theatres. The normally conservative architects Weeks & Day were anxious to create something entirely new in an area which had been inundated with 'Spanish' examples. As the local *Exhibition*

Herald announced in 1928, the architects 'drew upon India to produce this theatre that was to be different', and it was strikingly different to Thomas Lamb's vast Spanish baroque, Fox Theater then under construction across the bay at San Francisco. The exterior of the Oakland was very unusual since its towers and portico were enriched by polychromatic tiles. For all their interior brilliance cinemas were not normally as colourful on the exterior and by no means reflected the style inside. It may be that Weeks & Day had been influenced by another cinema architect from New York, Kenneth Franzheim. In an article published in the *Architectural Forum* in 1925, Franzheim appealed to theatre architects to consider the employment of external features which would be less at variance with the interior and be more imposing.[42] Few buildings he thought could be considered outstanding since the purpose of the theatre façade was to be eye-catching and entice 'the public with pleasurable expectation' yet he hoped that 'owners will see fit to encourage their architects

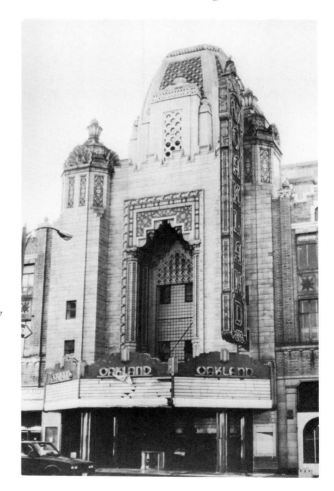

102. The Oakland, Oakland, California the only cinema to have a significant Hindu exterior. It was built in 1928 to the design of the architects Weeks & Day whose express intention was to produce a theatre radically different from anything else on the West Coast. The interior was also Indian.

151

in their desire and effort to create exteriors that would suitably comport with the interiors'. This Weeks & Day endeavoured to do. Once inside the Oakland patrons were greeted by a large mural painting of the 'goddess of fire' which soared above them in the 100 foot vestibule. An appropriately 'gloomy' interior, as befitted a Hindu temple, led to the auditorium which was awash with Indian details: a 'Mughal' proscenium arch, painted gods with lighted eyes and jewels, elephants, a house curtain depicting an Indian scene, and seated Buddhas in niches whose eyes glowed through the mystic incense which rose through grills around them. All these details and many more were liberally supplied with gold leaf which resonated with the rich red tones, to create an atmosphere of 'warmth, wealth and coziness' as Lamb put it, and more than a modicum of exoticism. Although no longer a cinema the building still survives. A vase finial which once crowned the tower in true Hindu style has gone, but the interior is almost intact and is being restored.

Of all cinemas in the United States and indeed anywhere in the world, the 'Hindu' extravaganzas which Thomas Lamb and his designers put together for Marcus Loew's theatres, the State, Syracuse (1928), the 175th Street **(100)**, New York (1930) and the 72nd Street, New York (1932) are the most powerful. The details of Hindu and Jain cave temple architecture are used with breathtaking virtuosity and they are combined in a way which none of the other designers could match. The rationale behind Lamb's eclecticisms shows clearly how latent orientalisms could surface whenever there was the urge to create a world of colour, magic and mystery. The grand foyer of the State Theater he described as 'a temple of gold set with colored jewels.' The large 'Indian' mural with elephants and *howdahs*, horses, slaves, princes and horsemen all silhouetted against a deep blue sky was described by Lamb as 'a pageant in its most elaborate form, and immediately casts a spell of the mysterious and to the Occidental mind exceptional'. The dome of the State was gold, its walls, ivory studded with brilliant colour, which suggested the warmth and luxury of sitting in an Oriental tent under 'a glorious canopy of silks and brocades'.[43]

In fact the auditorium of the State contained few direct references to Hindu architecture, its richness lay in its colour scheme which was devised by Harold Rambusch & Co. The foyers and promenades had specially designed 'Hindu' details and these were used again at the 175th and 72nd in a slightly altered way. The promenades were like gilded cave temples recalling details from the caves at Kanheri, Ellora, and Karli, as well as the Jain temples of Mount Abu, interspersed with cusped arches. The grand foyer had 'Jain' columns at ground floor level, while on the first floor there were the by now famous bulbous columns from the caves of Ellora, impeccably assembled and presented. E. C. Bullock one of George Rapp's design team gave the reason for such proliferation of detail in the public spaces outside the auditorium. Such variety and intricacy, grandeur and novelty were introduced in these areas 'to keep the

patron's mind off the fact that he is waiting'.[44] In the auditorium, generally speaking most of Lamb's designs tend to be more restrained since the audience's attention was to be directed towards the stage. This did not apply to his 72nd Street where he not only quoted extensively from Hindu architecture in the auditorium but also designed it as an 'Atmospheric'. However, all three cinemas used similar work, identical carpeting and light fixtures, even the same elephants on the newel posts. These ornamental theatres were cheaper to produce since all their mouldings were made of cast-plaster which as Ben Hall has noted cost a quarter of the price of a classical or baroque palace of the standard ormolu, crystal chandelier and marble variety. It must have come as something of a shock to the female patrons of the 72nd to wander through Hindu promenades into the Ladies' Room and find themselves, suddenly, in a French interior! Presumably the designers baulked at the idea of the Ladies' and Gentlemen's Rooms being Hindu, although elsewhere they had been almost everything else. At John Eberson's Avalon Theater (1927) in Chicago the rooms were in an Islamic style, the Ladies' Room resembling a Harem's quarters and the Gentlemen's a Caliph's Den. Both had octagonal centrepieces based upon the polygonal column in the Diwan-i khas at Fatehpur Sikri.

Fearing the erudite criticisms of his architectural colleagues, Lamb observed that during the time he had specialised in planning and building theatres, architecture had become so important that the interiors had to be exact in detail since 'now [they] are really educational for all those who are interested in this art, in decorative painting modelling etc'.[45] The edification of the patron has already been referred to and Lamb also observed that exotic styles when correctly designed not only created pleasure, but also imparted a knowledge of what other nations and races had done.[46]

The auditorium of the 175th was decorated in a mosaic pattern while the side walls were divided into bays by a series of columns and perforated screens of Indian origin. The Ladies' Room was a tent room and the Gentlemen's was 'Hindu-Chinese' with mirrors, ceramic tiles and buddhas. There is no doubt that good decorative schemes enhanced the box office receipts of theatres. When the 175th opened in 1930, in the first three days the paid attendance was above $48,000. 'It is the highest figure of any of the neighbourhood film palaces... The ornate Indo-Chinese architectural style, and the offering of Norma Shearer's film *Their Own Desire* and a lavish Capitol Theatre stage show are given as the reasons for the unprecedented drawing of the throngs.'[47]

In 1930 this point was made even more clearly by R. W. Sexton, an architectural critic.[48] After observing that theatre goers liked the thrill of 'rubbing shoulders' with the rich and famous and basking in the luxury which they could not afford at home he wrote that theatre owners claimed that audiences increased in proportion to the amount of ornamentation employed. For this reason managers did not wish to change to the modern 'logical' style

and discard the old historical ones. In only a few years Lamb's kind of interiors would be seen as old fashioned and 'illogical' but, before that occurred, another 'Indian' cinema was in the process of construction on the other side of the world.

The Civic Theatre, Auckland, New Zealand, built in 1929,[49] was the largest of the 'atmospheric' theatres in the Southern Hemisphere **(103)**. The exterior design was based on Occidental classicism having an elaborate cornice, Grecian friezes, iron-grilled panels, and a tower. The interior was exceptional for its use of exoticism; an 'Hindu' foyer gave on to an 'Islamic' auditorium, rich in minarets, domes, engrailed arches and an atmospheric sky with 800 stars made from 24 watt bulbs and a cloud machine. The underlying principle behind the scheme was to encourage the idea that the audience was sitting in an Islamic courtyard under the evening sky in Moorish Spain or Persia. The architect was C. H. Bohringer who had also been responsible for the design of the 'Moorish' State Theatre at Melbourne, Australia as well as another at Perth. The design of the interior devolved onto the Swiss artist Arnold Zimmerman. The foyer of the cinema concerns us since it was the most 'Indian' aspect of the interior. Its seated buddhas, elephants, bulbous columns and niches were intended to 'reproduce exactly an Indian rock-hewn temple' and especially the cave temples of Ellora, Bombay. Included in the foyer was a vase painted with an image of the Hindu Ganesha, the elephant god, which was specially imported from the ruins of the temple of Indra Sabha, Ellora. Ganesha's attributes were thought to be particularly auspicious for the founding of a new theatre. It may be that Zimmerman got the idea for an 'Indian' decor from seeing one of Harold Rambusch's decors in the *Motion Picture News* for June 1928, when a scheme which Rambusch had just finished at the State, Syracuse, was well illustrated in the firm's Rambusch's advertisement. As with Lamb's State at Syracuse, the foyer was painted with 'Indian' scenes. However, nothing so harmless as the festive procession used on that occasion was reproduced here. At the Civic one of a series of scenes showed a wrathful, cruel maharajah about to take his revenge on the lover of two of the ladies of his harem. The ladies were depicted almost naked which shocked and scandalised the local guardians of public morality who thought it more appropriate for an art gallery than a place of public amusement! The painting was banished forthwith although its whereabouts was recently discovered and it has since been re-installed in its original position.

In the *Civic Review*, published to coincide with the inauguration of the theatre in December 1929 there was a 'Dedication' beneath a picture of the Taj Mahal which made it clear that India and the world of the imagination were to be considered as being synonymous. The Dedication began 'Pictures are but historical records, placing before us the everchanging drama of life . . .' and continued 'To the imagination, by which the world must progress, is the Civic Theatre dedicated . . . May it be handed down to history as a temple of art, culture and refinement.'

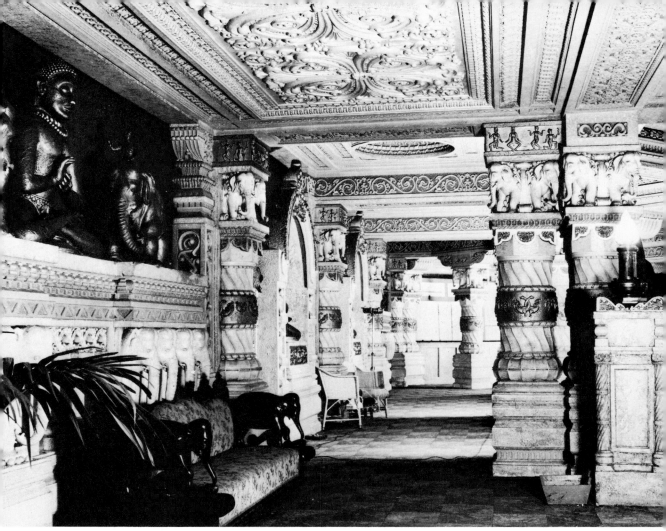

103. *Foyer of the Civic Theatre, Auckland, New Zealand. The most amazing interior in the southern hemisphere. Designed in 1928 by C. H. Bohringer, the interior was by Arnold Zimmerman who wished to 'reproduce exactly an Indian rock-hewn temple' – but only in the foyer, since the auditorium resembled a spectacular Moorish courtyard.*

During the period 1925-30 there was an increase in the employment of elaborate styles of ornamentation. This had happened as a direct response to the wishes of a public craving for a certain type of pleasure and the visual embodiment of their own imaginative desires. Impresarios such as 'Roxy' Hothafel not only realised this need but encouraged it.[50] However, he always considered that architectural style should be secondary to the entertainment itself. Results obviously did not bear this out for this was the period of greatest elaboration and, by implication, distraction. There developed such a plurality of architectural choice that the American humorist Dorothy Parker called such excesses 'early Marzipan'. These exotic styles were not confined to the United States: Britain had its 'Chinese' Palace Theatre, Southall (1929), 'Moorish'

155

Astoria, Finsbury Park (1930), 'Venetian-Gothic' Granada, Tooting (1932), 'Egyptian' The Pyramid at Sale, and the Riviera, Manchester. Islamic interiors were by far the most common being also found in Paris, Amsterdam and Melbourne, Australia. Numerically the 'Indian' theatres were in a small minority but none of these exotic forms ever rivalled the use of the Renaissance, French, Italian and Baroque styles. The use of exotic styles, including the Indian, were important, as Lamb noted, for demonstrating that it was possible to reproduce exotic forms in the Occident without incurring ridicule, as well as creating pleasure for the public and 'imparting knowledge of what other nations and races have done'. There were difficulties in the use of these styles as Lamb's decorator Harold Rambusch observes. While it was possible to recreate the elaborate forms of the architecture, it was difficult to 'round out those schemes with furniture etc. because these nations did not have settees, sofas, lamps, ash-trays like the West was used to'.[51] The designers therefore were forced to resort to other styles for the furniture.

By the end of the 1920s ornateness was being overtaken by a new desire for simplicity. One of the first designs to express this in the United States was the Ziegfeld Theatre of Thomas Lamb and Joseph Urban in New York (1927).[52] Fussy decorative schemes were replaced, and a greater accent put on the simple design of these buildings. However, even at the Ziegfeld, Rambusch & Co. found that the magical world of Indian and Persian painting was an inspiring source for the mural which covered the walls and ceiling in one unbroken curve.

The inception of 'logical' Modernism in Britain and the United States in the 1930s resulted eventually in the discarding of the historical styles in both the cinema and theatre. This was something that the British architect and author P. Morton Shand had long campaigned for.[53] They have not been revived in recent buildings and because of this the Indian, and other exotic styles have ceased to be part of the vocabulary of fantasy in these structures.

Ex Oriente Lux

The major innovation in the use of Indian elements in the West during the last hundred years has been in the erection of buildings associated with the religions of the sub-continent. In the eighteenth century it must have been unimaginable that buildings representing the various Indian religions would ever be erected in the West. However, translations of Sanskrit texts were warmly welcomed, not just by the literati, but by those who were disenchanted with rational Christianity and the European Christian tradition. Others, like Warren Hastings who often quoted from the *Bhagavad Gita* in his letters, found in Hinduism a way of expanding their philosophical ideals without rejecting their Christian upbringing.

Sir William Jones who lived in India until his death in 1794 was accused (wrongly) of being a pantheist, so greatly was he influenced by his environment and his studies of authentic traditions. But there is no doubt that he died a Christian. None went as far as John Dee, Queen Elizabeth I's court astrologer. He believed that the recovery of the occult wisdom of the East would lead to the foundation of a new universal faith which, under the rule of a benevolent British commonwealth, would bring peace to the world. It was for this reason that he was so enthusiastic a promoter of navigational exploration.[1]

During the late nineteenth century established religion again came under attack, this time as a result of the publication of Charles Darwin's theory of evolution, the development of scientific materialism and the sometimes hypocritical attitude of the clergy themselves. As a result the very foundations of the Christian church were open to question which left many without much faith, and some with an abiding sense of distrust. As in our own age, young people were particularly disenchanted with established religion and many turned to Eastern mystical traditions to supply the lack felt in the West. In this atmosphere a Russian, Madame Blavatsky, founded the Theosophical Society. Drawing heavily upon the mystical traditions of the East, the theology of Theosophy sought to re-establish the undercurrents of the numinous in the lives of all people. Blavatsky's books *Isis Unveiled* and *The Secret Doctrine* inspired a generation of impressionable young people, among whom were the poet W. B. Yeats, the composer Scriabin, the artist Kandinsky and many others from all walks of life.

This interest in Eastern occultism was paralleled by the increasing number of publications devoted to scholarly editions of religious texts. Especially

noteworthy were the Buddhist texts translated by the Frenchman Eugène Burnouf and the Englishman Brian Houghton Hodgson, and the German, Max Müller's translations in the encyclopaedic series *The Sacred Books of the East*. Sir Edwin Arnold's *The Light of Asia* (1879) was an influential poetic account of the life of the Buddha which became a bestseller in the East as well as the West. At one time Richard Wagner considered writing an opera based on the life of the Buddha, as did Debussy, but nothing came of either project.

Despite the interest in Indian religions it was rare indeed to find a European 'going' Indian. It is more common today but in the eighteenth and nineteenth centuries it was very unusual. The most famous exception was Charles 'Hindoo' Stewart, an English convert to Hinduism who lived in Calcutta at the beginning of the nineteenth century. In 'up-country' areas like Delhi there were probably quite a few converts to Islam in the early years, since it was relatively easy to follow exotic customs and religions unhindered by officialdom. After the arrival of Christian missionaries in 1813 this became more difficult. It is known that the British and other European residents were often deeply affected by their time in India. Often without realising it their thoughts would be moulded by the traditions around them. When they returned to Europe the habits of a lifetime in India were brought back too. However, because of official disapproval and the necessity for practising 'pagan' religious rituals in private, it cannot be ascertained how far Europeans continued Indian religious practices in England.

It therefore comes as quite a surprise to find the tenets of the Islamic faith being openly expounded in Victorian England in 1886. This was the year in which Dr Gottlieb Leitner returned to Britain to establish a mosque and an Oriental University Institute. Leitner had been a student of oriental languages at King's College, London before entering the Punjab Education Service in 1864. He was passionately interested in oriental studies and founded the University at Lahore in 1872. But his immense confidence and overbearing manner infuriated his friends and colleagues and when he retired from India in 1886 many were far from sorry to see him go. Before departing he managed to persuade the Shah Jehan Begum of Bhopal to give funds for an Islamic centre in England. **(104)**. Leitner settled at Woking in Surrey and commissioned a design from the architect W. I. Chambers. It was erected in 1889 and still serves the same function today.[2]

The single most important event to further the acceptance of oriental religions in the West was undoubtedly the World Parliament of Religions held during the 1893 Chicago Exhibition. Representatives from all creeds came from many parts of the world, one of the most popular of whom was the Hindu Swami Vivekananda. After the exhibition came to a close he was invited to stay on in the United States. His lectures given throughout the country explained for the first time the authentic beliefs of the Hindus unadulterated by the prejudices and superstitions of Christian missionaries. Not solely concerned with Hinduism he

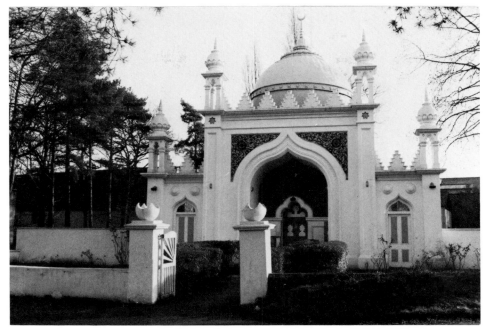

104. The mosque of the Oriental University Institute, Oriental Road, Woking, Surrey. It was founded by Dr Gottlieb Leitner and built to the designs of W. I. Chambers in 1889 with money provided by the Shah Jehan Begum of Bhopal.

also preached the harmony of all religions. The Vedanta Society of New York was founded by him in 1894 and another at San Francisco in 1905. It was in San Francisco that the desire for a universal faith first found an architectural expression. Between 1905 and 1908 a Vedanta temple was designed and built under the guidance of Swami Trigunatitananda and Joseph Leonard **(105)**. Its composite style was derived from several sources: a European crenellated castle, a double dome derived from temples in Bengal, a shaivite temple dome based upon examples at Dakshineswar, Bengal, another after temples at Benares, a Mughal or Islamic dome and on the roof hidden from view a Chinese arcade. In a town where there are so many irregular and highly decorated clapboard houses this building still surprises. I understand there are other examples in San Diego and Houston.

The presence of the Baha'i representative, Ibrahim Kheirallah, at the Chicago Exhibition was even more influential in architectural terms than that of Swami Vivekananda. The Baha'is too accepted the unity of all religions with Baha'u'llah as their prophet. When he died in 1892 in what was then Palestine his son Abdu'l-Baha was made Guardian and under his direction Baha'is created centres all over the world. The first temple in the West was built at Wilmette near Chicago. The architect Louis Bourgeois, a Baha'i convert and a pupil of Louis

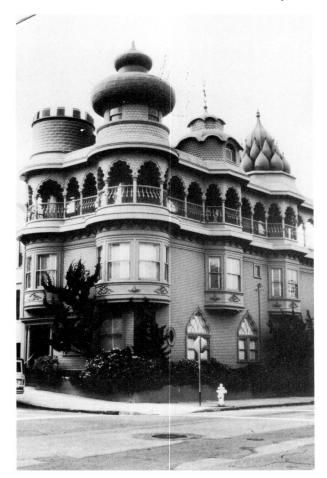

*105. The old Vedanta
Temple at 2963 Webster
Street, San Francisco which
incorporates a multitude of
architectural elements to
illustrate the unity of all
religions. Up to the first floor
level was built in 1905, the
upper levels in 1908.*

Sullivan, was asked to prepare designs in 1908. In so doing he developed a composite style which would express the geometrical essence of Egyptian architecture, also that of the Greek, the Roman, Arabic, Gothic and the Renaissance.[3]

It took over thirty years to build and was finally dedicated in 1953. There was nothing 'Indian' about it but the rationale which was developed during the process of its design influenced Baha'i temples everywhere.

Another Baha'i architect, the American Charles Mason Remey was asked for a design for a temple in Iran in the 1920s **(106)**. His views on the subject were expounded in two publications: *Architectural Compositions in the Indian Style: Designs for Temples and Shrines*, (1923) and *A Nonagonal Temple in the Indian Style of Architecture*, (1927). Remey had early become convinced that 'as the West has always received its religious and spiritual inspiration from the East so in like manner the art and architecture of the Orient have much to offer the

160

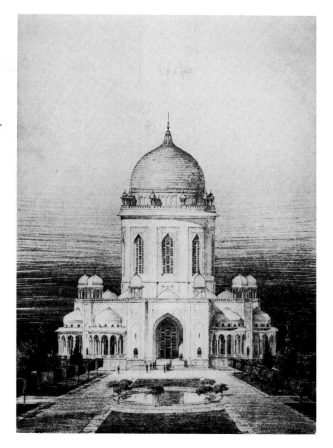

106. A design for a Baha'i Temple made in 1923 and illustrated in Architectural Compositions in the Indian Style *by the American architect Charles Mason Remey. It is based upon the Taj Mahal, Remey's symbol of architectural perfection.*

Occident'.[4] When he was asked for a temple design he chose as his model of perfection the Taj Mahal, for in this building alone could be found 'a symposium of the beauty of the spirit of religion combined with a beauty which appeals to all that is human in man in his love of beauty in nature. Thus, all of the craving of the heart for beauty both of a spiritual and of a human nature is satisfied, and the soul of the visitant finds exquisite satisfaction and joy.'[5] Although the temple in Iran was not built, others of his design were erected in Kampala, Israel and Sydney. Recently the British architect Quinlan Terry has produced a Baha'i temple design which mixed classical and Indian elements. In Delhi, F. Sabha & Associates have created an astonishing temple in the shape of an opening lotus, a motif chosen for its long association with Indian art and literature.[6]

Since that first Parliament of Religions few Western countries have been immune to the East's tender advances. France has a Sufi centre at Suresnes founded by the first Indian Sufi to visit Europe, Pir-o-Murshid Inayat Khan, who arrived in 1910. A huge Tibetan monastery is under construction at Odiyan, Sonoma County, California and in England the new town of Milton Keynes has a

Peace Pagoda built in the shape of a *stupa* **(107)**. The architect Tom Hancock collaborated with the Venerable Nichidatsu Fujii the Preceptor of the Japan Buddha Sangha and Professor Ohka of Japan.[7]

The design was agreed in 1978 and sixty acres of land were reclaimed to make a Peace Park, planted with cedar trees and a thousand cherry trees given by the people of Yoshino, Japan. Many of the architectural references are to the famous Buddhist monuments of India; the railings are derived from those at Sanchi, the guardian lions from examples at Sanchi and Sarnath, and the elaborately carved frieze which depicts the life of the Buddha is similar to the Amaravati sculptures. In an east-facing niche is a statue of the young Buddha. The monument is protected by a roof with a pinnacle which was made in Japan. The scheme was complete in 1980 and another has been built in Battersea Park, London.

107. *Peace Pagoda, Milton Keynes designed in 1978 and built according to the wishes of the Japan Buddha Sangha. Professor Minoru Ohka of Japan worked in consultation with Tom Hancock. The frieze and most of the monument was carved and erected by Buddhist monks and nuns. It was completed in 1980.*

The other major innovation which because of the wide extent of the subject can only be summarily treated is more concerned with the development of a house-type than with style or taste.[8] I refer to the bungalow, a world-wide phenomenon with regional variations. The term 'bungalow' comes from the Bengal word 'bangla' or 'bungelo', and in its original definition referred to a Bengal hut with a curved thatched roof, similar to the example copied by C. R. Cockerell at Sezincote in 1823 **(24)**. It also implied a single storey hut with a high pitched roof and a rectangular plan and sometimes a verandah. Occasionally it could be octagonal like the bungalow the Peshwa of Poona built in 1790 for the English artist James Wales.[9]

As early as 1800 a British architect John Plaw had produced a design for a rural dwelling 'with a viranda in the manner of an Indian bungelow' in his *Sketches for*

108. A bungalow at Mhow, India in cottage orné *style designed in 1836 by Lt-Col. William H. Graham who also worked at Meerut. Inscribed on the reverse:* Though humble be our little cot, and lone and barren be the spot, in all the world a place there's not, like Home.

Country Houses, Villas and Rural Buildings. It was probably not built. Plaw was not to know that this imported form would eventually cover great tracts of the British coastline and lay siege to many of Britain's cities and villages. By the 1820s and 1830s the bungalow had become an important feature of colonial life in India. As the British presence increased so the impermanent thatched hut used by district and military officers in early years was replaced by a more substantial dwelling. In the hands of an artistic engineer-architect the bungalow became more reminiscent of the European *cottage orné* than the Bengal hut **(108)**.

With the termination of the Nepal Wars in 1816 officers convalescing in the foothills of the Himalayas soon discovered the benefits of the hill station. It was not long before settlements were established at Almora, Mussoorie, Simla and Darjeeling and elsewhere in India. The bungalow modified to suit the extremes of climate soon became an inextricable part of the landscape of the Himalayan foothills. After the 1850s it became the custom to spend the hot summer season in these stations where there developed a way of life, a mixture of endless socialising, frivolity and boredom that had for many years characterised the watering-place, resort or spa in Europe.

The bungalow's connotations of leisure, health and convenience probably led to the introduction of the house-type into England in the 1860s. The first bungalows were built at the seaside resorts of Westgate and Birchington in Kent. Far from being a humble dwelling this new house-type was associated with all the exclusivity and social snobbery of the kind which had been so intimately a part of life in the hill station. It was very often a second home and by the close of

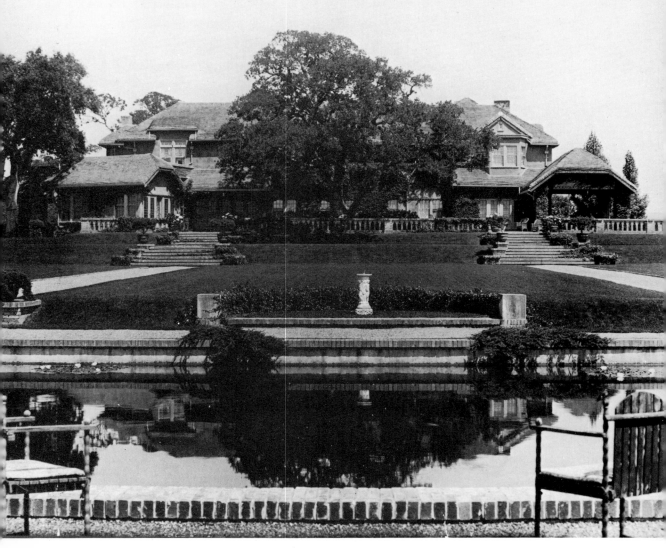

109. The Mortimer Fleishhacker residence, Woodside, California a sophisticated extension of the bungalow idea by Greene & Greene designed in 1911 and built over a number of years with various additions.

the nineteenth century it was also used as a rural retreat for country pursuits. Not surprisingly, it increased in size quite considerably to accommodate those who came for house parties. This was less true of the bungalow elsewhere, in Australia, Malaysia, British Columbia and California where it was still associated with the pioneering spirit.

California was eventually to be called 'bungalow land' so numerous did they become. In the hands of two architects Henry Mather Greene and Charles Sumner, the Californian bungalow lost its simplicity and instead became a work of art. Both architects had visited the Chicago Exhibition of 1893 and the San

Francisco Exhibition of 1894 where they had been very impressed by the lightness of construction and the sweeping lines of Japanese architecture. It so influenced Greene's work that his Irwin House of 1906 was sometimes called a 'Bungalow in the Japanese style'. Like their British counterparts the dwellings became elaborate structures often of more than one storey and of sophisticated design **(109)**.

Bungaloid estates became a feature of post-war Britain, and are so to this day. So popular have they become, particularly for the elderly who often retire to such estates at coastal resorts that many people feel them to be a 'naturalised' component of the landscape. The bungalow is not, as often thought, an indigenous form.

British domination of India came to an end in 1947 and with it a chapter in Anglo-Indian imperial architecture. In recent times foreign governments have been less diffident about adopting Indian styles and motifs for their embassies and consular buildings in Delhi. The most recent addition has been the Belgian

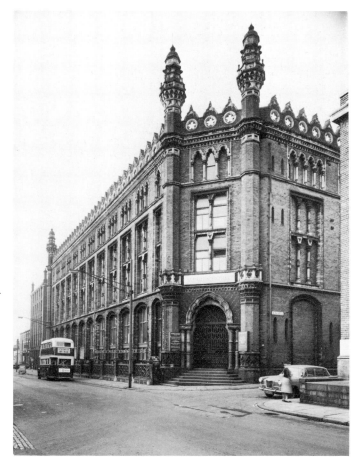

110. St Paul's warehouse, Park Square, Leeds an essay in the exotic by Thomas Ambler. Designed for the clothier Sir John Barran it was constructed in red brick and terracotta. The Indian minarets, columns and cusped arches harmonise well with the Venetian-Gothic elements.

Ambassador's residence designed by an Indian architect and based upon the domes and towers of the Tughluqabad monuments of ancient Delhi.

Indian crafts have lost their influence over Western craftsmen and art education policy, their place having been taken by those of Japan, China and tropical Africa. This change was largely due to the inception of Modern Movement aesthetics after the First World War which exalted the rational and the plain. The beloved intricacy of Victorian and Edwardian times was banished and with it the fashion for Indian woodwork and metalwork. Indian textiles alone have continued to exert a powerful influence on fashion and design in the West. The mastery of colour and materials is as much admired today as it has been ever since the sixteenth century. But no modern entrepreneur has followed Sir John Barran's example when, in 1878 he commissioned an Indian style warehouse and office from the architect Thomas Ambler which was erected on Park Square, Leeds **(110)**.

Indian style buildings have continued to be featured at exhibitions in widely differing circumstances and often for completely different reasons. One of the most unusual of these examples was constructed at the San Francisco Exhibition of 1939.[10] The purpose of the exhibition was to show the close connection which the West Coast had with the cultures and countries of the Pacific and

111. Bernard Maybeck's Hindu 'Temple of Youth' for the San Francisco Exposition of 1939 with the 'Pageant of the Pacific' in progress.

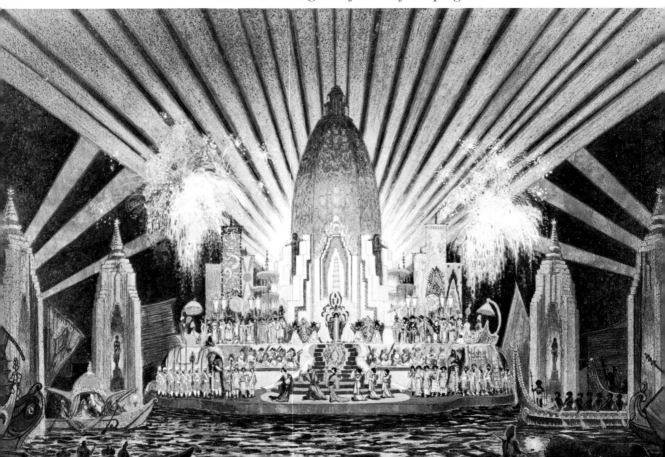

112. A houseboat at Sausalito near San Francisco first constructed in the 1960s then completely re-built in the early 1970s to resemble a Mughal gateway.

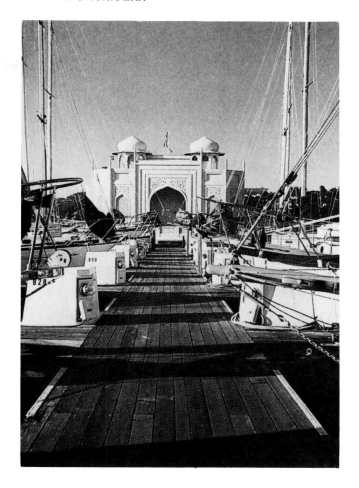

Indian oceans. Instead of the normal vast baroque palaces, the centrepiece of the exhibition was a Hindu 'Temple of Youth' designed by the brilliant eclectic architect Bernard Maybeck in conjunction with his associate William G. Merchant **(111)**. This was meant to symbolise the West Coast's relationship with the East and it did so with a spectacular display of Hindu towers and monoliths that provided an unusual amphitheatre wherein was enacted 'The Pageant of the Pacific'.

Indian garden ornaments and pavilions are still in demand for the adorning of gardens. The 'Indian' estates of Sezincote and the Brighton Pavilion continue to determine later additions. At Sezincote an Indian tennis pavilion was built during the 1950s and at Brighton serious consideration is being given at the time of writing to the construction of Nash's unbuilt 'Hindoo' conservatory. Already in this century Nash's extravaganza has inspired the erection of an Indian porch to the adjacent Dome Theatre, a memorial to the Indian dead of

the First World War and the remodelling of the Pavilion's South Gate, this time in Gujrati style.

Interest in Indian forms inspired one patron in the 1970s to have a Taj-Mahal style houseboat constructed at Sausalito, near San Francisco **(112)**. In Vienna, Hans Hollein's travel bureau of 1978 used a Rajasthani pavilion in a scheme

113. *The Rajasthani pavilion in Hans Hollein's scheme for a travel bureau in Vienna, built in 1978.*

114. The Mirror House, Saitama, Japan by Monta Mozuna, 1979, based upon Maharajah Jai Singh's observatory at Delhi which was built in about 1724. One of several house schemes by this architect to be based upon a cosmic symbology.

which employed other devices and symbols of antiquity to evoke the pleasure of visiting ruins and exotic locations **(113)**. By far the most original use of Indian forms has been by the Japanese architect Monta Mozuna. In his Mirror House **(114)** at Saitama, Japan of 1979 he has borrowed the ascending staircase idea from the Jantar-Mantar, one of the observatories built by Maharajah Jai Singh at Delhi in about 1724 **(15)**. The intention was to create an architecture in which metaphysical speculation was encouraged. It is a concept which obsesses the architect as can be seen in his Constellation House of 1976 and Kushiro of 1977 which is based upon the yin-yang symbol.[11]

All these examples prove that Indian architecture still has not exhausted its capacity to inspire and to provoke and that even today the study of Indian architecture of all styles may in Reynolds's words,

> furnish an Architect, not with models to copy, but with hints of composition and general effect, which would not otherwise have occurred.

Abbreviations

D.N.B.	*Dictionary of National Biography*
I.O.L.	India Office Library, now part of the British Library, London.
J.I.A.I.	*Journal of Indian Art and Industry*
N.M.R.	National Monument Record, Royal Commission on Historical Monuments, London.
R.A.S.	Royal Asiatic Society, London.
R.I.B.A.	Royal Institute of British Architects, London.

Glossary of Indian Terms

Ragamala	'A garland of musical modes.' A cycle of poems or pictures characterising the princes (*ragas*) and ladies (*raginis*) who personify the moods and characters of melodies on which Indian music is improvised.
Ganesha or Ganesh	The elephant-headed god of wisdom and remover of obstacles, son of Shiva and Parvati.
Lakshmi	Goddess of fortune, wife of Vishnu.
Nawab	A viceroy or governor of a province under the Mughal Government which became the title of any man of high rank without office being attached to it.
Choultry	A term peculiar to South India: a hall, shed or covered platform used as a traveller's resting place.
Chujja	An over-hanging cornice, eave.
Serai	A traveller's halting place.
Lingam	The phallus: a symbolic form in which the god Shiva is normally worshipped.
Jali	Literally 'a net'. A lattice or perforated pattern.
Ghat	A landing place, steps on a river bank, a quay.
Chattri(s)	A pavilion, kiosk or small pavilion acting as a turret on a roof.
Mandapam	An open hall.

Sikhara	Spire or tower.
Mistri	A workman.
Stupa	From the Prakit *thupa*. Tumuli of brick, sacred mounds commemorative of Buddha.
Munshi	Teacher of languages.
Shaivite	Follower of Shiva
Howdah	Elephant seat.

Photographic Acknowledgements

My thanks to all those who helped me to obtain photographs especially my wife who took many of the uncredited pictures, as well as the following:

103, Amalgamated Theatre Collection, New Zealand Film Archive, Wellington; **97**, Anderson & McMeekin, Belfast; **99**, Battersea Public Library, London; **109, 111**, Berkeley, University of California, Dept. of Environmental Design; **47, 70** Yu-Chee Chong; **18, 19**, Conway Library, London, reproduced by permission of the Soane Museum, London; **2**, *Country Life*; **55, 59**, Philip Davies; **108**, Simon Digby; **11**, **14**, **15**, Eyre & Hobhouse Ltd, London; **52**, Sven Gahlen; **24**, Gloucester Record Office; **26**, Gloucester *Echoe*; **41**, Hamburger Kunsthalle; **95**, Hastings Museum and Art Gallery; **49**, O. G. Jarman; **113**, **114**, Charles Jencks; **65**, A. F. Kersting; **101**, Los Angeles Library; **66**, **67**, **68**, **69**, Dr Akhros Moravansky, Budapest; **77**, Museum of the City of New York; **81**, Lt Col. Nye, Bagshot Park; **48**, H. Roger-Viollet, Paris; **4**, **13**, **60**, **83**, **110**, Royal Commission on Historic Monuments, London; **98**, Dennis Sharp; **100**, Theater Historical Society, Chicago; **1**, Victoria and Albert Museum, London.

NOTES

A Passage to India – and Back

1 For an account of this embassy see Foster, William, _The Embassy of Sir Thomas Roe to India 1615–19_, (London: 1926).

2 Terry's account was first published in 1655, and was reprinted in Foster, William, _Early Travels in India 1583–1619_ (London: 1921) pp. 288–332.

3 Ibid., p. 327.

4 Gray, E., (ed)., _The Travels of Pietro della Valle in India_, Vol. II. (London, 1892), p. 328.

5 _Itinerario_ (Amsterdam: 1596). English and German editions 1598; two Latin editions 1599; French edition 1610; Dutch edition much reprinted.

6 Burnell, A. C., and Tiele, P. A., (eds), _The Voyage of J. H. van Linschoten_, 2 vols., (London: 1885), pp. 289–91.

7 Temple, R. C., (ed), _The Travels of Peter Mundy_, Vol. II (Cambridge: 1914–36), p. 210.

8 Tavernier, Jean Baptiste, _Les Six Voyages de_... (Paris: 1676); translated by J. Phillips and E. Everard, _Collection of Travels_... part I, (London: 1684), pp. 110–11.

9 Bernier, F., _Travels in the Mogul Empire 1656–1668_ (Paris 1670); English translation included in J. Phillips and E. Everard _Collection of Travels_... (London: 1684); modern edition edited by Archibald Constable, reprinted New Delhi 1972.

10 Bernier, F., _Travels_... edited by Archibald Constable, (New Delhi: 1972), p. 286.

11 Quoted in Hautecour, Louis, 'Le Regne de Louis XIV', _Histoire de l'architecture classique en France_ Vol. II, (Paris: 1948) p. 362. Hautecour quotes from J. F. Blondel, _L'Architecture Française_ vol. IV, (Paris: 1752–56) p. 12. But Charles Perrault who mentions the project in _Parallèle des Anciens et des Modernes_... 4 vols., (Paris, 1688–97,

reprinted Munich 1964), makes no mention of a Siamese room and instead includes a Spanish room.

12 Perrault, C. is quoted in Germann, George, *Gothic Revival in Europe and Britain: Sources, Influences and Ideas* (London: 1972), p. 21. Germann and Joseph Rykwert in *The First Moderns* (London: 1980), p. 62, both mis-translate 'Mogol' as Mongolian.

13 See Standen, Edith A., 'English Tapestries "after the Indian Manner"', *Metropolitan Museum Journal* No. 15 (New York: 1981), pp. 119–42. Queen Mary's tapestries have not been traced but about fifty other 'Indian' pieces are known to be in various public and private collections.

14 Elihu Yale (1648–1721), one time Governor of Fort St George, Madras and a Director of the East India Company, endowed the American university which bears his name. Neither Indian miniatures nor the 'Indian' tapestries which he is thought to have had were among the 10,000 items sold after his death. A tapestry set may have been inherited by his daughter. Veronica Murphy of the Indian Dept., Victoria and Albert Museum, London has suggested the influence of the Indian *rumal* or decorative cloth used by princes for covering gifts. Such textiles have the same arrangement of isolated groups on a patterned background within a border. Examples in Metropolitan Museum, New York and Victoria and Albert Museum. See Irwin, John, 'Golconda Cotton Painting' *Lalit Kala* No. 5, April 1959.

15 See Honour, Hugh, *Chinoiserie: The Vision of Cathay*, (London: 1961), p. 252.

16 See Strzygowski, J., 'Die Indischen Miniaturen in Schloss Schönbrunn', *Wiener Drucke* (1923) plate 55F.

17 Quoted in Kaye, John W., *Life and Correspondence of St George Tucker*, (London: 1854).

18 *The Nabob: or Asiatic Plunderers. A Satyrical Poem* (London: 1733), preface p. iii.

19 *Correspondence with Sir Horace Mann* ed. Lewis W. S., vol. VII (London: 1967), p. 400.

20 There is no modern study of the nabob, but see Holzman, John, *The Nabob* (New York: 1926). For an economic history of the nabob in eighteenth century India see Marshall, Peter J., *East Indian Fortunes* (Oxford: 1976).

21 Illustrated in Bence-Jones, Mark, *Clive of India* (London: 1974), facing p. 302.

22 See Aslet, Clive, 'Stanstead Park', *Country Life* 11, 18, 25 February

1982. Barwell may well have had a 'minaret' erected as a heating chimney as an anonymous drawing in article dated 18 February, shows.

23 Girouard, Mark, 'Preston Hall, Midlothian', *Country Life* (24, 31 August 1961), pp. 394–7, 454–7.

24 *The Nabob at Home*, vol. II (London: 1840), p. 153.

25 Illustrated in Horsfield, T. W., *History of Sussex* vol. II, (London: 1835) p. 203.

26 Shown on the 'Plan of the Farm and Policy of Novar for General Munro – David Aitkin December 1777' (Scottish Record Office, Edinburgh, R.H.P. 10671). Copy also in Novar House. The estate also included a Chinese temple, a castle and an obelisk. For information about Sir Hector Munro see Mackenzie, Alexander, *History of the Munros of Foulis*, no. 4 (Inverness: 1898) p. 534 ff.

27 Quoted in *Humphry Repton Landscape Gardener 1752–1818*, edited by George Carter, Patrick Goode and Kedrun Laurie (Norwich, 1982) pp. 135–6.

28 See entry under Stanmore, *Beauties of England and Wales: London and Middlesex* edited by Brayley and Britton. Forbes was the author of *Oriental Memoirs* (London: 1813). His papers and drawings were given to Oscott College, Birmingham but were dispersed at auction in the mid 1960s. More information about Forbes is in *Notes and Queries* vol. CXCII (1947) p. 409; vol. CXCIII (1948) p. 210.

29 See Archer, Mildred, *India and British Portraiture 1770–1825* (London: 1979) pp. 187–203.

30 *Hansard* vol. xxii (1782), p. 1285.

31 Quoted in Coupland, R., *The American Revolution and The British Empire* (London: 1930) p. 194, see also Embree, Ainslee, *Charles Grant and British Rule in India* (London: 1962) p. 188.

32 The *European Magazine* December, vol. XLII (1802), pp. 449–50 described it as follows:

The area of the temple, including the portico, is about 22 feet by 15, and its height nearly 20 feet. The pillars and pilasters, besides the usual decorations peculiar to this order of Hindu architecture, are adorned with a number of mythological figures and emblems; particularly the principal incarnation of Vishnu who, according to the belief of the Brahmans, has from time to time appeard under various material forms for the support of religion and virtue and the reformation of mankind. The figure of Ganesa, the genius of wisdom

and policy, has its appropriate place over the portal: for he is the Janus of the Hindus.

There is a full account of Osborne and the temple in *Bengal Past and Present* vol. XL, part II, no. 80 (1930) pp. 71–8. See also *Report on the MSS of The Late Reginald Rawdon Hastings, Esq.* (H.M.S.O. London, 1934) p. 223, 311–12.

33 Paintings in which he is included are to be seen in Archer, Mildred, *India and British Portraiture* (London: 1979).

34 Polier, A. L. H., *Shah Alam II and his Court*, edited by P. C. Gupta, (Calcutta: 1947).

35 See Compton, Herbert, *A particular account of the European military adventurers of Hindoustan from 1784 to 1803* (London: 1892); and a biography of de Boigne: Desmond Young's *Fountain of Elephants* (London: 1959).

36 Sappey published a portfolio of his designs in 1838 which I have not seen, but which Desmond Young says show that Sappey left enough space for four imaginary posteriors to stand cheek to cheek! Later on the firm of Sappey in Grenoble, carved a 'Hindoo' monument to Doudart de Lagrée. He was a celebrated author, explorer and administrator who travelled in South East Asia. Lagrée died in Saigon in 1868 and in 1896 a Hindu monument was erected in Grenoble, now removed to his birthplace St Vincent de Mercuze, near Grenoble.

37 I would like to thank Professor Jean-Marie Lafont, formerly of the University Oriental College, Lahore, for his help. But see also Archer, W. G., *Paintings of the Sikhs* (London: 1966) and Aijuzuddin, F. S., *Sikh Portraits by European Artists* (London: 1979).

38 See article by Cotton, J. J., in *Calcutta Review* (1905).

39 See Head, R., 'Indian Fantasy in Devon', and 'From Obsession to Obscurity', *Country Life* (21 May 1981), pp. 1524–8; (28 May 1981), pp. 1432–5.

40 Sir John Shore (Lord Teignmouth) to F. J. Shore, 1818. Teignmouth *Memoir*, vol. II (London: 1843) p. 352.

A Pleasing and Tasty Style

1 *Discourse XIII*, first given in December 1786, see Reynolds, Joshua Reynolds's *Discourses on Art* edited by Robert R. Wark (London and New Haven: 1981).

2 From 'The New History composed by Munshi Isma'il in the year 1185 Hijri (AD 1772)', MS in the possession of Simon Digby, London formerly in the collection of Sir Thomas Phillips, no. 18225.

3 All quotes from *Discourse XIII*.

4 See Steube, I. C. S., *The Life and Works of William Hodges* (New York and London: 1979).

5 Archer, Mildred, *British Drawings in the India Office Library* vol II. pp. 640–2.

6 The MS of Sandby's lecture notes is in the R.I.B.A. Library, London and another copy is in the Soane Museum. Sandby's illustrations were taken from the drawings of Dr James Lind (1736–1812) who had visited India and China in 1768 and again in 1779. He lived at Windsor and for a time was physician to George III. A drawing of Elephanta made in 1770 by T. Sandby for his lectures is now in the Paul Mellon Collection, U.S.A. Seven other drawings of Indian architecture were sold at Leigh and Sotheby 19 July, 1799.

7 Details taken from Stroud, Dorothy, *George Dance Architect 1741–1825* (London: 1971) pp. 119–21.

8 Dance's library included several books on India as well as 'Twenty-Four Views in Hindoostan' by the Daniells (1795) and other Indian drawings by Thomas Daniell; sale catalogue in British Library. See *Sale Catalogues of Libraries of Eminent Persons: vol. IV., Architects*, edited by D. J. Watkin (London, 1972).

9 Quoted in Stroud, *George Dance, Architect*, pp. 120–1.

10 See Harlow, Vincent, *The Founding of the Second British Empire 1763–93* (London: 1964) p. 799.

11 Norton, P. F., 'Daylesford: S. P. Cockerell's Residence for Warren Hastings', *Journal of the Society of Architectural Historians*, vol. XXII, (October 1963), pp. 127–9. See also Feiling, Keith, *Warren Hastings* (London: 1954).

12 See Dow, Alexander, *Dissertation concerning the Customs Manners, Language, Religion and Philosophy of the Hindoos*, inserted into the 1772 edition of his translation of Ferishta's *History of the Deccan*, vol. VI, pp. 382–3.

13 See *Archaeologia* vol. VII, (1787), pp. 251–89.

14 See *Archaeologia* vol. X, (1792), pp. 449–59.

15 See under the various subject headings in the index to *The Letters of Sir William Jones*, edited by Garland Cannon (Oxford: 1970).

16 See Head, Raymond, 'Corelli in Calcutta – Colonial Music-making in 18th century India', *Early Music* (November 1985).

17 For an account of the Daniells see Shellim, Maurice, *India and the Daniells* (London: 1979) and Archer, Mildred, *Early Views of India* (London: 1979).

18 *Travels of Mirza Abu Taleb Khan* translated by Charles Stewart, (reprinted New Delhi, 1972) p. 100.

19 Ibid., pp. 76–81.

20 For a full account see Watkin, David, *Thomas Hope and the Neo-Classical Idea* (London: 1968).

21 For a discussion of this subject see Conner, Patrick, 'A Composition Picture', *Burlington Magazine* (London: June 1982).

22 Op. cit. p. 227.

23 Ibid.

24 Mordaunt Crook, J., 'Regency Architecture in the West Country: The Greek Revival', *Royal Society of Arts Journal* (June 1971) pp. 440–8.

25 Dance's drawings for the mentioned schemes are in the Sir John Soane Museum, London. See Stroud, *George Dance Architect*.

26 Illustrated in Conner, Patrick, *Oriental Architecture in the West* (London: 1979), p. 131.

27 In 1807 a bas-relief of two satyrs in coade stone on the front of his house at Hyde Park Corner was suddenly attacked as obscene by the Society for the Supression of Vice. This after 25 years. Cockerell won his case and was held up to the readers of *The Repository* in March 1810 as an enlightened person well able to defend the arts against 'bigotry and ignorance'.

28 Letter from S. P. Cockerell to Charles R. Cockerell (7 May 1816); Cockerell MSS, Mrs B. Crichton Collection.

29 A drawing of 'Sesincot' (Sezincote) once in the collection of the Prince of Wales is in the Prints and Drawings Room of the British Museum.

30 Drawings for Sezincote are in the R.I.B.A. Drawings Collection, Portman Square, London.

31 For information about Taylor see Binney, Marcus, *Sir Robert Taylor* (London: 1984).

32 S. P. Cockerell wrote to C. R. Cockerell on 7 May 1816 'You may even

recollect how beautiful as a whole tho' mooresque and barbarous in its parts is the celebrated Marble monument in the country of Oude in Bengal called the Tage Mahall with its vast Portal, its singular dome and minarets at the Angles forming in every view of it a triangular elevation'. (Cockerell MSS, Mrs B. Crichton Collection).

33 William Hodges much preferred the flowing outlines of Mughal domes to classical examples. So too did R. Payne Knight, (*Principles of Taste* (1808) p. 81), but he could not agree to their use in England. I have wondered whether William Wilkins was influenced by the Indian calix when he designed the domes for the National Gallery (1825) and University College, London (1832). In both cases the domes rise to the lanterns via a series of concentric rings and a calix, thus avoiding the angular effect of classical domes with lanterns which Hodges disliked. William Wilkins, together with C. R. Cockerell and William Daniell, was appointed to read Ram Raz's *Essay on the Architecture of the Hindus* (1834), prior to publication. All warmly approved its publication.

34 See Mordaunt Crook, J., 'Xanadu by the Black Sea, The Woronzow Palace at Aloupka', *Country Life*, 2 March, 1972.

35 See Shellim, Maurice, *India and the Daniells*, p. 86.

36 There was a brief but appreciative description and an engraved view in Neale, *Beauties of England and Wales* (London, 1823) vol VI. Another is in the journal of a local resident, Rev. F. E. Witts, where it is referred to as 'striking and picturesque'. See *The Diary of a Cotswold Parson* edited by David Verey, (Gloucester: 1978), p. 75.

37 My thanks to Professor M. J. McCarthy of Toronto University for telling me of a design which once hung in the house. Its present whereabouts are unknown.

38 Fosbrooke, Rev. T. D., *A Picturesque and Topographical Account of Cheltenham* (Cheltenham: 1826) pp. VI–VII. Of the New Market at Cheltenham he wrote '[it] is Asiatic. No scientific approbation can possibly be given to the oriental style but there may be an elegance in fancy work, a kaleidoscope produces interesting arrangements of shapeless masses', (p. 40).

39 Remarks made in an unpublished preface originally intended to accompany 'Nash's Views of the Royal Pavilion', (dated 1826, but published in 1827). This preface was published in full in Musgrave, Clifford, *The Royal Pavilion ...* second revised edition (London: 1959).

40 Bond to Porden 28 July 1806, letter in Royal Academy, Jupp Catalogue Ju/8/215. Perhaps inspired by Porden's stables, Bond designed a

Moorish room at Southampton Castle for the Marquis of Lansdowne in 1809.

41 Published in Conner, P., (1979) plates 95–8. See also John Morley, *Brighton Pavilion* (London: 1984).

42 Published in Carter, Goode and Laurie, *Humphry Repton Landscape Gardener 1752–1818* (Norwich: 1982), p. 86.

43 Op. cit.

44 Musgrave, C., *The Royal Pavilion* (1959), p. 91.

45 Copies of the original drawings are in the National Trust Archive, Dublin.

46 There is a chapter on A. H. Wilds in Dale, Anthony, *Fashionable Brighton 1820–1860* (1967).

47 In 1827 the land was bought by Sir David Scott, who, like his father was a one-time director of the East India Company. Wilds designed Sillwood House for him. Two houses in Sillwood Place by Wilds have Indian exteriors which doubtless recalled Scott's Indian background.

48 Illustrated in Hix, John, *The Glass House* (London: 1974) figure 25.

49 Illustrated in Kohlmaier, G., and von Sartory, Barna, *Das Glasshaus* (Munich: 1981).

50 Description in *The Gentleman's Magazine* (1836) vol I, p. 654. An engraving published in 1842 by W. H. Bartlett (copy in N.M.R.) shows how like a *ghat* it was.

51 See Linstrum, Derek, *Sir Jeffrey Wyatville Architect to the King* (Oxford: 1972) pp. 213–16.

52 See Barnum, P. T., *Struggles and Triumphs of P. T. Barnum Told by Himself* (first published 1882, new edition, London: 1967), edited by John G. O'Leary; *Selected Letters*, edited by A. H. Saxon (New York: 1983).

53 Two volumes of Austin's drawings are in the Manuscript and Archives Department, Yale University Library, New Haven.

54 See Lancaster, Clay, 'Oriental Forms in American Architecture 1800–1870', *The Art Bulletin* vol XXIX, (1947) pp. 183–93.

55 Drawings at Yale University Library. Many of Austin's New Haven buildings are illustrated in Brown, Elizabeth M., *New Haven: a Guide to Architecture and Urban Design* (London and New York, 1976).

56 See *L'Architecture* (1897), pp. 293–6.

Other Sheep I have

1 Queen Victoria's text, taken from the Bible, which she chose to be inscribed on the tomb of Princess Victoria Gouramma Campbell, daughter of the Raja of Coorg, who died in England in 1864. See M. Alexander, *Queen Victoria's Maharajah* (London: 1980), p. 102.

2 Translated by Captain James Alexander and published in London in 1827.

3 I am grateful to Mr Simon Digby, London, for drawing my attention to these two accounts. Munshi Isma'il's account, 'The New History composed by Munshi Isma'il in the year 1185 Hijiri (AD 1772)' is an unpublished MSS in Mr Digby's possession. It was originally in the Sir Thomas Phillips Collection, no. 18225. See also p. 21.

4 For further information about General Benoît de Boigne, see Young, D., *Fountain of Elephants* (London: 1959).

5 See Musgrave, C., *The Royal Pavilion* (London: 1970), pp. 203–5.

6 For accounts of Elveden see Alexander, M., *Queen Victoria's Maharajah* and two articles by Clive Aslet, 'Elveden Hall, Suffolk', *Country Life* 8 March 1984, pp. 607–11; 15 March 1984, pp. 672–6 also Clive Aslet, *Elveden Hall Volume VII, A History of Elveden* (London, 1984), a booklet published by Christie's to accompany the sale of the contents of Elveden in May 1984. There is an account of Maharajah Duleep Singh and his family in Aijazuddin, F. S., *Sikh Portraits by European Artists* (London, 1979).

7 See Woodham-Smith, C., *Queen Victoria Her Life and Times 1819–1861* (London, 1972, reprinted 1975), p. 490.

8 The first in 1861 was to bring his mother to London. She resided at Abingdon House, Kensington with her Indian servants.

9 See plan and elevation in *The Builder* 18 November 1871, pp. 905–7.

10 *The Builder*, ibid.

11 Duleep Singh died in 1893 in Paris. His wife Princess Bamba, much neglected, died in 1887. Both are buried in Elveden churchyard. In accordance with terms made with the Government of India, Elveden was sold in 1894 and bought by the 1st Earl Iveagh.

12 William Prinsep (1794–1874) was the fifth son of John Prinsep who had a chintz factory in Bengal at Pultah. There is a drawing of it in the Wellcome Institute, London. William arrived in Calcutta in 1817 and retired in 1842, first joining the firm of Palmer & Co, and then setting

up his own mercantile business with his brother George. He is best known as a talented artist, a pupil of George Chinnery. The original drawings of the Roy monument are in a private collection. These and other architectural sketches suggest he designed some buildings in Calcutta. See Archer, M., *British Drawings in The India Office Library* (London, 1969), vol. I, p. 288–92; Archer, M., *Thomas and William Prinsep in India*, catalogue of an exhibition at Spink & Son (London, 1982); Conner, P., *The Overland Route of William Prinsep*, catalogue of an exhibition at the Martyn Gregory Gallery, London 1984; Sir H. T. Prinsep, 'Three Generations in India', (MSS Eur. C. 97 1–4), India Office Library, London.

13 Cimino, R. M., and Scialpi, F., (eds), *India and Italy* (Rome: 1974), catalogue of an exhibition in New Delhi, plate 51, p. 117. See also Baroda, Maharajah of, *The Palaces of India* (London: 1980), pp. 126–31.

14 For Major Charles Mant (1848–81), see Stamp, G., 'British Architecture in India 1857–1947', *J.R.S.A.* vol. CXXIX (May 1981), p. 366. A design for a palace in India, probably at Cooch Behar *c.* 1875 is illustrated in Darby, M., *The Islamic Perspective* (London: 1983) p. 131.

15 *Oxford Times* 17 February 1872, quoted in a booklet *The Public Well at Stoke Row, Ipsden, Oxfordshire, The Gift of the Maharajah of Benares* (Oxford: *c.* 1972); see also *The Maharajah's Well ... An Illustrated History* (Uxbridge: 1979).

16 The example of the Maharajah was followed by the Maharajah of Vizianagram who gave money for a drinking fountain which was erected in Broad Walk, Regent's Park in 1868. Sir Cowasjee Jehangir Readymoney funded another fountain which was built near Marble Arch, Hyde Park in 1869. Both were Gothic spires, and the latter has been removed.

17 Owen Jones provided plans for 24 Palace Gardens in 1845 when the Commissioner found it 'very Moresque but not unpleasing'. In 1879 various alterations took place including the removal of 'cement ornaments' on the front façade. It was probably at this time, or soon after, that the domes were added. They provide an odd and unintegrated element that Jones would not have approved of. See Darby, M., *The Islamic Perspective*, pp. 69–71.

Imperial Sentiment and Anglo-Indian Architecture

1 Annesley, George Viscount Valentia, *Voyages and Travels to India, Ceylon ... in the years 1802, 1803, 1804, 1805 and 1806* (London: 1809) vol. 1, p. 240.

2 For Metcalfe see Kaye, M. M., *The Golden Calm* (Exeter: 1980); and for Major General Claud Martin, *Bengal Past and Present* vol. III, no. 1 (1909) pp. 102–9.

3 For an illustration of the 'Strawberry Hill' gothic Residency building at Khatmandu, see Hodgson Collection at the Royal Asiatic Society, London, no. 232 and forthcoming catalogue of the R. A. S. Collection of paintings and drawings. Another view is in the India Office Library, London.

4 There were always a few civil architects in India although it was official policy only to employ civil architects on important works if there was no engineer in the locality. This view was re-enforced in a letter from the Court of Directors in London to Bengal dated 25 May 1841 (*Indexes to Despatches To Bengal and India 1837–46* I.O.L.) The position altered after 1855 when the Public Works Department was established as a civil, not a military department and after 1858 when responsibility for Indian affairs passed from the East India Company to the Government.

5 Robert Chisholm (1840–1915), 'New College for The Gaekwar of Baroda, with Notes on Style and Domical Construction in India' *Transactions* R.I.B.A. (1882–3) p. 141. For a full discussion of British architecture in India see Davies, Philip, *Splendours of the Raj* (London: 1985).

6 See also remarks in chapter 3, pp. 69–71.

7 Discussion only printed in *The Builder* 16 June 1888, pp. 430–1 which accompanied a report of C. Purdon Clarke's lecture 'Examples of Moghul Art in the India Museum', *Transactions*, R.I.B.A. (1888) pp. 122–32.

8 Colonel Sir Samuel Swinton Jacob (1841–1917); commissioned in Bombay Artillery 1858; served in Public Works Department 1862–96 mostly in Jaipur State. Architectural works include: Secretariat Offices, Simla; Victoria Memorial Hall, Peshawar; Bank of Madras; Albert Hall, Jaipur; St Stephen's College, Delhi; Public Offices at Jodhpur and Dholpur; Hospital, Bharatpur; College, for Begum of

Bhopal; Palaces for Maharajahs of Kotah and Bikaner; Church, Jaipur; Daly College, Indore; etc. Knighted in 1902.

9 Later republished in two parts: *Indian Architecture of To-Day as exemplified in New Buildings in the Bulandshahr District* (Part I Allahabad 1885; Part II Benares 1886). Apart from the P.W.D. he was also hostile to the official policy of occupancy rights in the District. The two factors led to his instant transfer to Fatehpur within two weeks of the publication of *Bulandshahr . . .* Growse was an admirer of the ideas of Lockwood de Forest, whom he met, and from whom he received a presentation copy of *Indian Domestic Architecture*.

10 *J.R.S.A.* (1890) p. 519.

11 Ibid.

12 See note 7.

13 *Transactions* R.I.B.A. (1888) pp. 131–2.

14 For a discussion of this aspect and the New Delhi scheme, see Irving, Robert Grant, *Indian Summer Lutyens, Baker and Imperial India* (New Haven and London, 1981) pp. 91–116.

15 The artist William Daniell, William Wilkins and Charles R. Cockerell were asked to write an appraisal of the work and they unanimously agreed to its publication. At a Royal Academy dinner in 1833, Sir John Soane told Charles W. Williams Wynn, the President of the Royal Asiatic Society, that he was 'strongly in favour of it, as an object of deep interest' (*Proceedings of the R.A.S.* 11 May 1833, p. 58). The original drawings are in the R.A.S. Collection nos. 332–403.

16 The relative merits of Indian architecture which Fergusson expounded were received by some critics with hostility. The critic of *The Architect* reviewing a later edition of the *History of Indian and Eastern Architecture*, referred to Fergusson's self-taught background and Indian upbringing as being responsible for his judging all other art by that of India and its 'semi-barbarous standards' *The Architect* (31 July 1891), pp. 64–7.

17 Preface, *Jeypore Portfolios . . .*

18 *The Building News* (19 December 1890), p. 875.

19 In 1891 John Tavernor Perry exhibited at the R.A. a design for a 'Chimneypiece' and an 'Indian Room' for the Hotel Cecil. The 'Chimneypiece' is probably the elaborately tiled 'Indian' chimneypiece mentioned in *The Building News* (24 April 1896), vol. LXX, p. 599 and illustration. The 'Indian rooms' comprised the table d'hôte, billiard and smoking-rooms. According to *The Building News*

it was the long, low rooms which suggested this style. The details of the columns, fireplaces and colours were taken from Fatehpur Sikri. Sir Henry Doulton, an admirer of Indian crafts, worked closely with the architects in the designs of the hand-painted tiles which covered the walls and encased the columns. In 1908 at a Royal Asiatic Society dinner in these rooms the first performance of Gustav Holst's *Rig Veda* songs was given.

20 Illustration no. 55 in *Getting London in Perspective*, exhibition catalogue Barbican Art Gallery (London: 1984). Drawing in the Victoria and Albert Museum, London.

21 Quoted in David Cole, *The Work of Sir Gilbert Scott* (London: 1980) pp. 76–7.

22 Lieutenant Henry Hardy Cole (1843–1916) Royal Engineers, see Bonython, Elizabeth, *King Cole: A Picture Portrait of Sir Henry Cole K.C.B. 1808–1882* (London, 1982).

23 Model and drawings are still at Knebworth.

24 Illustrated in *Survey of London* vol. XXXVIII (1975), The Museums Area of South Kensington and Westminster (London: 1975) p. 342. Illustrated in plates 108, 109.

25 Remarks made by Birdwood at the end of C. Purdon Clarke's 'Some notes upon the Domestic Architecture of India'. *J.R.S.A.* vol. XXXII (1883), p. 746.

26 *Journal of the East Indian Association* (July 1910), pp. 153–81.

27 Clarke worked in conjunction with the architect William Young, and upon his death in 1900 with his son Clyde. Clarke was also responsible for furnishing the new wing. For more details of this scheme see Aslet, Clive, *History of Elveden*.

28 See *Magyar Müvészat 1890–1919* ed. L. Nemeth (Budapest, 1981) illustration no. 189.

29 I am most grateful to Elizabeth Ryecroft, London for sharing her extensive knowledge of Hungarian architecture with me and to Dr Akhros Moravansky, Budapest, for all his help.

30 Published by Ferenc Vamos in *Müvésvet* (Budapest, September 1964). Quotation kindly supplied by Dr Akhros Moravansky and translated by Gillian Naylor.

31 See Imre Kathy *Medgyaszay István* (Budapest; 1979).

32 See *Art Nouveau Architecture* edited by Frank Russell, (London: 1979).

33 The Imperial Court was first built for the Indian Empire Exhibition in 1895. In the enclosed court there was an 'Indian' pavilion which was completely remodelled and made more 'authentic' for the 1908 exhibition. Photographs in Central Library, Kensington.

34 Spooner had worked in Ceylon and was State Engineer 1891–1901. See Gullick, J. M., 'Kuala Lumpur 1880–1895', *Journal of the Malaysian Branch of the Royal Asiatic Society* vol. XXVIII, pt. 4, (August 1955).

Indian Crafts and Western Arts

1 Jones, Owen, *Grammar of Ornament* (London: 1856) p. 77.

2 Ibid., pp. 77–8.

3 Published in London by the Oriental Translation Committee of the Royal Asiatic Society.

4 See especially their series of 24 views entitled *Antiquities of India* (London, 1798–1808) reproduced Archer, *Early Views of India*.

5 *Annals* vol. II, pp. 733–4. Colonel James Tod (1782–1835) served in Rajasthan from 1799–1823 and commissioned his Indian artist Ghassi to make detailed drawings of ancient monuments. These and many other drawings were presented to the R.A.S. in 1850 by his executors. Prior to the publication of the *Grammar* Jones had visited the R.A.S. from which he obtained a specimen of 'Hindoo' ornament from a statue of Surya, but nobody seems to have shown him the Tod drawings, see Jones p. 82.

6 Wilson, Horace H., *A descriptive catalogue of the oriental manuscripts and other articles illustrative of the literature, history, statistics and antiquities of South India . . .* (Calcutta: 1828). See Archer, *British Drawings in the India Office Library* pp. 472–3.

7 Jones, O., *Grammar of Ornament*, p. 82.

8 Mitter, Partha *Much Maligned Monsters* (Oxford, 1977) pp. 223–9.

9 Wornum, Ralph N., 'The Exhibition as a Lesson in Taste', *Art Journal Illustrated Catalogue* (London: 1851) pp. 6 et. seq.

10 Ruskin, John, *The Two Paths* (London, 1859) p. 261, see also Mitter op. cit. pp. 238–51.

11 Op. cit. p. 230.

12 Trevelyan, Sir Charles, 'Testimony before the Select Committee of the House of Lords on the Government of Indian Territories 21 June 1853', reprinted in 'The Education Despatch of 1854', *Modern Review* (Calcutta), 11 (1912), 347–8. For a study of British art education in India see Tarapor Mahrukh, 'J. L. Kipling and Art Education', *Victorian Studies* Indiana University, (Autumn 1980) vol. 24, no. 1. pp. 53–81.

13 Birdwood, George, *Handbook to the British Indian Section* (London and Paris 1878). Reprinted with additions in *The Industrial Arts of India* (London, 1880).

14 William Morris to Birdwood, 1 May 1879, reprinted in *Journal of Indian Art and Industry* no. 65 (January 1899) pp. 51–2. Signatories included: George Aitcheson, Thomas Armstrong, Edwin Arnold, C. Purdon Clarke, Walter Crane, Henry Doulton, Carl Haag, George Howard, E. Burne Jones, Frederic Leighton, John Everett Millais, Arthur Morrison, Richard Redgrave, Vincent Robinson, R. Norman Shaw, E. Alma Tadema, Philip Webb, Thomas Woolner.

15 For biographical information about J. L. Kipling (1837–1911) see Tarapor, 'J. L. Kipling and Art Education', and Carrington, Charles, *Rudyard Kipling: His Life and Work* (London: 1978); Wilson, Angus, *The Strange Ride of Rudyard Kipling* (London and New York: 1978); Kipling Papers, University of Sussex Library.

16 John Griffiths (1837–1918) was an artist who exhibited Indian views regularly at the Royal Academy. Between 1872 and 1885 and with the help of his students, he copied the frescoes at Ajanta which were reproduced in *The Paintings in the Buddhist Temples of Ajanta* (London: 1896). He retired from India in 1895. See *John Griffiths (1837–1918)* the catalogue of an exhibition held at Eyre and Hobhouse, Duke Street, London, from May to June, 1980. Griffiths's report on the Ajanta paintings is in the India Office Library, London and his correspondence is in the National Library of Wales, Aberystwyth.

17 Lockwood de Forest (1850–1932). All biographical and other information has been taken from Lewis, Anne Suydem, *Lockwood de Forest, Painter, Importer, Decorator*, Heckscher Museum, 1975, Huntington, New York.

18 See Faude, Wilson H., 'Associated Artists and the American Renaissance in the Decorative Arts', *Winterthur Portfolio* vol. X, (1975), pp. 101–30.

19 Quoted in William Henry Shelton 'The Most Indian House in America', *House Beautiful* vol. VIII no. 1, (June 1900), p. 422.

20 In an unpublished typescript of his journeys in India, 'Indian

Domestic Architecture' *c.* 1919, quoted by Anne S. Lewis (op. cit., p. 12) de Forest wrote 'In 1880 I made up my mind that more could be learned from the East than anywhere else, so I started to make a study of the Architecture and all the arts and crafts of India'.

21 Some carved panels made by the Ahmedabad Wood Carving Company are illustrated in *Journal of Indian Art and Industry* no. 2 (January 1887) pl. 16. A teakwood cabinet by Hutheesing was specially mentioned in *Journal of Indian Art and Industry* no. 7 (September 1888), p. 55, when it was exhibited at the 1887 Antwerp Exhibition, also illustrated. Illustrations of sample carved panels are in de Forest, L., *Indian Domestic Architecture* (Boston: 1885) and *Indian Architecture and Ornament* (Boston: 1887), *Illustrations of Design* (Boston: 1912).

22 Caspar Purdon Clarke was sent to India to make purchases for the Indian Section between November 1881 and April 1882. He sent back 3,400 acquisitions during that time, see Skelton, Robert, 'The Indian Collections 1798 to 1978' *Burlington Magazine* vol. CXX, no. 902 (May 1978), p. 301. A description of Clarke's travels is to be found in Mme de Ujfalvy-Bourdon, *Voyage d'une Parisienne dans L'Himalaya Occidental* (Paris: 1887).

23 See Sheldon, George, *Artistic Houses*, 2 vols. (New York 1882–1884) reprinted in 1971, see vol. 1, p. 53.

24 Sheldon, G., op. cit., vol. 2. p. 95, 'the mirror, in a metal frame, is divided into various designs, and inclosed (sic) in an outer frame of East India panels of carved teak wood, lightened-up with bronze on the projecting points'.

25 Ibid., vol. 2. p. 150.

26 Ibid., vol. 2, p. 159, Sheldon erroneously referred to it as 'a large Moorish screen'.

27 'Moorish Decoration', *Decorator and Furnisher* (January, 1885), p. 141.

28 Sheldon, G., op. cit., vol. 1, p. 1. Sheldon noted the complete lack of 'servile imitation'. In the Tiffany House on 72nd Street, New York there was a remarkable carved overmantel with struts, presumably designed by Tiffany and made in Ahmedabad, see photo in New York Historical Society illustrated in R. Bishop and P. Coblentz *The World of Antiques, Art and Architecture in Victorian America* (New York: 1979), plate 69.

29 De Forest also designed a bedroom for Carnegie. Both rooms have survived relatively intact. The Mansion on East 91st Street, New York is now the Cooper-Hewitt Museum.

30 Perhaps also the Ralph H. White Residence, Boston, *c*. 1883, see Sheldon vol. II, p. 125 where Indian carved panels may have been used on the walls and door surrounds. The intricate woodcarvings to be found in the Court of Appeals Chamber, Albany, New York of 1884 would appear to reflect his interest in the Indian carvings of Lockwood de Forest, as illustrated in Bishop and Coblentz, *The World of Antiques*, pl. 298.

31 Coleman, Cary, 'India in America', *Decorator and Furnisher* (March 1885), p. 202.

32 Described in Shelton, W. H., 'The Most Indian House in America', *House Beautiful* (Chicago: 1899–1900), vol. VII–VIII, pp. 419–23.

33 This is now a reception room in the Jason Downer Center at Lawrence University, see Lewis, A., op. cit., p. 30, note 14.

34 See Merriam, Ruth Levy, *A History of the Deanery* (Bryn Mawr College, 1965).

35 See Shelton, W. H., 'The Most Indian House in America', *House Beautiful*, p. 422.

36 Lewis, Anne S., op. cit., p. 19, note 16.

37 J. L. Kipling, 'Punjab Wood-Carving', *Journal of Indian Art and Industry* (1886) no. 4, pp. 1–3.

38 Ibid., designs by Ram Singh working under the direction of Kipling are illustrated plate vi.

39 Ibid., pp. 1–3.

40 Very little had changed in 100 years of British occupation. In 1784 Abdul Karim Kashmiri, a Muslim traveller then in Calcutta wrote, 'The Company did not provide employment on a traditional scale for people of education or soldiers; merchants were deprived of business by the public and private trade of the English; and the English had no taste for the handicrafts of India, which the Indian gentle classes no longer had the means to support, leaving the craftsmen also without a livelihood', excerpt from *Bayan i waqi*, 'an account of the author's travels', British Library, Or. 181. I am grateful to Simon Digby for drawing my attention to this.

41 Reprinted in *Journal of Indian Art and Industry* no. 1. (1886), pp. 1–4.

42 For biographical details see Ashton, George, *H.R.H. Duke of Connaught and Strathearn* (London: 1929).

43 Illustrated in Warner, Marina, *Queen Victoria's Sketchbook* (London: 1982).

44　　See Crew, G. C. E., *Bagshot Park Surrey and the Royal Army Chaplain's Departmental Museum* (Derby: 1974).

45　　Kipling Papers, University of Sussex Library; Princess Louise at Meerut to Kipling, Lahore, 23 June 1884.

46　　For details of this scheme see Head, Raymond, 'Bagshot Park and Indian Crafts', *Sources of Inspiration for Victorian Art and Architecture*, Society of Antiquaries (London) Occasional Papers, New Series no. 7, (London: 1985).

47　　Kipling Papers, University of Sussex Library.

48　　See Adburgham, Alison, *Liberty's A Biography of a Shop* (London: 1975), pp. 59–60. There were 43 craftsmen in London for the Colonial and Indian Exhibition and their names are recorded in Cundell, Frank, *Reminiscences of the Colonial and Indian Exhibition* (London: 1886). Two of them, Muhammed Baksh and Juma, stayed on in London after the exhibition had finished because they had received so many commissions. According to a letter the work at Bagshot was overseen by, Caspar Purdon Clarke, see Connaught at Poona to Kipling, Lahore, 24 January 1885 (Kipling Papers).

49　　See illustration in Head, R., 'Bagshot Park and Indian Crafts'.

50　　A trophy and a gun room were added in about 1910. The connecting archway was designed and made in carved wood by Sadhoo Singh and Gurbachan Singh, students at the Lahore School of Art. The work was overseen by the principal Lionel Heath and cost 486 rupees. Information taken from the original drawing now in the Indian Study Room, Victoria and Albert Museum.

51　　C. Purdon Clarke, 'Some Notes upon the Domestic Architecture of India', *Transactions of the Society of Arts*, vol. XXXI (1883) pp. 731–46. One of Shaw's clients, Vincent Robinson a scholar, oriental carpet dealer and a signatory of the letter to Birdwood 1 May 1879, bought an Ahmedabad carved bay window from Purdon Clarke which the latter had purchased from Lockwood de Forest. It may have been incorporated into Robinson's house *Hopedene*, Holmbury St Mary, Surrey which had an extension designed by Shaw.

52　　A palazzo-style house at 998 Great Western Road, Glasgow built for an ironfounder in 1877 by James Boucher. Now St Mungo's Academy F. P. Centenary Club.

53　　Letters relating to the project are in the Kipling Papers, University of Sussex Library. Although it has acquired the name 'Durbar Room', the original estimate and references in letters make it clear that it was to be built as an 'Indian' dining-room.

54 The 'authentic' Indian decoration was carried out by Jackson & Sons.

55 Illustrated in *Designs for the Dream King – The Castles and Palaces of Ludwig II of Bavaria* (London and New York, 1978) plates 12–13.

56 George Jackson & Sons, 49 Rathbone Place, London. For a description see Hopkins, R. Thurston *This London – Its Taverns, Haunts and Memories* (London, 1921), pp. 234–6.

57 Carton pierre was a form of *paper maché* which was made in metal moulds and used for detailed, three dimensional work. It was much lighter than fibrous plaster.

58 This failed to materialise even though Wagner had sketched out the plot. Many of the musical ideas were subsequently incorporated into *Parsifal*. At the turn of the century Debussy considered the same subject but he too finally rejected it.

Marble Walls and White Reflections

1 Information from *The Builder*, (6 April 1867), and illustration.

2 Illustrated in Conner, Patrick, *Oriental Architecture in the West* (London: 1979), p. 157.

3 Whittock, Nathaniel, *On the Construction and Decoration of Shop Fronts* (London: 1840), p. 3.

4 Ibid., pp. 3–4.

5 Ibid., p. 12.

6 Ibid., pp. 3–4.

7 For more information about the development of the East India Company's museum see Desmond, Ray, *The India Museum 1801–1879* (London: 1982).

8 Quoted in Sedlemayer, H., *Art in Crisis* (London, 1957) p. 52. Various countries built 'national' houses including Egypt, Turkey, Tunisia, Morocco, Russia, Austria, Britain, Holland and Spain. These gave the French architectural historian Alfred Normand the opportunity to make a comparative study of the buildings which he accepted as true representations of the various styles. The countries had of course flattered themselves. It was from these 'national' houses that national pavilions with all their curiously exaggerated characteristics derived:

Normand, Alfred, *L'Architecture des Nations Etrangères . . . à l'Exposition Universelle de Paris*, (Paris, 1870).

9 They were all illustrated in *Journal of Indian Art and Industry* nos. 11–14. Some are shown in Cundell, F., *Reminiscences*, (1886).

10 A letter in the Kipling Papers dated Simla, 31 January 1886. Kipling was nervous about the Punjab screen because it looked monotonous. The exhibition had been arranged in a hurry which meant that little time could be devoted to details. His patience and energy had been exhausted by all the exhibitions and he hoped that after 1886 there would not be any more.

11 Illustrated in Cundell, F., *Reminiscences* (1886).

12 It had been commissioned by the Maharajah in 1883 and made by local stone carvers after a design by Major J. B. Keith of the Archaeological Survey of India. *J.I.A.I.* no. 14, p. 109.

13 See *Illustrated London News* (14 July 1886).

14 *J.I.A.I.*, no. 14, p. 105.

15 Now in the Indian Section, Victoria and Albert Museum.

16 There is a portrait of Santiagoe by Sir John Lavery in the Wakefield Art Gallery, Lancashire.

17 Details from *J.I.A.I.*, no. 28, pp. 19–21.

18 Figures quoted in *J.I.A.I.*, no. 7, p. 55.

19 Burg, David F., *Chicago White City of 1893* (University Press of Kentucky, 1976) p. 222.

20 Ibid.

21 Imre Kiralfy, (1845–1919), exhibition designer and entrepreneur, designer of many exhibitions in London including: 1895 Indian Empire Exhibition; 1908 Hungarian Exhibition; 1908 Franco-British Exhibition. Kiralfy owned a copy of Antonio Basoli's *Collezione di Varie Scene Teatrali*, (Bologna: 1821) which contains many exotic settings including Indian scenes. Kiralfy purchased the volume in 1887 and it is now in the British Library.

22 Details of Indian pavilion in *J.I.A.I.*, no. 67 (July 1899).

23 Quoted by Frank Russell, *Art Nouveau Architecture* (London: 1979) p. 13.

24 For an account see Knight, Donald R., *The Exhibitions Great White City, Shepherds Bush, London* (London, 1978).

25 First published 1901 by William Heinemann, London, thereafter

went through an amazing seventeen editions, the last in 1914 with colour illustrations by Byam Shaw. Some of the poems were set to music by Amy Woodford-Finden and called *Indian Love Lyrics* and were probably even more popular than the poems.

26 For information see *The Lady Brassey Museum*, an undated guide of about 1890; Griffiths, M., 'Lord and Lady Brassey', *Strand*, vol. VIII, no. 37 (1894) pp. 517–27. Also Devenish, David, 'The Brassey Collection', *Area Service Magazine* Area Museums Service, (Summer 1976), no. 29 (Milton Keynes) pp. 6–8. The Brassey room was given to Hastings Corporation in 1918 by Lord Brassey and is now in the Museum and Art Gallery.

27 At 27 Grosvenor Square, London, illustrated in *Survey of London, The Grosvenor Estate in Mayfair* vol. XL, 1980, part 2, p. 145.

28 Illustrated in Robertson, E., *Cast Iron Decoration* (1977) plate 468. Bought by the Maharajah of Mysore and erected in his new palace *c*. 1905 Baroda and Fass, *The Palaces of India* (London: 1980), p. 144.

Fantasy and Illusion

1 Britton, J., and Pugin, A. C., *Illustrations of the Public Buildings of London* (London: 1825), vol. I, pp. 262–72.

2 Ibid.

3 Ibid.

4 *Times-Picayune*, New Orleans 18 January 1843, quoted in Young, William C., *Documents of American Theater History Vol. I. Famous American Playhouses 1716–1899* (Chicago: 1973), pp. 154–5, illustration facing p. 159.

5 Now called the Golden Temple, it was built about 1750 and is dedicated to Biseswar (Sanskrit: Visveswar).

6 Hodges, W., *Voyage Pittoresque de l'Inde, fait dans les années 1780–1783*, 2 vols., French translation by Louis Langlés (Paris, 1805).

7 Originally this was at 167 Drury Lane. The 'Mogul Saloon' opened on 27 December 1847. From 1851 it became known as the Middlesex Music Hall, and was rebuilt in 1911 as the Winter Garden Theatre by Frank Matcham. Demolished 1965.

8 See Ritchie, J. Ewing *The Night Side of London . . .* (London, 1857) pp. 165–71.

9 Boulton, W. *The Amusements of Old London*, 2 vols., (London: 1901). Vol. I. p. 66. There are anonymous drawings in the Crace Collection, Prints and Drawings Dept., B.L., entitled 'White Conduit House Tavern and Tea Gardens 1817' and 'Birds Eye View of WHITE CONDUIT GARDENS from a drawing taken in 1849'.

10 *Illustrated Handbook* (London: 1854) p. 13.

11 T. Hayter Lewis's address to R.I.B.A., London, reported in *The Builder* 14 May 1853, pp. 308–9.

12 *Illustrated Handbook*, p. 13–14.

13 *Survey of London* vol. XXXIV, The Parish of St Anne, Soho, 1966, pp. 492–7; *The Builder*, 14 May 1853, pp. 308–9; *Civil Engineer and Architect's Journal*, vol. XVI, 1853, p. 161; Darby, M. *The Islamic Perspective* (London: 1983) pp. 125–8.

14 *Denver Tribune*, 4 September 1881, quoted in *Documents of American Theater History Vol. I. Famous American Playhouses 1716–1899* (Chicago: 1973), p. 278. with illustration.

15 Ibid.

16 The *Denver Republican* 10 May 1891, p. 24, column 2, states that the architect of the Metropole Hotel was 'the veteran hotel constructor, Colonel J. Wood of Chicago'. This would appear to be an error, since stylistically the complex is so similar to Frank Edbrooke's work, and the 1891 *Chicago City Directory* merely lists Wood as a 'contracting agent'.

17 *Denver Republican* (18 August 1890), quoted in *Documents of American Theater Vol. I. Famous American Playhouses 1716–1899* (Chicago, 1973) no. 115. The theatre opened on 18 August 1890; $175,000 was spent on the interior alone.

18 For another view of the safety curtain see, Brettell, R., *Historic Denver: The Architects and the Architecture 1858–1893* (Denver: 1973). The Broadway Theater was demolished in December 1954 and the hotel is under threat of demolition. For an account of Frank E. Edbrooke (1840–1918) see Brettell pp. 32–63.

19 Ibid., p. 226.

20 Walter Emden (1847–1913), born in London, studied engineering in the workshops of Maudsley Sons & Field, Lambeth; civil engineer in the firm of Thomas Brassey, railway engineer. Architectural pupil of Kelly & Lawes F.R.I.B.A. 1870. In 1890 was elected mayor of the London City Council. Commissions include 1871 Royal Court; 1899 Garrick (with C. J. Phipps); 1892 Duke of York's and other theatres in

Sheffield, Southampton, etc. See biography, *Curtains !!!* ed. Iain Mackintosh and Michael Sell (Eastbourne: 1982) p. 212.

21 For Emden's ideas on theatre construction see 'The Construction of Theatres', *The Architect* 20 April 1888, p. 231.

22 Originally called the Tivoli concert-hall and restaurant. Description in *The Builder* (31 May 1890), p. 398. Illustrated in Glasstone, V. *Victorian and Edwardian Theatres* (London, 1975), p. 76. According to the description in *The Builder* there was no Indian style buffet on the ground-floor, as suggested by Glasstone p. 75.

23 *Decorator and Furnisher* (New York: November 1884), p. 42.

24 It has recently been fully restored to its original grandeur. See *Frank Matcham Theatre Architect*, ed. Brian M. Walker (Belfast: 1980), pp. 95–118. Quotes from *Belfast Newsletter* (17 December 1895).

25 There were no other theatres with significant use of Indian details, although several 'Oriental' theatres existed, including the Oriental Palace of Varieties, Denmark Hill, Camberwell, London (later Palace of Varieties) 1896, which had an 'Islamic' exterior of minarets and cusped windows. It was remodelled inside by E. A. Woodrow in a 'Saracenic' style. See illustration in Southwark Public Library. Description in *The Builder*, 1899 2 December, p. 516; 8 December p. 762. There was another Oriental Theatre in Poplar High St., London.

26 For biography see *Curtains !!!*, op. cit., p. 211.

27 Melville Seth Ward, F.R.I.B.A. (1869–?), 104 Victoria Street, Westminster, London. Articled to Ernest Newton, R.A. Worked on rebuilding of Yorgate Hall, Norfolk, 1900–3; restorations and additions to Rushbrooke Hall, Suffolk 1908–10; Cadbury Court, Somerset 1914–16; Heatherden Hall, Bucks., 1914–20; Halings House, Bucks., 1923. Drawings for the Globe in Battersea Public Library, London.

28 Sharp, D., *The Picture Palace: and Other Buildings for the Movies* (London: 1969) p. 63.

29 Thomas Lamb (1871–1942), information from two unidentified newspaper clippings for 26 February 1942 in the clippings file (71), Lincoln Center Theater Collection, New York. 20,000 of Lamb's drawings were given to Columbia University, New York in the summer of 1983 and are in the process of being catalogued.

30 Quoted in Hall, Ben M., *Best Remaining Seats* (New York: 1961) pp. 39–40.

31 Quoted Naylor, D., *American Picture Palaces* (New York and London: 1981) p. 31.

32 Lamb, T., 'Good Old Days to These Better New Days', *Motion Picture News* (June 1928), pp. 29–54. For an appraisal of Thomas Lamb and the Adam revival style see Freeman, Hilary, *All that Glitters . . . Canadian Historic Sites; Occasional Papers in Archaeology and History – No. 13* (Ottawa, 1975).

33 Ibid., p. 33.

34 Ibid., p. 34.

35 Ibid.

36 Illustrated in Sharp, D., *The Picture Palaces*, p. 52. Designed by Cogswell, A. E., a local architect responsible for several other cinemas, opened 21 February 1921.

37 Now a Fiorucci boutique.

38 *Denver Post* (17 Oct. 1926); *Rocky Mountain News* (29 Oct. 1926); *Denver Post* (11 Oct. 1959); *Denver Post* (30 April 1982).

39 Quoted, Naylor, D., *American Picture Palaces*, p. 31.

40 Quoted, Hall, Ben M., *Best Remaining Seats*, p. 141.

41 Journal of the International Theatre Organ Society of America, *The Console*, November 1965, pp. 11–12.

42 Franzheim, K., 'Present Tendencies in the Design of Theater Facades' *Architectural Forum*, (June 1925), p. 365.

43 The scheme was devised by Rambusch's chief designer of the time, Lief Neandross. It is not certain who designed the 'Indian' mural; the Rambusch firm suggested that it was painted by an Englishman Alfred Tulk, who was hired by them. He later taught at Yale College of Art. Mr Lief Neandross in a conversation in October 1983 said he thought it was painted by a Bavarian while Mr John MacNamara, who joined Lamb's office as a graduate in 1923, thought it was by a Russian, probably Emil Melina, who he thought had visited India. According to Mr Neandross it was Melina who procured books on Asian architecture and who suggested the 'Hindu' style to Lamb.

From conversations with both these gentlemen in October 1983, it was clear that in both Lamb's and Rambusch's offices there worked several emigrés from Europe. Mr MacNamara thought there were five or six, all middle-aged, including two Germans, a Hungarian, an Italian and a Russian. The Rambusch Library still exists and contains copies of Martin, F. R., *The Miniature Painting and Painters of Persia, India and Turkey from the 8–18th Century* (London: 1912); Laurence Binyon's *The Poems of Nizami*, illustrated with Persian and Indian miniatures in the British Museum (London, 1928). The Library

also had James Ward *Historic Ornament* (London: 1897, reprinted 1917) which has a section on Indian textiles, metalwork and pottery; and Glazier, Richard, *A Manual of Historic Ornament* (London, 1899, reprinted 1906, 1914) has a chapter on Indian textiles and illustrates Hodges's 'Vish Visha' column at Benares. The State, Syracuse has recently been restored by Rambusch & Co. 40 West 13 Street, New York.

44 Quoted Naylor, D., op. cit., p. 36.

45 Op. cit., p. 33.

46 Op. cit., p. 41.

47 'Loew's 175th Street Theater, New York City', *Architecture And Building*, New York, vol. 62, June 1930; p. 164, pp. 177–9. Press cutting 7 February 1930 (no title) Lincoln Center Theater Collection, New York.

48 Robert W. Sexton, 'Tendencies in the Design of the Present Day Theater', *American Theaters of Today* (New York, 1930) vol. 2, pp. 1–4.

49 Information kindly supplied by Mr Michael Moodabe, Amalgamated Theatres Ltd., Auckland, New Zealand.

50 *Architectural Forum* (June 1925), p. 362. See also 'The Architect and the Box Office', *Architectural Forum* (September 1932), pp. 194–6.

51 Harold W. Rambusch, 'The Decorators of the Theater', pp. 23–30; R. W. Sexton, *American Theaters of Today* (New York: 1930), vol. II.

52 Illustrated in *Architectural Record* (New York) Vol. LXI, (Jan–June 1927), pp. 385–93.

53 See Shand, P. Morton, *Modern Theatres and Cinemas: The Architecture of Pleasure* (London: 1930).

Ex Oriente Lux

1 See French, Peter J., *John Dee: The World of an Elizabethan Magus*, (London: 1972; reprinted 1984), pp. 180–1.

2 *The Building News* (1889), August 2, p. 142; August 9, p. 201; November 15, p. 684; November 22, p. 718. Leitner (1841–99) was born in Budapest of German parents and came to England in 1858. He was appointed lecturer in Arabic, Turkish and Greek at King's College, London. Established the Oriental University Institute soon after his return to England; much visited by Hindu and Muslim

scholars; published *Asiatic Quarterly Review*. For recent accounts of the Institute see Whiteman, J. R. and S. E., *Victorian Woking* (Guildford: 1970), and Keay, John, *The Gilgit Game* (London: 1979), pp. 14–40.

3 See illustration and architect's note facing p. 8 in *The New Orient* vol. III (December 1925) no. 1; *Bahai World* vol. X, 1944–6, pp. 411–17.

4 Preface, *A Nonagonal Temple* . . .

5 Introduction, *Architectural Compositions* . . . C. M. Remey, born Burlington, Iowa 1874, died Florence, Italy 1974; educated at Cornell University 1893–6, Ecole des Beaux Arts, Paris 1896–1903; travelled in Europe and the Orient; Professor of Architecture George Washington University 1908–10; made a detailed study of Oriental architecture; Patron of Metropolitan Museum of Art; made designs for a National Church and Shrine (1927) which was not built. Some of his drawings are at Columbia University, New York.

6 See *New Civil Engineer* (20 September 1979), pp. 22–3.

7 'Symbol of Peace', *Concrete Quarterly*, vol. 128, Jan–March (London: 1981) pp. 16–19.

8 For an exhaustive study of the bungalow see King, Anthony D., *The Bungalow: The Reproduction of a Global Culture*, (London: 1984). I am also grateful to Martin Segger, Director of the Maltwood Art Museum and Gallery University of Victoria, British Columbia, Canada and Professor Balwant Saini of the Architectural Department University of Queensland Brisbane, Australia for sharing their research with me.

9 Drawing and plan in the Yale Center for British Art, New Haven, Connecticut, U.S.A.

10 Drawings and archive material for this are in the Maybeck Archive, Dept. of Environmental Design, University of California, Berkeley. For an account and illustrations of a preliminary scheme see the Magazine Section, *Christian Science Monitor Weekly*, (26 October 1938), pp. 8–9.

11 See *The Japan Architect* vol. 53 (June 1978); Jencks, Charles, *Current Architecture* (London: 1982), pp. 198–9.

Bibliography

Adburgham, Alison, *Liberty's a Biography of a Shop* (London: 1975).

Aijazuddin, F. S., *Sikh Portraits by European Artists* (London & New York: 1979).

Aikin, Edmund, *Designs for Villas and other Rural Buildings* (London: 1808, reprinted 1835).

Alexander, Michael and Sushila, Anand, *Queen Victoria's Maharajah Duleep Singh 1838–93* (London: 1980).

Annesley, George Viscount Valentia, *Voyages and Travels to India, Ceylon . . . in the years 1802, 1803, 1804, 1805 and 1806* (London: 1809).

Archer, Mildred, *Indian Architecture and the British* (London: 1968).

Archer, Mildred, *British Drawings in the India Office Library* (London: 1969).

Archer, Mildred, *India and British Portraiture 1770–1825* (London: 1979).

Archer, Mildred, *Early Views of India* (London: 1980).

Archer, Mildred and Lightbown, Ronald, *India Observed: India as viewed by British Artists 1760–1860*, catalogue of an exhibition held at the Victoria and Albert Museum, London, 1982.

Archer, William G., *Paintings of the Sikhs* (London: 1966).

Artistic Houses (New York, D. Appleton, 1883).

Aslet, Clive, *A History of Elveden* (London, 1984), volume VII of catalogue of a sale held by Christie's, London.

Aslet, Clive, 'Elveden Hall, Suffolk I' *Country Life* (8 March 1984), pp. 607–11; 'Elveden Hall, Suffolk II' *Country Life* (15 March 1984), pp. 672–6.

Aston, George, *H.R.H. Duke of Connaught and Strathearn* (London: 1929).

Baroda, Maharajah of, *The Palaces of India* (London: 1980).

Benedict, Burton, *The Anthropology of World Fairs* (London and Berkeley: 1983).

Binney, Marcus, *Sir Robert Taylor* (London: 1984).

Birdwood, George, *Handbook to the British Indian Section . . .* (London: 1878).

Birdwood, George, *The Industrial Arts of India* (London: 1880).

Bishop, R. and Coblentz, P., *The World of Antiques, Art and Architecture in Victorian America* (New York: 1979).

Bognar, Botand, 'Odon Lechner and Aladar Arkay – Secession Architecture in Hungary', *Architecture and Urbanism*, no. 90 (April 1978), pp. 41–54.

Bonython, Elizabeth, *King Cole A Picture Portrait of Sir Henry Cole K.C.B. 1808–1882* (London: 1982).

Burg, David F., *Chicago White City of 1893* (University of Kentucky Press, 1976).

Carrington, Charles, *Rudyard Kipling: His Life and Work* (London: 1978).

Carter, G., Goode, P. and Laurie, K., *Humphry Repton Landscape Gardener 1752–1818* (Norwich: 1982).

Chamberlain, M. E., *Britain and India: The Interaction of Two Peoples* (Newton Abbot: 1974).

Chisholm, Robert, 'New College for the Gaekwar of Baroda, with Notes on Style and Domical Construction in India', *Transactions* (R.I.B.A. 1882–3), pp. 141–6.

Cimino, R. M. and Scialpi, F., (eds), *India and Italy*, catalogue of an exhibition in New Delhi, (Rome: 1974).

Clarke, Caspar Purdon, 'Some notes upon the Domestic Architecture of India', *Transactions of the Society of Arts* Vol. XXXI (1883), pp. 731–46.

Clarke, Caspar Purdon, 'Examples of Moghul Art in the India Museum', *Transactions R.I.B.A.* (1888) pp. 122–32.

Clarke, Caspar Purdon, 'Modern Indian Art', *Transactions of the Society of Arts*, Vol. XXXVIII (1890), pp. 511–26.

Cole, David, *The Work of Sir Gilbert Scott* (London: 1980).

Coleman, Cary, 'India in America', *The Decorator and Furnisher* (March, 1885), pp. 202–3.

Crew, G. C. E., *Bagshot Park Surrey and the Royal Army Chaplain's Departmental Museum* (Derby: 1974).

Conner, Patrick, *Oriental Architecture in the West* (London: 1979).

Cooper, Nicholas, 'Indian Architecture in England 1780–1830', *Apollo* (August 1970), pp. 124–33.

Cundall, Frank, *Reminiscences of the Colonial and Indian Exhibition* (London: 1886).

Darby, Michael, *The Islamic Perspective* (London: 1983).

Davies, Philip, *Splendours of the Raj* (London: 1985).

Desmond, Ray, *The Last Empire: Photography in British India 1855–1911* (London: 1976).

Desmond, Ray,, *The India Museum 1801–1879* (London: 1982).

Devenish, David, 'The Brassey Collection', *Area Service Magazine* of the Museums of South East England, Summer, no. 29 (Milton Keynes: 1976).

Faude, Wilson H., 'Associated Artists and the American Renaissance in the Decorative Arts', *Winterthur Portfolio* no. 10, (1975) pp. 101–30.

Feiling, Keith, *Warren Hastings* (London: 1954).

Fergusson, James, *On the Study of Indian Architecture* (London: 1867).

Fergusson, James, *The History of Indian and Eastern Architecture* (London: 1876).

Forest, Lockwood de, *Indian Domestic Architecture* (Boston: 1885).

Forest, Lockwood de, *Indian Architecture and Ornament* (Boston: 1887).

Forest, Lockwood de, *Illustrations of Design* (Boston: 1912).

Foulston, John, *Public Buildings erected in the West of England* (1838).

Franzheim, Kenneth, 'Present Tendencies in the Design of Theater Facades', *Architectural Forum* (June 1925), p. 365.

Getting London in Perspective, exhibition catalogue, Barbican Art Gallery (London: 1984).

Girouard, Mark, *The Victorian Country House* (London: 1979).

Glasstone, Victor, *Victorian and Edwardian Theatres* (London: 1975).

Greenberger, Allen J., *The British Image of India* (London: 1969).

Griffiths, John, *The Paintings in the Buddhist Temples of Ajanta* (London: 1896).

Growse, F. S., *Indian Architecture of Today as Exemplified in New Buildings in the Bulandshahr District*, Part I Allahabad, (1885); Part II Benares, (1886).

Gullick, J. M., 'Kuala Lumpur 1880–1895', *Journal of the Malaysian Branch of the Royal Asiatic Society*, vol. XXVIII, part 4 (August 1955).

Hall, Ben M., *The Best Remaining Seats* (New York: 1961).

Harris, John, *Sir William Chambers* (London: 1970).

Head, Raymond, 'An Endless Source of Amusement – Amateur Artists in India', *The Connoisseur* (February 1980), pp. 93–101.

Head, Raymond, 'From obsession to obscurity: Colonel Robert Smith: Artist, Architect and Engineer – I', *Country Life* (21 May 1981), pp. 1432–4.

Head, Raymond, 'Indian Fantasy in Devon: Colonel Robert Smith: Artist, Architect and Engineer – II', *Country Life* (28 May 1981), pp. 1524–8.

Head, Raymond, 'Indian Architecture through Western Eyes', *Antique Collector* no. 4 (April 1982), pp. 90–3.

Head, Raymond, 'Divine Flower Power Decoded, the flower paintings of Sir William Jones', *Country Life* (18 September 1984).

Head, Raymond, 'Corelli in Calcutta: Colonial Music Making in eighteenth century India', *Early Music* (November 1985).

Head, Raymond, 'Bagshot Park and Indian Crafts', *Sources of Inspiration for Victorian Art and Architecture* Society of Antiquaries Occasional Papers, New Series no. 7 (London: 1985).

Head, Raymond, *Catalogue Raisonée of the Paintings and Drawings in the Royal Asiatic Society, London* (forthcoming publication).

Hermann, Wolfgang, *The Theory of Claude Perrault* (London: 1973).

Holzman, John, *The Nabob* (New York: 1926).

Hodges, William, *Travels in India During the Years 1780, 1781, 1782 and 1783* (London: 1793).

Honour, Hugh, *Chinoiserie: The Vision of Cathay* (London: 1961).

Irving, Robert Grant, *Indian Summer: Lutyens, Baker and Imperial India* (New Haven and London: 1981).

Hutchins, Francis G., *The Illusion of Permanence: British Imperialism in India* (Princeton University Press, 1967).

Irwin, John, *The Kashmir Shawl* (London: 1973).

Irwin, John and Brett, Katherine, *Origins of Chintz* (London: 1970).

Jacob, Samuel Swinton, *Jeypore Portfolios of Architectural Details* (London: 1890, 1894, 1898).

Jackson, Carl Thomas, *The Swami in America: A History of the Ramkrishna Movement in the United States 1893–1960* Ph. D. Thesis, (University of California, Los Angeles: 1964).

Jencks, Charles, *The Language of Post-Modern Architecture* (London: 1978).

Jencks, Charles, *Current Architecture* (London: 1982).

Jones, Owen, *Grammar of Ornament* (London: 1856).

Journal of Indian Art and Industry (London, 1886–).

Kaeppelin, Paul, *La Compagnie des Indes Orientales et François Martin* (Paris: 1908).

Kathy, Imre, *Medgyaszay Istvan* (Budapest: 1979).

Kaye, M. M., *The Golden Calm* (Exeter: 1980).

King, Anthony D., *The Bungalow: the Reproduction of a Global Culture* (London: 1984).

Kipling, John L., 'Punjab Wood-carving', *Journal of Indian Art and Industry* vol. 1, no. 4, (1886), pp. 1–3.

Lach, Donald F., *Asia in the making of Europe*, 2 vols. (Chicago and London: 1965, 1970).

Lamb, Thomas W., 'Good Old Days to these better New Days', *Motion Picture News* (30 June 1928), pp. 29–54.

Lancaster, Clay, 'Oriental Influences on the American Architecture of the Nineteenth Century', *Marg* Bombay vol. 6, no. 2. (1952) pp. 6–21.

Lancaster, Clay, *New York Interiors at the Turn of the Century* (New York: 1976).

Lewis, Anne Suydern, *Lockwood de Forest, Painter, Importer, Decorator* (Hecksher Museum, Huntington, New York: 1975).

Linstrum, Derek, *Sir Jeffrey Wyatville, Architect to the King* (Oxford: 1972).

Liscombe, R. Windsor, *William Wilkins 1778–1839* (London: 1980).

Loudon, John Claudius, *An Encylopaedia of Gardening* (1822).

Lutyens, Mary, *The Lyttons in India: An Account of Lord Lytton's Viceroyalty 1876–1880* (London: 1979).

Mackintosh, Iain and Sell, Michael (eds), *Curtains!!!* (Eastbourne: 1982).

Marshall, Peter J., *East Indian Fortunes* (Oxford: 1976).

Magyar Muveszet 1890–1919 Akademiai Kiado (Budapest, 1981).

Mayhew, Edgar and Minor, Myers, *A Documentary History of American Interiors from the Colonial Era to 1915* (New York: 1980).

Merriam, Ruth Levy, *A History of the Deanery* (Bryn Mawr College, 1965).

Mitter, Partha, *Much Maligned Monsters* (Oxford: 1977).

'Moorish Decoration', *The Decorator and Furnisher* (January, 1885), p. 141.

Morley, John, *Brighton Pavilion* (London: 1984).

Morris, Jan and Winchester, Simon, *Stones of Empire* (Oxford: 1983).

Musgrave, Clifford, *The Royal Pavilion: An Episode in the Romantic* (London: 1959).

Musgrave, Clifford, *Life in Brighton* (London: 1970).

Naylor, David, *American Picture Palaces: The Architecture of Fantasy* (New York: 1981).

Nilsson, Sten, *European Architecture in India 1750–1850* (London: 1968).

Ovington, John, *A Voyage to Surat in the Year 1689* (London: 1696; new ed. New Delhi: 1976).

Owen, Tom, 'Lavish Palace Shuttered', *The Console* (Publication of the International Theater Organ Society, November 1965), pp. 11–13.

Ponsonby, Arthur, *Henry Ponsonby Queen Victoria's Private Secretary: His Life from His Letters* (London: 1942).

Raymond, E. Neill, *Victorian Viceroy. The Life of Robert, the First Earl of Lytton* (London: 1980).

Ram Raz, *Essay on the Architecture of the Hindus* (London: 1834).

Ranlett, William H., *The Architect: a series of Original Designs* (New York: 1848).

Remey, Charles Mason, *Architectural Compositions in the Indian Style* (privately printed 1923).

Remey, Charles Mason, *A Nonagonal Temple in the Indian Style of Architecture* (privately printed 1927).

Repton, Humphry, *An Enquiry into the Changes of Taste in Landscape Gardening* (London: 1806).

Repton, Humphry, *Designs for a Pavillon at Brighton . . .* (London: 1808).

Richards, J. M. and Pevsner, N., (eds), *The Anti-Rationalists* (London: 1973).

Robertson, E. Graeme and Robertson, Joan, *Cast Iron Decoration: A World Survey* (London: 1977).

Robinson, Vincent, *Eastern Carpets* (London: 1983).

Ruskin, John, *The Two Paths* (London: 1859).

Russell, Frank, (ed), *Art Nouveau Architecture* (London: 1979).

Sharp, Dennis, *The Picture Palace and other buildings for the movies* (London: 1969).

Sheldon, George, *Artistic Houses*, 2 vols. (New York: 1882–4). Reprinted in 1971 in one volume.

Shellim, Maurice, *India and the Daniells* (London: 1979).

Shelton, William Henry 'The Most Indian House in America', *House Beautiful* vol. 8, no. 1. (June 1900).

Skelton, Robert, 'The Indian Collections, 1798 to 1978', *Burlington Magazine* Vol. CXX no. 902. (May 1978), pp. 297–304.

Sloan, Samuel, *The Model Architect* (New York: 1852).

Stamp, Gavin, 'British Architecture in India 1857–1947', *Journal of the Royal Society of Arts* vol. CXXIX, (May 1981), pp. 357–79.

Standen, Edith, A., 'Some Exotic Subjects', *Apollo* (July 1981), pp. 44–54.

Standen, Edith A., 'English Tapestries "after the Indian Manner"', *Metropolitan Museum Journal* no. 15 (New York: 1981), pp. 119–42.

Steube, I. C. S., *The Life and Works of William Hodges* (New York and London: 1979).

Stroud, Dorothy, *George Dance Architect 1741–1825* (London: 1971).

Summerson, John, *John Nash* (London: reprinted 1984).

Tarapor, Mahrukh, 'John Lockwood Kipling and British Art Education in India' *Victorian Studies*, vol. 24, no. 1, (Indiana University, Autumn 1980), pp. 53–81.

The Letters of Sir William Jones edited by Garland Cannon, (Oxford: 1970).

The Maharajah's Well . . . An illustrated History (Uxbridge: 1979).

The Public Well at Stoke Row, Ipsden, Oxfordshire, the Gift of the Maharajah of Benares (Oxford: 1972).

Thomas, John, 'The Architectural Development of Hafod', (1786–1882), Ceredigion, *Journal of the Ceredigion Antiquarian Society* vol. vi, 1973–74 pp. 151–69; vol. vii, 1974–75 pp. 215–29.

Tod, James, *Annals and Antiquities of Rajasthan*, 2 vols. (London: 1829, 1832).

Travels of Mirza Abu Taleb Khan, translated by Charles Stewart, (published Calcutta: 1814, reprinted New Delhi: 1972).

Ujfalvy-Bourdon, Mme, de, *Voyage d'une Parisienne dans L'Himalaya Occidental* (Paris: 1887).

Vamos, Ferenc, 'Lechner Odon', *Architectural Review* vol. 142, (July 1967), pp. 59–62.

Walker, Brian Mercer, *Frank Matcham Theatre Architect* (Belfast: 1980).

Watkin, David, *Thomas Hope and the Neo-Classical Idea* (London: 1968).

Watkin, David, *Life and Work of C. R. Cockerell* (London: 1972).

Weiner, Piroska, 'Aperçus de l'histoire du Musée des Arts Decoratifs', *Ars Decorativa*, vol. I (Budapest: 1973), pp. 31–54.

Bibliography

Weinhardt, Carl J., 'The Indian Taste', *Metropolitan Museum of Art Bulletin*, vol. XVI (March 1958), pp. 208–16.

Welch, Stuart Cary, *Room for Wonder: Indian Painting during the British Period* (New York: 1978).

Wilson, Angus, *The Strange Ride of Rudyard Kipling* (London and New York: 1978).

Wilson, Horace H., *A Descriptive catalogue of the oriental manuscripts and other articles illustrative of the literature, history, statistics and antiquities of South India ...* (Calcutta: 1828).

Wornum, Ralph N., 'The Exhibition as a Lesson in Taste', *Art Journal Illustrated Catalogue* (London: 1851).

Young, Desmond, *Fountain of the Elephants* (London: 1959).

Index

(Figures in *italic* type refer to illustration captions)

Agra 3, 9, 76, 80, 82
Ahmedabad 84, *102*, 103, *105*, 106, 107, 108, 119,
 125
Akbar's Tomb 2, 29
Alipur 25
American Colonies 12
Architects
 Adam, James & Robert 147
 Aikin, Edmund 27, 30, 50, *50*, 51, 59, 60, 62
 Ambler, Thomas *165*, 166
 Austin, Henry 60, *61*, 62
 Baker, Herbert 79, 87, *87*, 88
 Banks, Thomas *27*, 32
 Beaumont, Sir George 34, 36
 Blackadder, Dr Adam 28
 Bohringer, C. H. 154, *155*
 Chambers, W. I. 159
 Chisholm, Robert *74*, 75–7, 79, 85, *86*, 87, 90
 Clarke, Casper 77–9, 88, *89*, 103, 114, 119, *122*,
 122–5, *126*, 128–9, 132
 Clowes, Charles 128, 129
 Cockerell, Charles R. 43, *43*
 Cockerell, Samuel P. 12, 13, 14, *16*, 24–6, 30, 31,
 35, 37, *37*, 39, *41*, 43–5, 46, 49, 50, *56*, 162
 Cole, Lt Henry 80, 81–4, *84*, 95
 Collcutt, Thomas 83
 Crace, J. D. 83
 Dance, George 23–4, *24*, 26, 34–7, *36*, 48–9, 55,
 82, 90
 Dick & Baur 150
 Dupire-Rozan, Charles 63, *63*
 Eberson, John 153
 Edbrooke, F. E. 136, *137*, 138
 Edwards, M. F. 88, *88*
 Eidlitz, Leopold 59, *59*
 Emden, Walter 138, 139
 Emerson, Sir William 85
 Ferguson, James 80–2
 Foulston, John 34–5, *35*, 55
 Hancock, Tom *162*
 Holland, Henry 26
 Hollein, Hans 168, *168*
 Jacob, Colonel S. 76–7, *77*, 79
 Jones, Owen *71*, 72, 95, 96, 98
 Kalman, Gerster 90
 Kipling, John L. 77, 100, 102, 110–13, 116, 119,
 122, 123, 132
 Lamb, Thomas *145*, 146, 152–6
 Lechner, Odon 90, *92*, *93*, *94*
 Loudon, J. C. 55, *56*

Lutyens, Sir Edwin *78*, 79, 87
McLaren *62*, 63
Matcham, F. 138–9, 140, *141*
Maybeck, Bernard *166*
Medgyaszay, Isran 92
Mozuna, Monta 169
Nash, John 25, 30, 39, 43–4, *51*, 51–3, 56, 59,
 60–2, 134, 167
Norman, A. C. 93, *94*
Ohka, Prof. M. *162*
Perry, Joseph *81*, 82
Phipps, C. J. 138
Plaw, John 162
Prinsep, W. H. *68*, 69
Rambusch, H. 152, 156
Ram Raz 59–60
Ranlett, William 59, *60*
Rapp & Rapp 149
Remey, Charles *161*
Repton, Humphrey 10, 30, 38–9, *42*, *47*, 46–53,
 48, *49*, *51*, *52*, 59, 60, 67
Robinson, J. T. 139
Ruskin, John 98
Sandby, Thomas 23
Scott, Gilbert 82
Seitz, Frans 116
Shand, P. M. 156
Singh, Ram 112, *113*, 114, 117–18
Smith, Edmund 81
Smith, Colonel R. 19, *19*
Spiers, R. P. 75
Stevens, F. W. 91, *92*
Taylor, Sir Robert 25, 37–8
Thomas & Mercier 150
Tondoire, Marius 130
Town, Ithiel 60
Urban, Joseph 156
Wilds, A. H. *54*, 55, 57, 58
Wren, Sir Christopher 27
Wyatt, Benjamin 134
Wyatt, James 23, 26
Wyatt, M. D. 82, 121
Zimmerman, Arnold 154, *155*
Architecture
 Bengal Huts 43, *43*
 Capped Turrets 36, *36*
 Chattris 69, 85
 Choultry 23, 28
 Chujja 39, 84, *84*
 Ellora Columns 61–2

Ghats 58, *58*, 78
Gopuram, Temple Gate 33
Hindu Style 39, *40*, 46–8, *48*, 53, 87–9, 135, 150, 152
Indian Calix 9, *9*
Indian Style 47–9, *49*, *50*, 51, 103, 141–2, 148
Indo-Saracenic 129
Jain 152
Jali *51*, 53
Mandapam 69
Mughal Style 4–6, 13, *16*, 23, 32, *35*, 37, 39, *40*, 45, *48*, 55–6, *57*, 59, 62, 73, 79, 80–5, *89*, *93*, 129, 141, *144*, 148
Obelisk 'Fountain' 15, *18*
Octagonal Pavilion 10, *42*
Overhanging Eaves 9, *9*, 39, *61*
Pinjra 110, 113
Serai 39, *39*, *41*, 49
Sikhara 69
Stupa 78
Architecture of Ahmedabad 119
Arthur Duke of Connaught 111
Artists
Blechen, Carl *57*
Colman, Samuel 101, *104*
Daniells, Thomas 9, 13, *14*, *16*, 29, 30, 31, 32, 33, *33*, 34, 35, 38, 39, 40, 43, 46, *47*, *48*, 50, 53, 58
Daniells, William 9, 29, 30, 31, 32, *32*
Daniells Bros, Oriental Scenery Aquatints 9, 29, 30
de Forest, Lockwood 100–1, *102*, 103, *104*, 105, *106*, 107–8, *109*, 110, 114, 122, 138
Devis, Arthur 32
Dumoulin, Louis 129, *130*
Erikson, Jens 138
Farrington, Joseph 29
Ferry, Benjamin 111
Greene & Greene *164*
Griffiths, John 100
Hodges, William 9, 22–5, *22*, 29, 48, 59, 60, 80, 'Select Views' 9, *22*
Kandinsky 157
Moses, Thomas 138
Northcote, James 32
Reynolds, Sir Joshua 21, *22*, 23, 28
Richardson, N. H. 106
Sumner, Charles 164
Terry, Quinlan 161
Tiffany, Louise 101, *103*, *104*, 110
Wales, James 162
Ward, Francis S. 22, 23
Wheeler, Candace 101, *104*
Wornum, Ralph 98
Wyatt, Matthew D. 115
Ashmolean Museum 43
Asiatic Society, Bengal 12, 28

Bahadur Shah 11 Emperor 72
Barnum, P. T. 59, *59*
Baroda, Maharajah 72

Barrett, Colonel N. 60, *60*
Bath 44
Benares 58, *58*, 72, 159
Bengal 2, 25
Benoit de Boigne, General 15–16, *18*
Berlin 56, 57
Bhagavad Gita 12, 28, 157
Bikaner, Maharajah of 77
Bihar 29
Birchwood, Sir G. 99
Bombay 2, 98, 100, 113, 123
Bournemouth 111
Bristol *68*
Brussels 56
Bulandshahr 77, *78*
Burgess, James 81
Buildings, America
Avalon Theatre 153
Beverly Theater, L. A. 148–9, *149*
Capitol Theatre N.Y. 147
Carnegie Mansion N.Y. 105, *106*
Charles Yerkes House 109
Flood House S. Francisco 109
Frank C. Haven House 109
Frank McVeagh House 106
Hindu Temple of Youth *166*, 167
Hoffam House Hotel 139
J. D. Pile House 109
Milwaukee Oriental 150
Mortimer Fleishbacker, California *164*
Nelson Hotchkiss House *61*
Odiyan, California 161
Portland Oriental 150
Railroad Station, Plainville 62
Staten Island House 60, *60*
The Chicago Oriental 150
The Oakland, California *157*
The State, Syracuse 152
Vedanta Temple, S. Francisco 160
Willis Bristol House *61*, 62
Ziegfield Theatre 156
72nd New York 152
175th Street New York 152
Buildings, Black Sea
Aloupka 39
Buildings, Belgium
Grand Opera House *141*
Kursaal, Oostend 133
Buildings, England, Scotland
Ashburnham Place 36, *36*
Bagshot Park, Surrey 67, 111, *112*, 113
Brighton Hippodrome 141
Brighton Pavilion 38–9, 44–6, *46*, 47, *47*, *48*, 51, *51*, *52*, 53, *54*, 55, 56, *59*, *61*, 62, *62*, 63
Breadsall Priory 115
Christian Science Church 85
Clifton Baths, View *58*
Coleorton House 36
Daylesford House *13*, 14, 25, 26, *27*, 31
Durbar Hall *124*, *132*

Electric Theatre, London 142, *143*
Elephant Chapel, Wickham 111
Elveden House 64, *65*, 66–8, 80, 88, *89*, 117
Globe Cinema, Putney 133, 142, *144*
Guildhall, London 23, *24*, 26
Hindu Temple 14, *14*
Hotel Cecil, London *81*, 82
Indian Museum, London 86
Indian Well, Stoke Row 71
Knebworth 85
Lower Swell 43, *44*
Melchet Park 13, 14, *14*
Milton Keynes Peace Pagoda 161, *162*
Oriental University Inst., Surrey *159*
Osborne 68, 118
Palace Theatre, Portsmouth 148
Paxton's Crystal Palace 95
Preston Hall 9, *9*, 10
Redcliffe *19*, 20
Royal College of Music *84*
Royal Panopticon, London 135
Sezincote *16*, 31, *37*, 38–40, *40*, *41*, *42*, *43*, 44,
 44, *45*, 46, 49, 51, *56*, 58, 162, 167
Theatre Royal, London 134
Tivoli Restaurant 136
White Conduit House 135
12 Palace Gardens 115
24 Palace Gardens *71*, 72
Buildings, France
 Chateau Vaissier, Lille 63
Buildings, Hungary
 Art Museum, Budapest 91, *92*, *93*
 Deak Mausoleum 90
 Drechscer Palace 90
 Geological Inst, Budapest 94
 Vszprem Theatre 92
Buildings, India
 Bombay School of Art 100
 Bombay Terminus 91, *92*
 Chepauk Palace, Madras *74*
 Constanta, Lucknow 15, 73
 Cotsea Bhajg, Delhi *47*
 Egmore Rail Station 75
 Government Ho, New Delhi *78*
 High School, Surat 70
 Jami Masjaid, Delhi 53
 Jantar-Mantar, Delhi *32*
 Mayo College, Ajmer *76*
 Mayo School of Art 100
 Metcalfe's House 83
 Najafghar Palace 73
 Palaces at Baroda, Darbhanga Kolhapur 71
 Peoples Palace, Jaipur *77*
 Post Office, Madras 75
 Sanchi, North India 148
 Town Hall, Kolhapur 70
 University Senate House 75
 Victoria Memorial Hall 85
Buildings, Ireland
 Dromona 54, 55

Buildings, Italy
 Prince of Kolhapur's Monument, Florence 83
Buildings, Japan
 The Mirror House, Saitama 169
Buildings, Malaysia
 Secretariat, Kuala Lumpar 93, *94*
 Sultan Mosque, Singapore 62, *62*
Buildings, New Zealand
 Civic Theatre, Auckland 154, *155*
Buildings, Vienna
 Rajasthani Pavilion *168*

Calcutta 2, 15, 28–9, 73, 98, 113
Cave Temples 28
Chait Singh of Benares 12
Chandernagar 7
Cheltenham 44, *45*
Christian Missionaries 158
Clive, Robert, *see* Nabobs
Cockerell, Charles 25, 31, 37–9, 40, 43, 46, 80
Cockerell, Lt Col John 25, 31, 37
Colbert, Jean 60–3
Comte de Boigne, General 64
Cunningham, Col Alexander 80

Daboda, Dawajee 69, *70*
Delhi 3, 19, *19*, 29, 32, 67, 76, 80, 82, 102, 158, *169*
Delhi Durbar 72, 84
Duleep Singh, Maharajah 64–8, 72, 88, 111

East India Company 1, 7, 8, 11, 12, *16*, 18, 20, 25, 30,
 64, 73–4, 80, 82, 86, 121
East India Company, European 15
Elephanta 2, 23, 28, 48, *48*
Ellora 28, 48, 154
Exhibitions
 Antwerp 1885 126
 Brussels 1897 128
 Calcutta 1883–4 122
 Columbia 1893 109
 Chicago's Columbian 127, 164
 Dublin International 80
 Empire of India 1895 128
 Franco-British, London 1908 129, *131*, 142, *143*
 Glasgow 1888 126
 Glasgow International 1901 141
 Great Exhibition 1851 95
 Hungarian, London 1908 93
 Indian & Colonial 1886 *102*, 108, 113, *123*, 124
 Indian Village, London 1885 108
 Melbourne 127
 Paris 1900 *129*, *130*
 Paris Universal 1867 80, 99, 119, *120*, *122*, *126*
 San Francisco 1894 165

Fatehpur Sikri 29, 81
Fish, Hamilton 103, *104*
Florence 69, *70*

Ganesha, Elephant God 114, 154

Ghazipur 23
Glasgow 115, 133
Greenwich Village 107
Growse, F. S. 76–7, *78*
Guinness, Edward 88, *89*
Gwalior Gateway *123*

Hastings Museum *132*
Hastings, Warren, *see* Nabobs
Hill Forts 49
Hindu Monuments of S. India 28
Hindu Mythology 26
Hope, Theodore 119, *120*
Hope, Thomas 33, *33*, 34
Hurdwar 29
Hyderabad 123

Imperial Institute 83, 86
India Museum 67, 87
Indian Mutiny 12, 66, 72, 74, 79, 87
Indian Pavilion *122*
Indian Pleasure Garden 72
Indian Room, Bagshot 116

Jacob, Colonel Swinerton 128
Jahangia, Emperor 1
Jains 2, 101
Jaipur, Maharajah of 82, 102
Jai Singh, Maharajah *32*, *167*
Jones, Sir William 28
Journal of Indian Art and Industry 111, 113, 124
Juma 124

Kankeri 28
Kashmir 80, 123
Kew 58
Khurja 77, *78*
Kimball, N. S. 103, *105*

Lahore 17, *65*, 67, 80, 100, 102, 112, 118, 123
Lahore School of Art 114
Lakohrai, Goddess of Good Fortune 25
Leitner, Dr Gottlieb 158, *159*
Leonard, Joseph 159
Lucknow 10, 15, *17*, 113

Macaulay Education Minute of 1835 19
Macneill, Hector (Scots Poet) 28
Madras 2, 33, 73, 98, 103, 123
Madura 23, 28–9
Maharajah of Scindia *123*
Mahratta Army 15
Malabar 7
Marquess of Aberdeen 133
Martin, General Claud 15, 73
Masulipatam 7
Mir Jafar 7
Mirza Abu Taleb Khan 30–1, 34, 37, 64
Mirza I'tisam al'Din 64
Mosques 49, 76, 102

Mount Abu 113
Muggenbhai Hutheesing 101, *102*
Muhanumad Baksh 124
Munshi Ismail 64
Muttra 80
Mysore 123, 128

Nabobs
 Clive, Robert 7, 8, 11
 Cockerell, Sir Charles 14, *16*
 Hastings, Warren 11, 12–13, *13*, *14*, 25–6, *27*, 28, 31
 Munro, Sir Hector 10, *11*
Nepal 103, 123
New Delhi 79, 87

Oudh 123
Oudh, Begums of 12, 15

Palace of Soviets, Moscow 146
Pir-o-Murshid Inayat Khan 161
Plassey, Battle of 7
Polier, Colonel Antoine 15, *17*
Pondicherry 2, 7
Presidencies of British India 2
Prince Frederick of Prussia 111
Prince of Wales (Prince Regent) 13, 31, 37–8, 44–5, 46, *46*, 47–9, 50–5, 64, 71, 83–4, 113
Prince of Wales (Edward VII) 66, 88
Prince R. Chattrapati 69, *70*
Princess Louise Margaret 111
Punjab 123
Punjabi Woodcarvers 110, 113

Queen Adelaide 58
Queen Victoria 66, 72, 83–4, 118

Raja of the Carnatic 1
Rajasthan 65, 67, 76, 82, 88
Rajmahal 29
Ram Mohun Roy's Tomb *68*, 69
Ram Raz 80
Ranjit Sing, Maharajah 16, 64
Reade, Edward 71
Reynolds 169
Rochester, N.Y. 103, 105
Rockefeller, J. D. 115
Roe, Sir Thomas 1
Rotasgarh Fort, Bihar 142
Royal Asiatic Society 34, 80, 86, 98
Royal Institute of British Architects 77

Sakuntala, Play by Jones 28
Santa Barbara, Calif. 107, 108
Sarnath 162
Sausalito, Taj-Mahal style houseboat 168
Scriabin, Composer 157
Settlements, European 2, 7
Shah Jehan 34, 158, *159*
Sheldon, George 104

Sheven Pagoda 121, *121*
Shiva 33
Shuja-ud-Daula 15
Sikandrabad 2, 29
Simla 84, 85
Société Asiatique 30
Society of Antiquities 30
South Kensington Museum 81, 83, 86, 88, 90, 98, 100, 103
Srinagar 29, 103
Srirangham 23
Surat 1, 70
Swami Trigunatitananda 159

Tagore, D. 69, *70*
Taj Mahal 2, 29, *31*, 33, 39, 161, *161*
Tavernier, Jean Baptiste 3
Tibetan Monastery 161
Travellers' Reports 1–6
Trevelyan, Sir Charles 98
Trichinopoly 30
Tuscan Villas 60, *61*

United States of America 60, *61*

Usual Indian Features
 Domes 13, 36, 39, 44, 45, *51*, 53, 63, 67, 69, 71, 78, 148
 Minarets 10, 23, 36, 39, *51*, 53, 67

Vanderbank, John 4, 5
Vanderbilt, W. 115
Vedanta Society of New York 159
Viceroy Lord Curzon 86
Viceroy Lord Harding 79
Viceroy Robert Lytton 80, 84, 85

Vienna 6
Vishnu 33

Wagner 118
Walpole, Hugh 8, 34
Wellesley, Arthur 12
White City 131
Wilberforce, William 19

Yale, Elihu 6
Yates, (Poet) 157